GIACOMETTI
The Complete Graphics

Participating Museums

The Milwaukee Art Center, Milwaukee
The Albright-Knox Art Gallery, Buffalo
The High Museum of Art, Atlanta
The Finch College Museum of Art, Contemporary Wing,
 New York
The Joslyn Art Museum, Omaha
The Museum of Fine Arts, Houston
The San Francisco Museum of Art, San Francisco

Exhibition arranged by the Milwaukee Art Center

GIACOMETTI
The Complete Graphics

and 15 Drawings

By Herbert C. Lust

Introduction by John Lloyd Taylor

Assistant Director and
Director of Exhibitions,
The Milwaukee Art Center

TUDOR PUBLISHING COMPANY
NEW YORK

Designed by Alfred Campisi

CONTENTS

ACKNOWLEDGMENTS

First, to the intelligent enthusiasm of Messrs. Tracy Atkinson, Director, and John Lloyd Taylor, Assistant Director and Director of Exhibitions of the Milwaukee Art Center, without whose guidance this book would not have been possible.

Secondly, to that great scholar of graphics and rare books, Edwin Engelberts, who has over the years been of counsel to me, and who has been of especial assistance in the compilation of the *Catalogue Raisonné*.

Special thanks are also due George Barkin and the editorial staff of Tudor Publishing Company for their many suggestions and creative editing.

Finally, to the Museum of Modern Art, New York, Galerie le chat Bernard, Chicago, and those private collectors who have generously granted us permission to reproduce some rare prints from their collections.

H. C. L.

INTRODUCTION

During the past decade the graphic work of Alberto Giacometti, heretofore relatively unknown, has attracted increasing attention. Until recent years his etchings and lithographs had been looked upon as secondary in importance to his achievements in sculpture and painting. But just as there is no question that Giacometti ranks as one of this century's major artists and that, stylistically, he stands alone, there is no longer much doubt that his graphics have a stature equal to his achievements in other media. Furthermore, they occupy a unique place in the corpus of his work. Whereas his sculptures and paintings embody the quintessence of being, the graphics are their commentary and affidavit—testimony *in propria persona* of his multifaceted genius.

The exhibition which originated in Milwaukee in May, 1970—and this volume which serves as the exhibition catalogue—is the first extensive presentation of Giacometti's graphics, thus providing a unique opportunity to examine and study this creative dimension of his work. Over two hundred and fifty items are included in the exhibition. The seventeen lithographs of 1954, known as the Studio series, are shown together for the first time. Similarly, the impressive studies of Diego, Annette and Caroline, as well as the landscapes and still lifes, are also included. Giacometti's iconographic world is thus fully documented, and this publication enables the reader to examine it in its entirety.

Neither the exhibition nor this book could have been realized without the singular dedication of Herbert C. Lust, an art collector from Illinois who, long before most, came to recognize the significance of Giacometti's achievement in graphics. A number of years ago he committed himself to the arduous task of assembling the most complete collection of these works. His were not the motives that usually animate the collector, for he developed his unique collection as a sincere tribute to a friend. His commitment was a personal one, in which bonds of affection, understanding and loyalty existed between collector and artist.

Of the three hundred and sixty-eight works illustrated in this volume the majority are contained in the Lust collection. Including fifteen drawings, it represents the largest collection of Giacometti graphics in the country.

Mr. Lust's *Catalogue Raisonné* is the first complete documentation to be done on this body of work and marks an important accomplishment in research. It is definitive to the extent that every known print is now catalogued. There remains the possibility that, unknown to either Lust or Giacometti's previous graphics cataloguer, Edwin Engelberts, further unique impressions and states may exist and could come to light at any time. For the purpose of present scholarship, however, it is surely appropriate to entitle this book "The Complete Graphics."

The author's treatment of Giacometti's development takes the form of a personal reminiscence rather than that of an essay in critical connoisseurship. Thanks to this subjective approach much fresh material is presented which will be a welcome addition to the slight but rapidly growing literature on Giacometti.

Lust's text and his recorded conversations with the artist's brother Diego offer a framework for critical examination of the graphics and drawings, as well as a rare and fascinating insight into the personality of Giacometti the man.

— John Lloyd Taylor

PART I.

Giacometti's Graphic World

1. The Unusual Scope of Giacometti's Graphics

Giacometti's most important prints were issued in small editions of thirty, and consequently are seldom seen at museums or found at dealers'. Thus, many critics or collectors do not suspect the amazing scope of his graphic production. Yet this graphic work is a majestic endeavor consisting of some 60 major works and almost 300 minor ones, and covers all the important phases and favorite subjects of the artist's career. It may well be that not even Giacometti's drawings could give a much better idea of his genius than do the complete graphics. In fact, Giacometti makes his major statement on his own sculptures in his 1954 lithographs, not in his drawings. And, although Giacometti did many major landscape drawings, none surpasses the two lithographs of the Alps he published in 1957.

Indeed, those who love Giacometti drawings will find in the graphics—all but one in black and white—their brilliant extension and complement. The amazing power and draftsmanship of the drawings remain intact in the graphics. True, Giacometti's brilliant erasures and smudges indicating levels of light are not in the graphics. On the other hand, no Giacometti drawing surpasses the exquisite subtlety of the 1955-1956 etchings, the visionary turbulence he consigned to the 1954 lithographs, or the stately spacing of the last lithographs.

The 350 Giacometti graphic works indicate new dimensions for his draftsmanship and entitle him to rank among the greatest and most original graphic artists of our century.

(Text continued on p. 69)

13

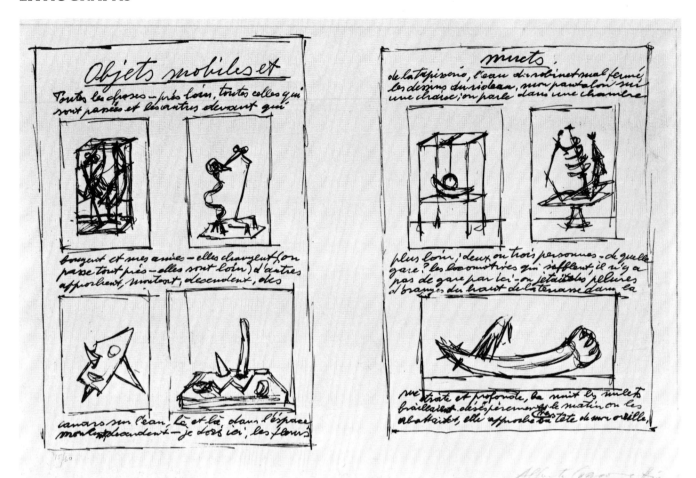

1. MOVING, MUTE OBJECTS *(Objets mobiles et muets)*. 1931.

Offert au
Museum of Modern Art
TZARA
déc. 49

2. TRISTAN TZARA. 1949.

Collection, The Museum of Modern Art,
New York. Gift of Tristan Tzara.

7/16

Alberto Giacometti

Tristan TZARA

TRÉSÉE

33/50

3. THE COUPLE *(Le Couple)*. 1951.

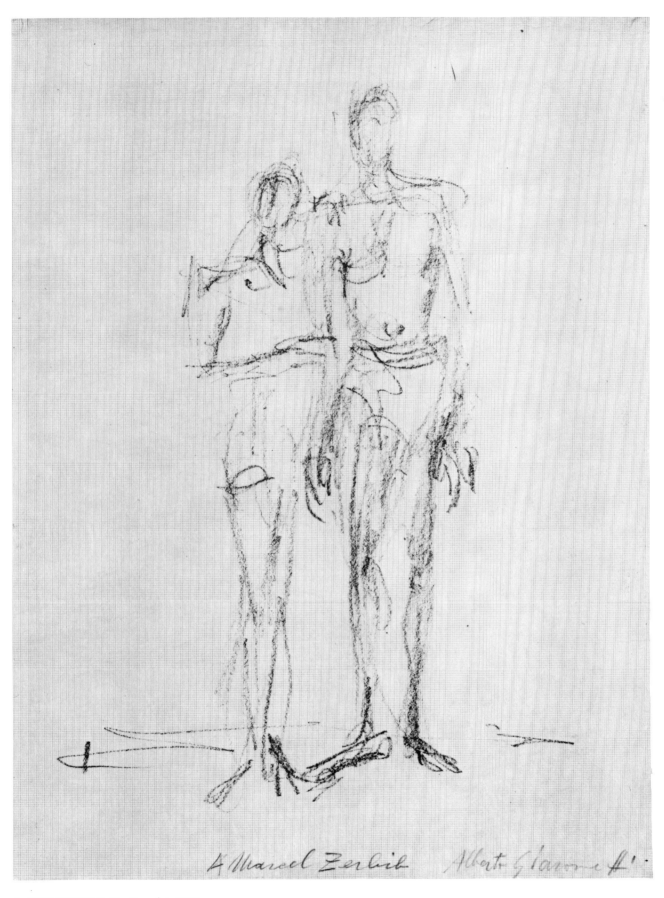

À Marcel Zerbib Alberto Giacometti

4. THE COUPLE *(Le Couple)*. 1951.

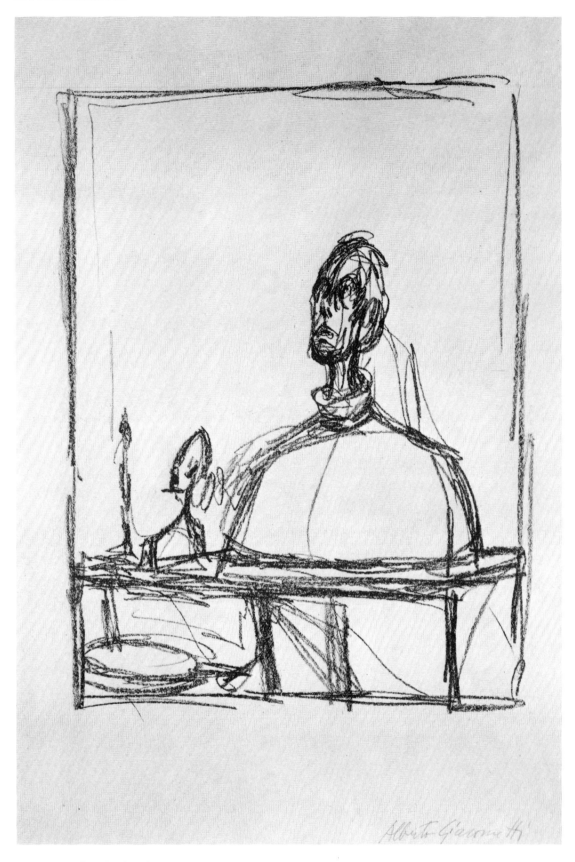

5. THE CAGE *(La Cage)*. 1951.

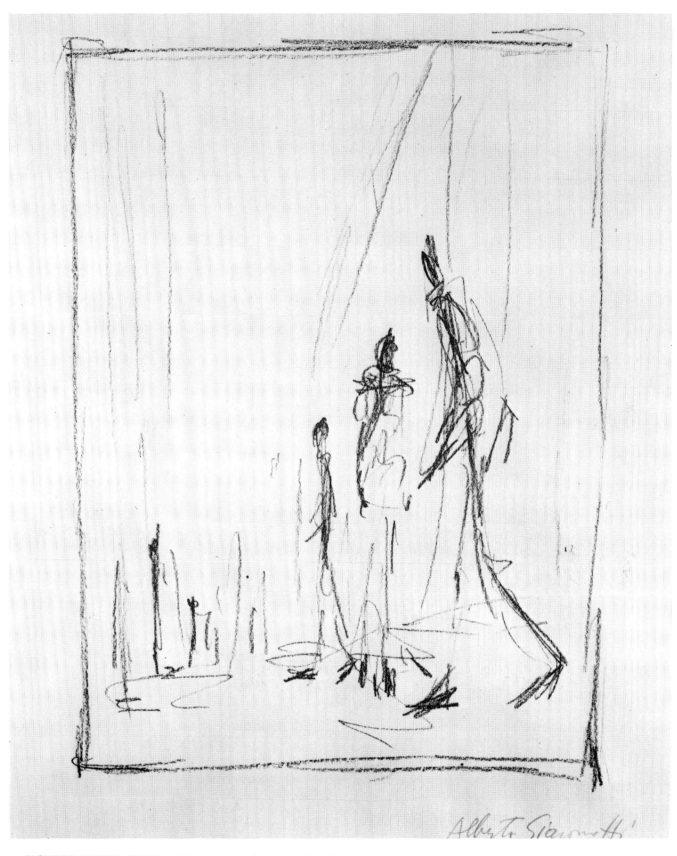

6. FIGURES IN THE STREET *(Personnages dans la rue)*. 1951.

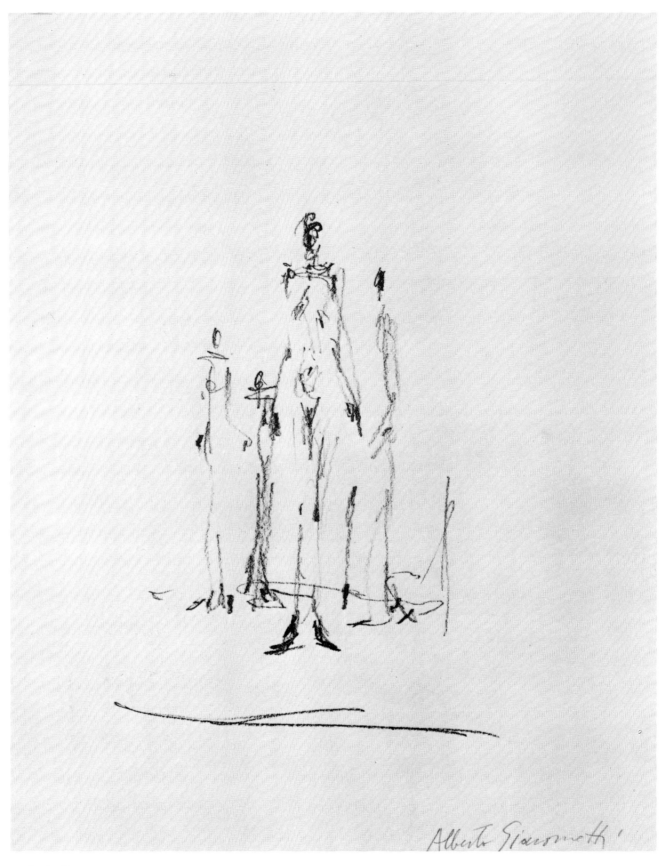

7. STANDING FIGURES. 1951.

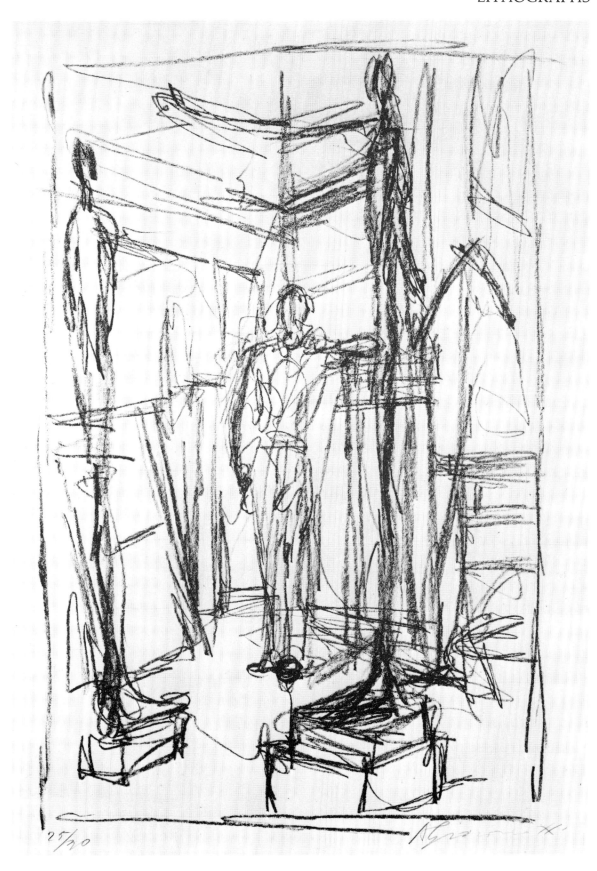

8. FIGURE IN THE STUDIO *(Personnage dans l'atelier)*. 1954.

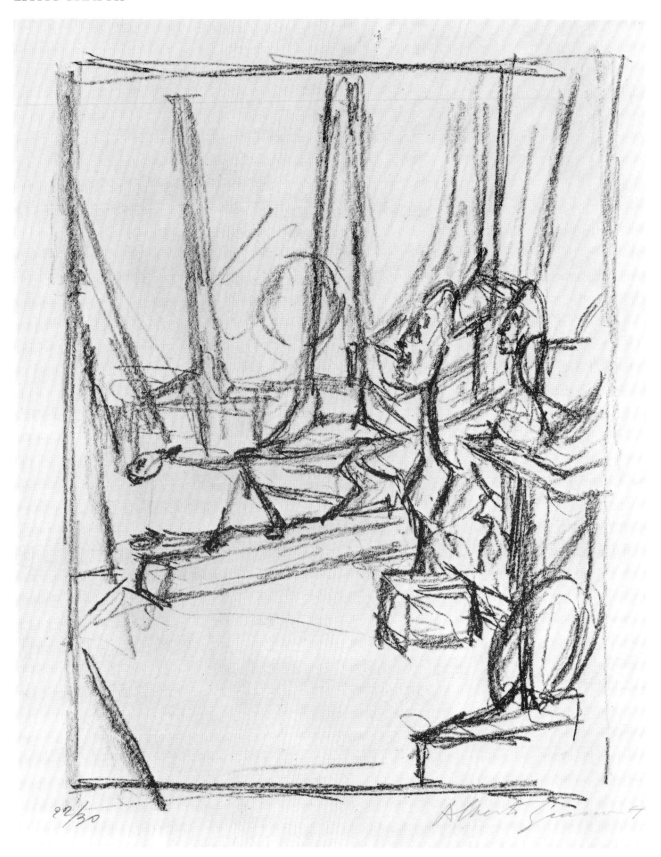

9. HEAD OF A CAT *(Tête de chat)*. 1954.

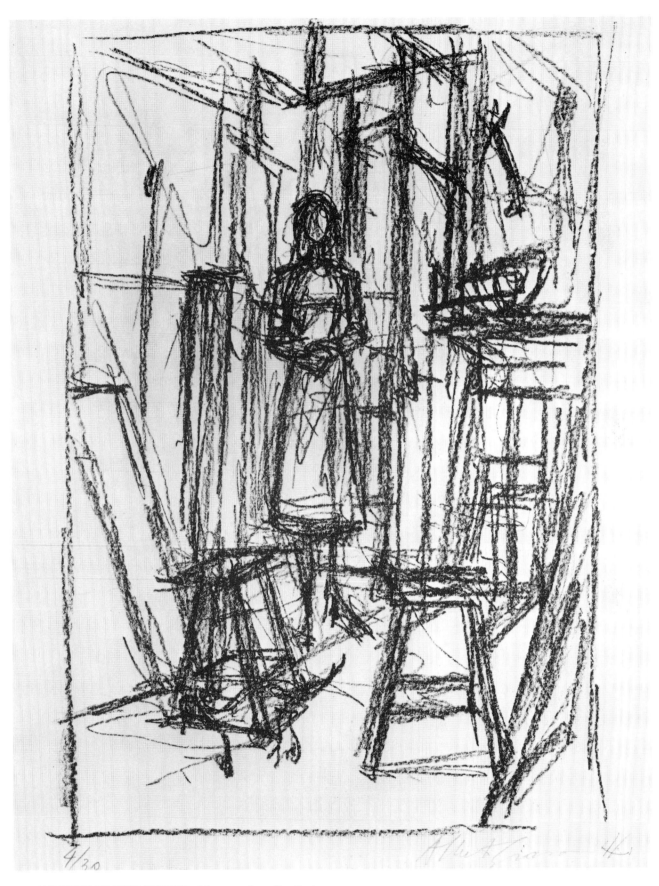

4/30

10. ANNETTE IN THE STUDIO *(Annette dans l'atelier)*. 1954.

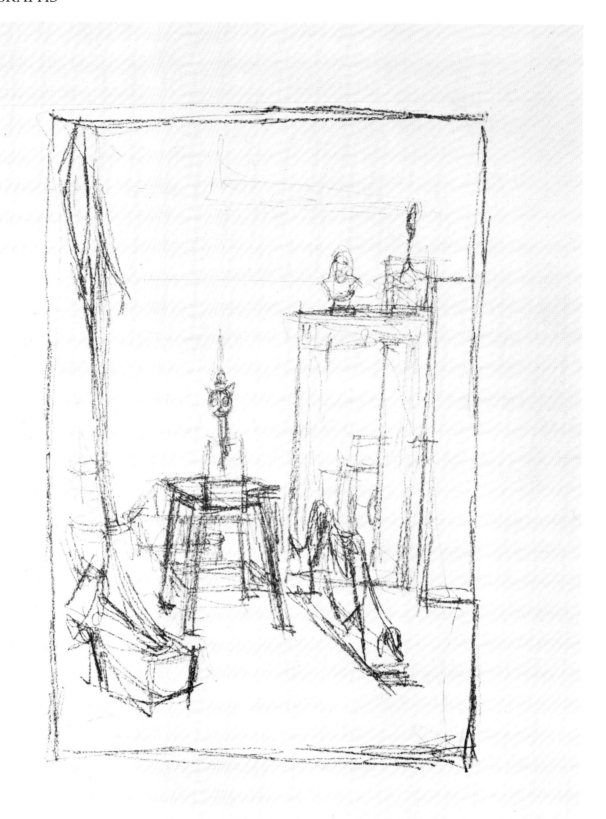

11. DOG AND CAT *(Chien et chat)*. 1954.

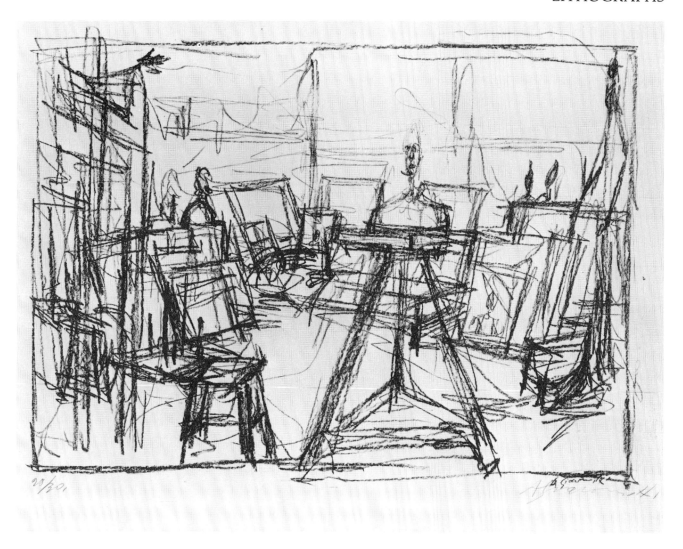

12. BUST IN THE STUDIO *(Buste dans l'atelier)*. 1954.

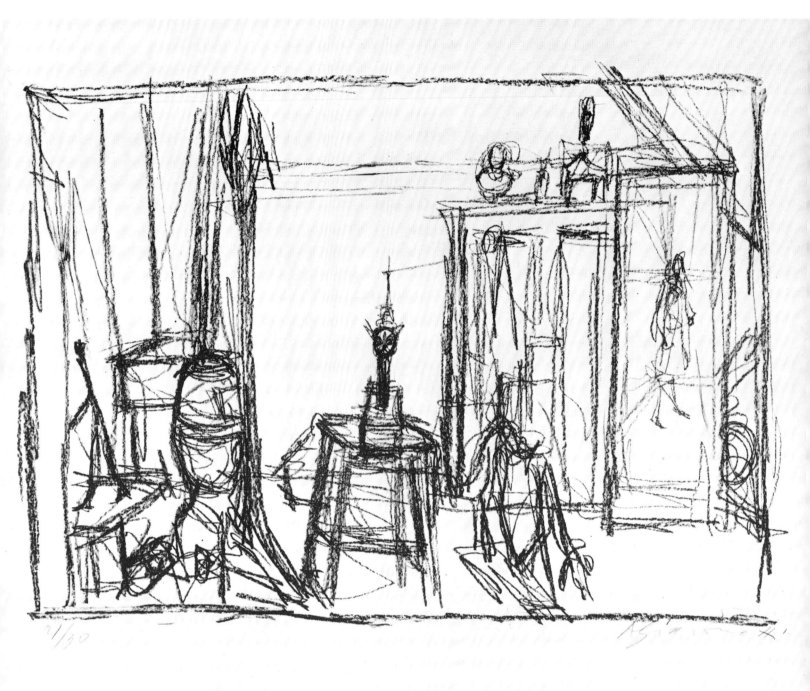

13. DOG, CAT, PICTURE (*Chien, chat, tableau*). 1954.

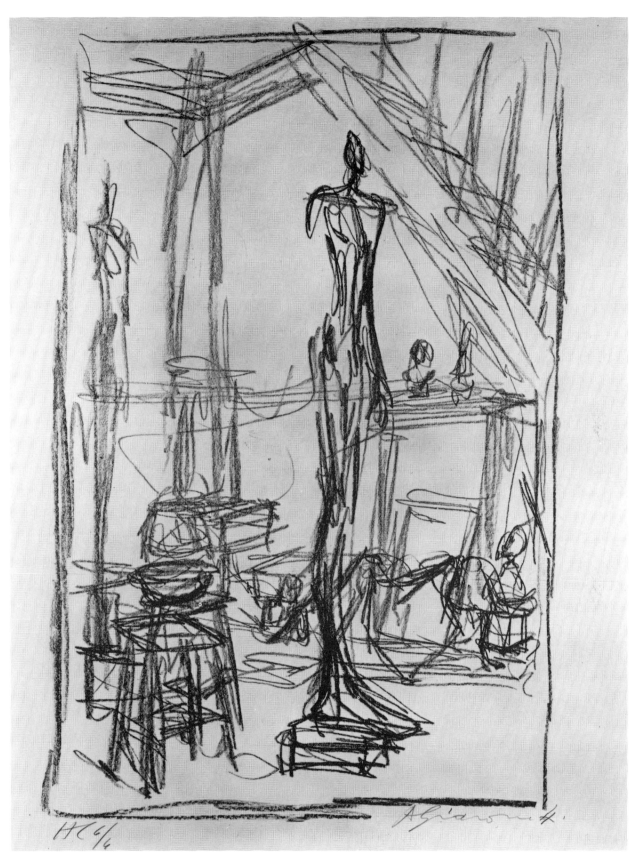

14. SCULPTURES. 1954.

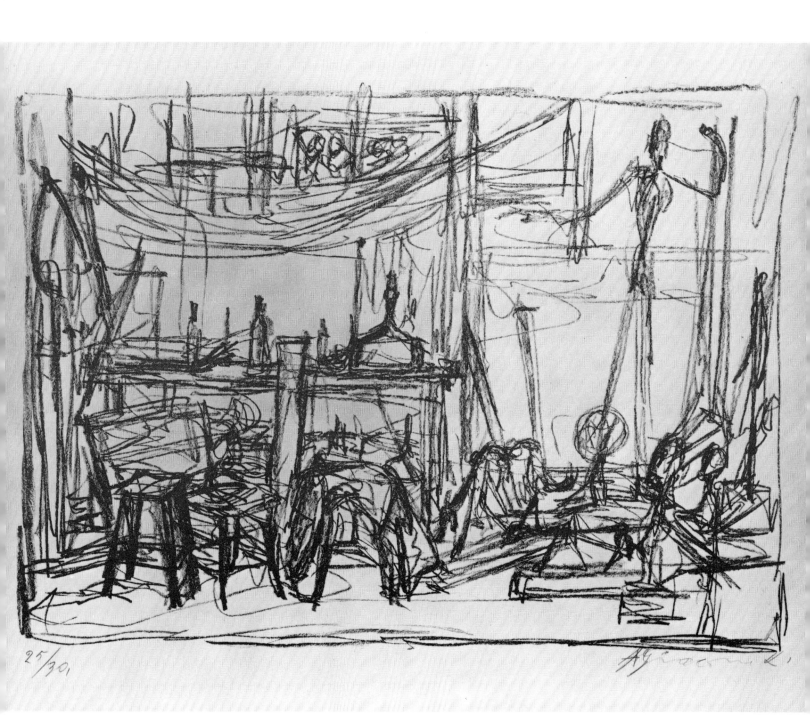

15. STUDIO II *(Atelier II)*. 1954.

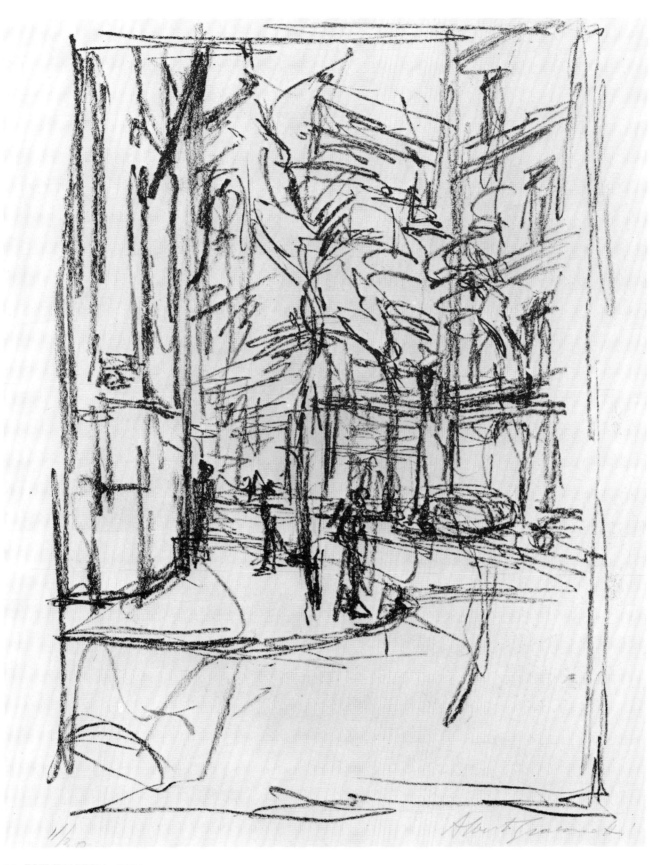

16. RUE D'ALESIA. 1954.

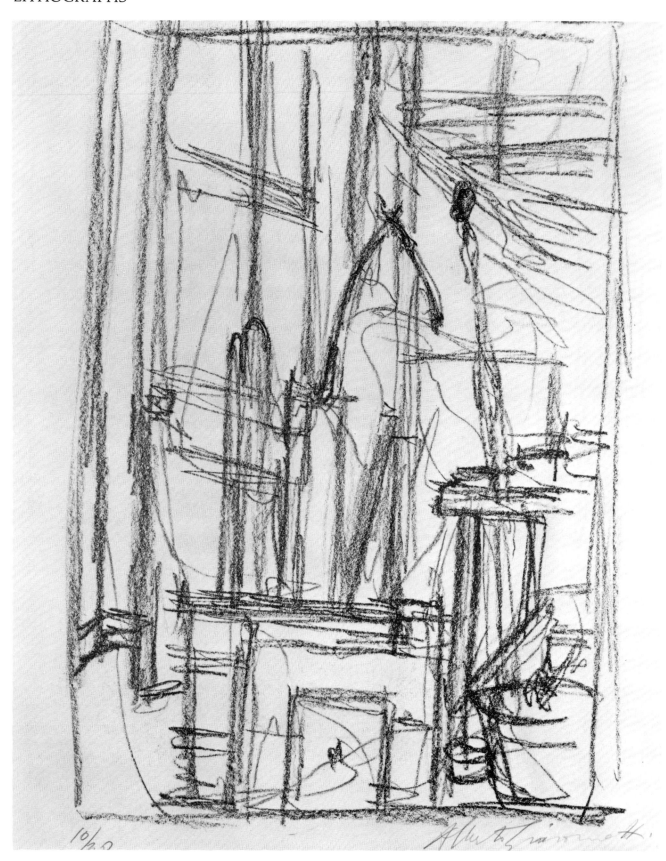

17. HEAD OF A HORSE I *(Tête de cheval I)*. 1954.

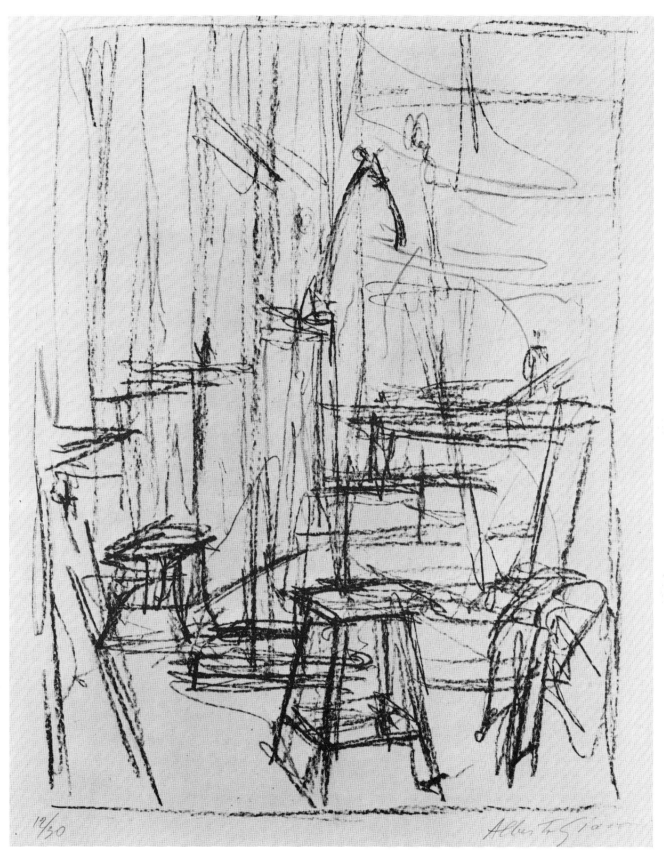

12/30

18. HEAD OF A HORSE II *(Tête de cheval II)*. 1954.

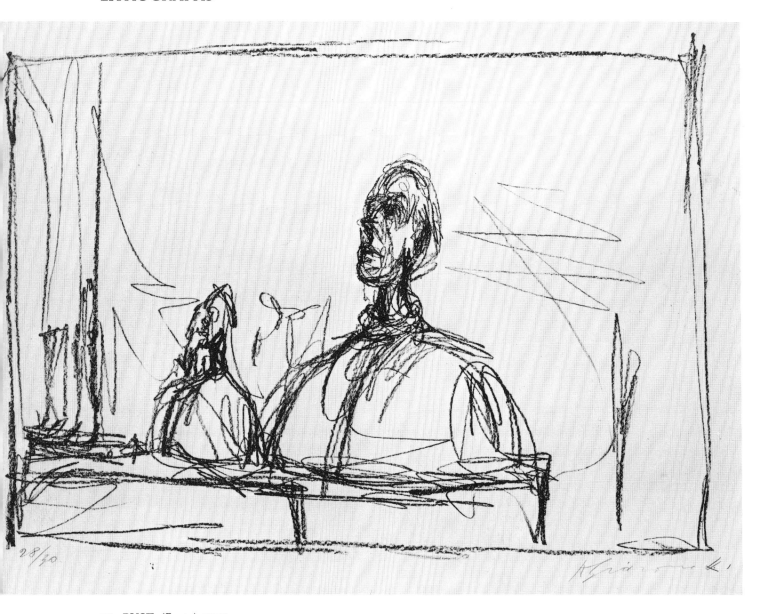

19. BUST (*Buste*). 1954.

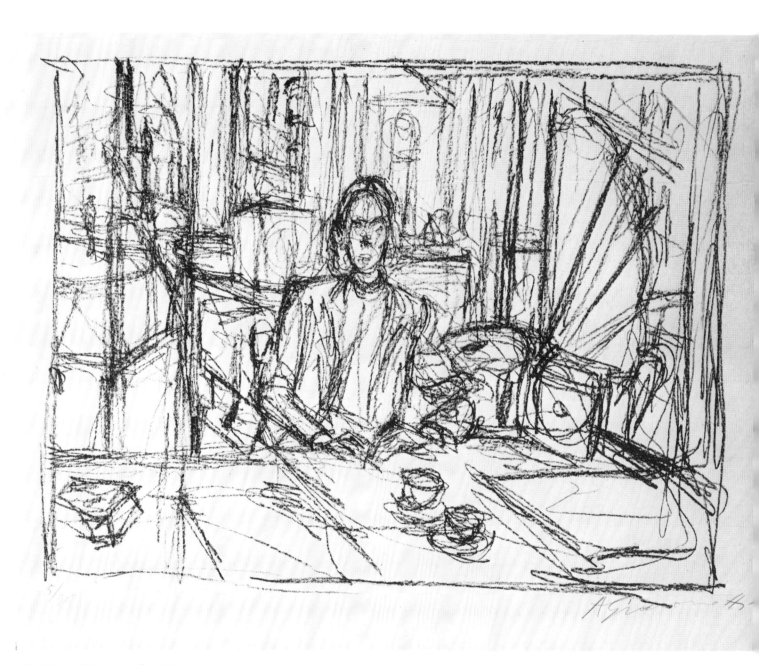

20. IN THE CAFE *(Au café)*. 1954.

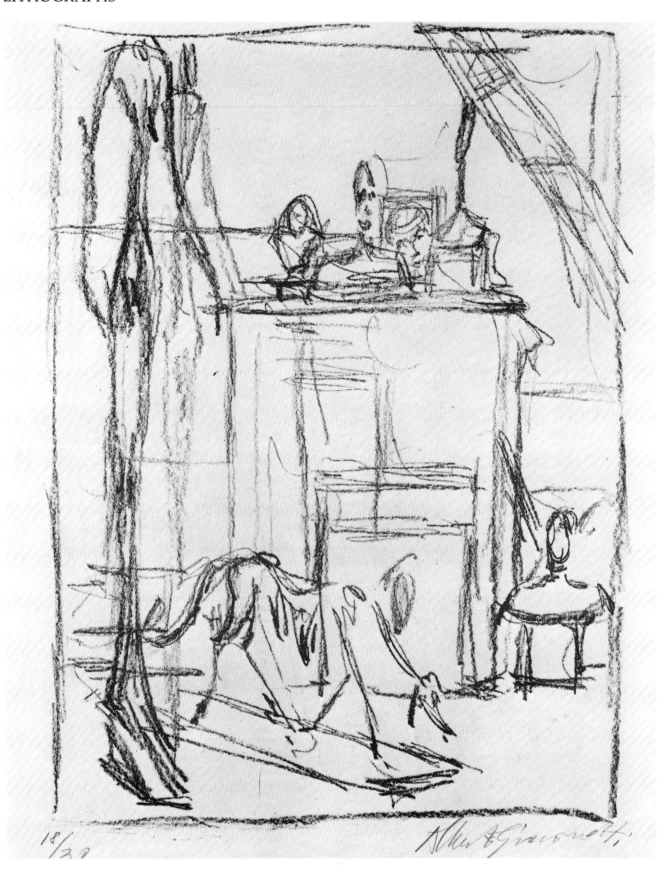

21. THE DOG (*Le Chien*). 1954.

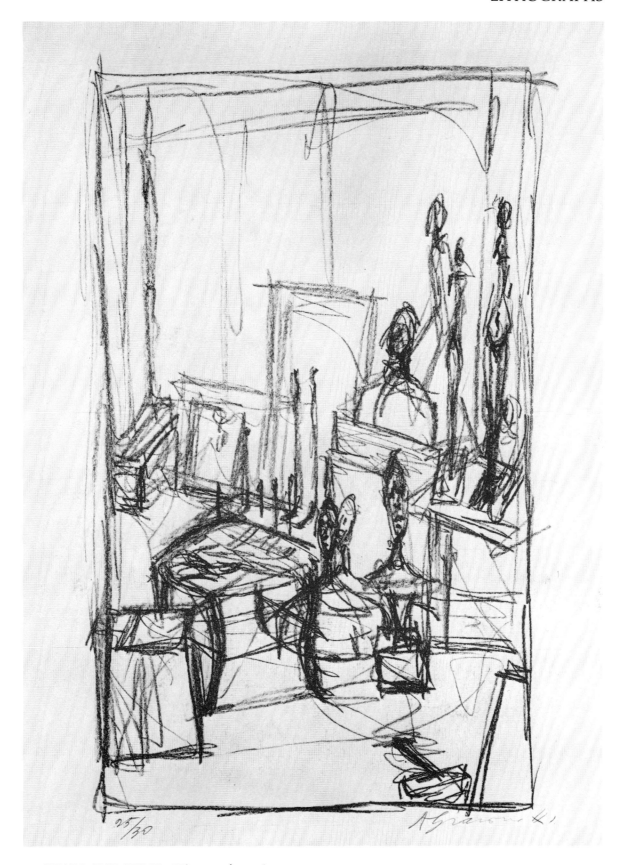

22. HEADS AND STOOL *(Têtes et tabouret)*. 1954.

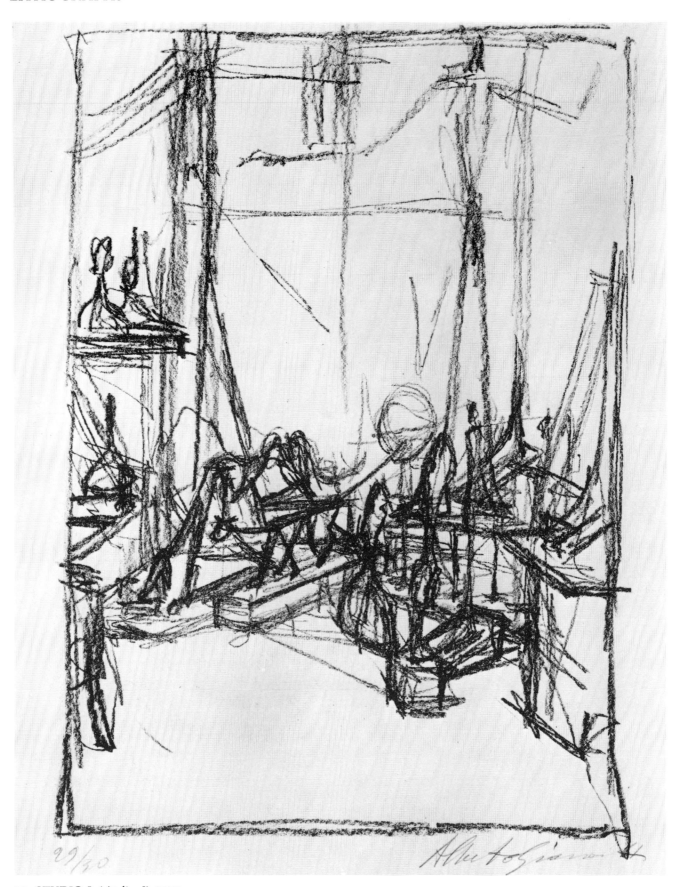

23. STUDIO I *(Atelier I)*. 1954.

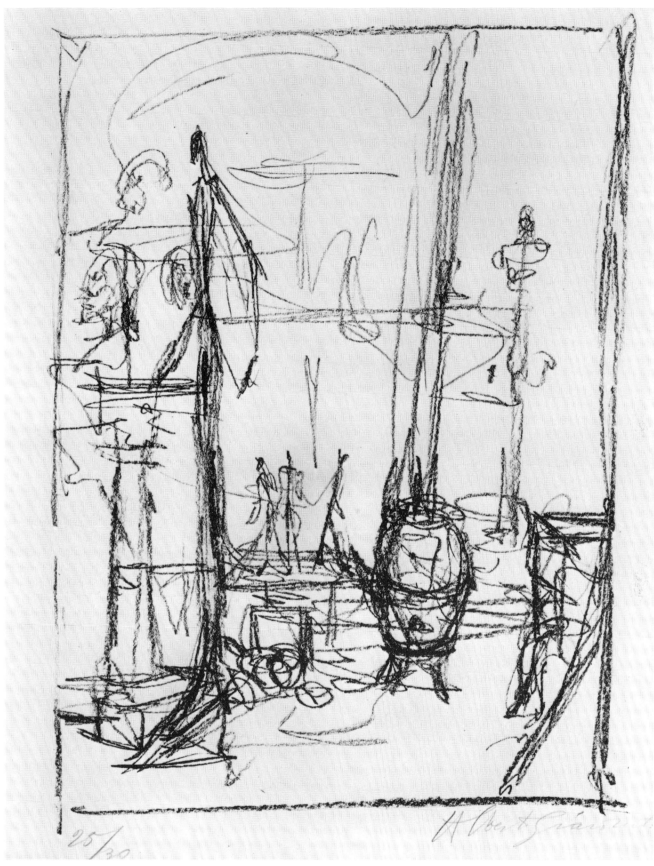

24. FIGURINES AND STOVE (*Figurines et poêle*). 1954.

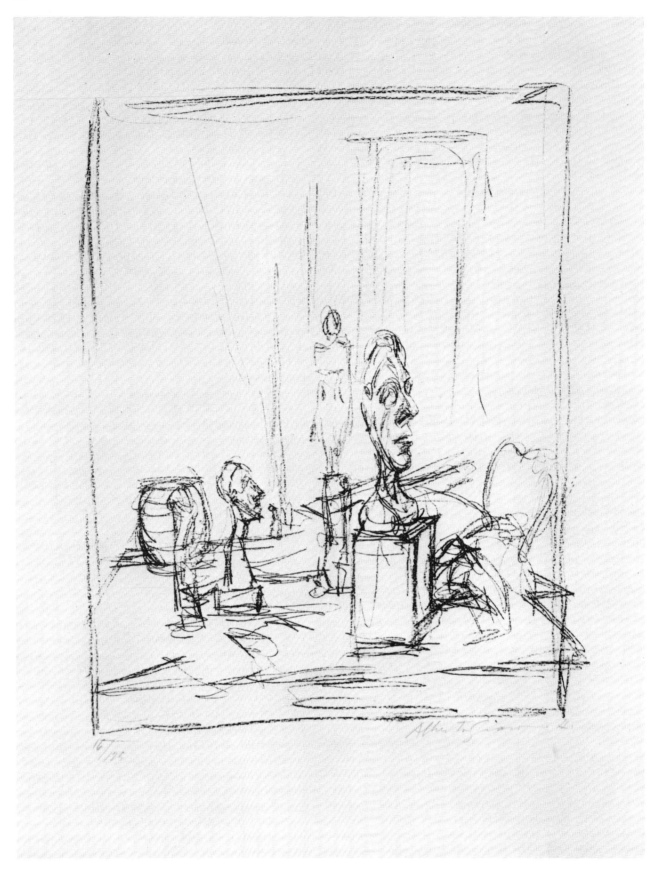

25. THE STUDIO 1955 (L'Atelier 1955). 1956.

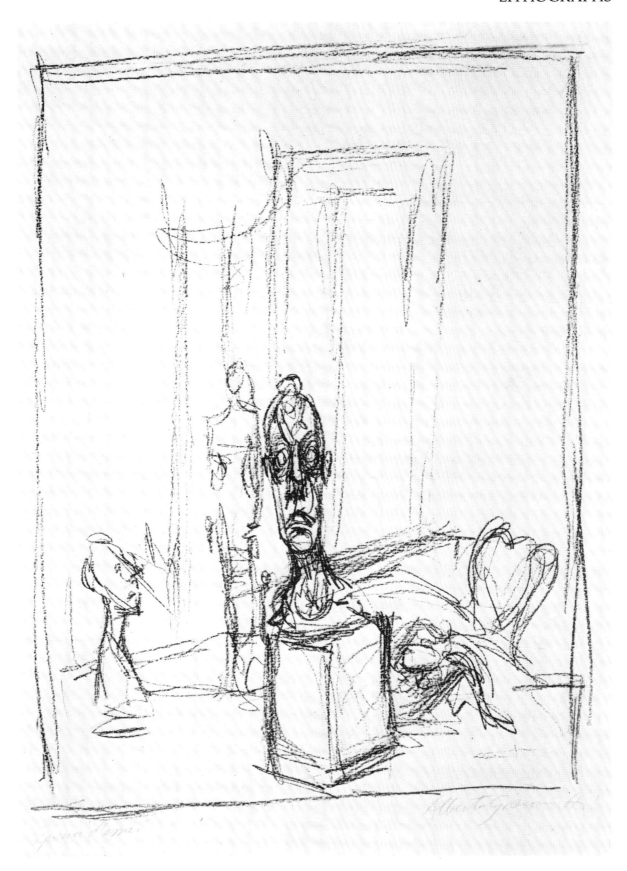

26. THE STUDIO 1955 (*L'Atelier 1955*). 1956.

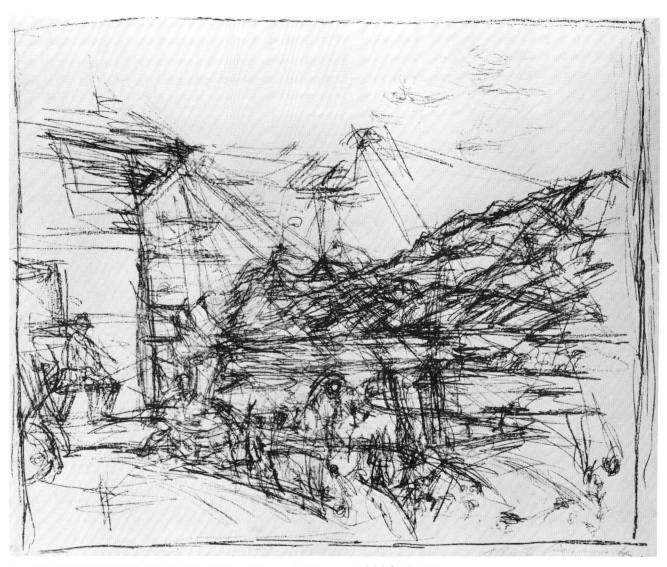

27. GIACOMETTI'S HOUSE IN MALOJA *(Maison de Giacometti à Maloja)*. 1957.

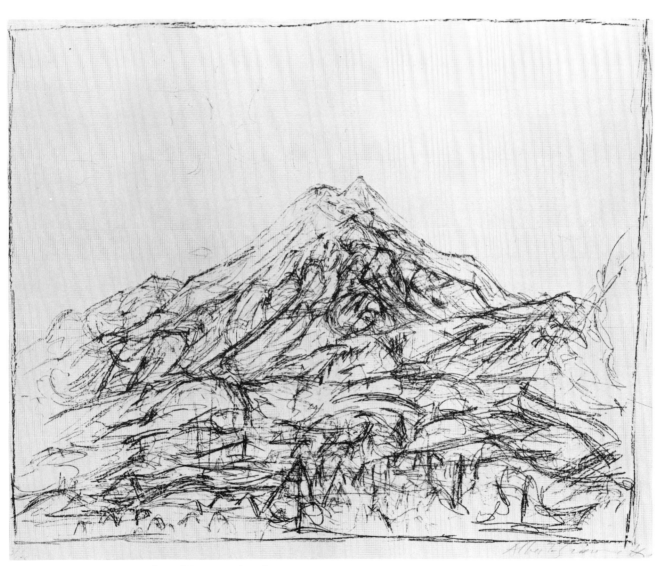

28. MOUNTAIN IN MALOJA *(Montagne à Maloja)*. 1957.

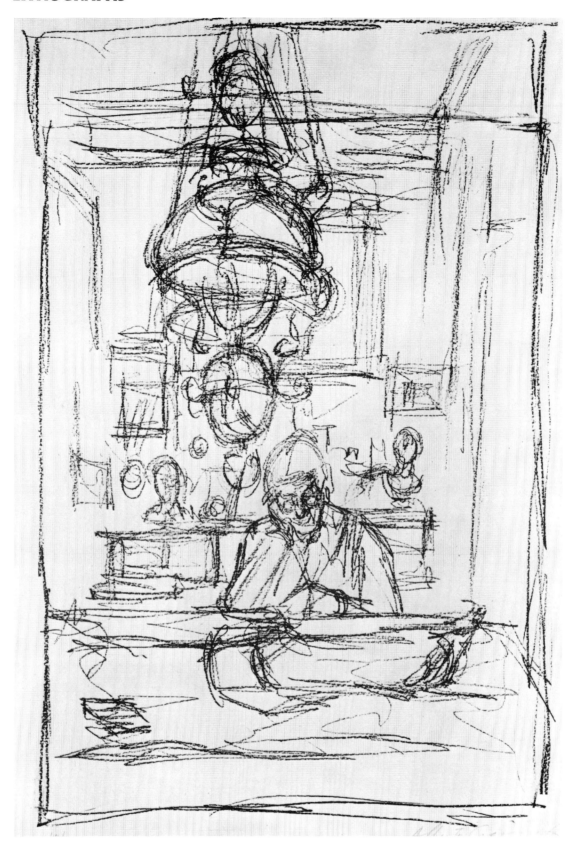

29. CHANDELIER *(La Suspension)*. 1959.

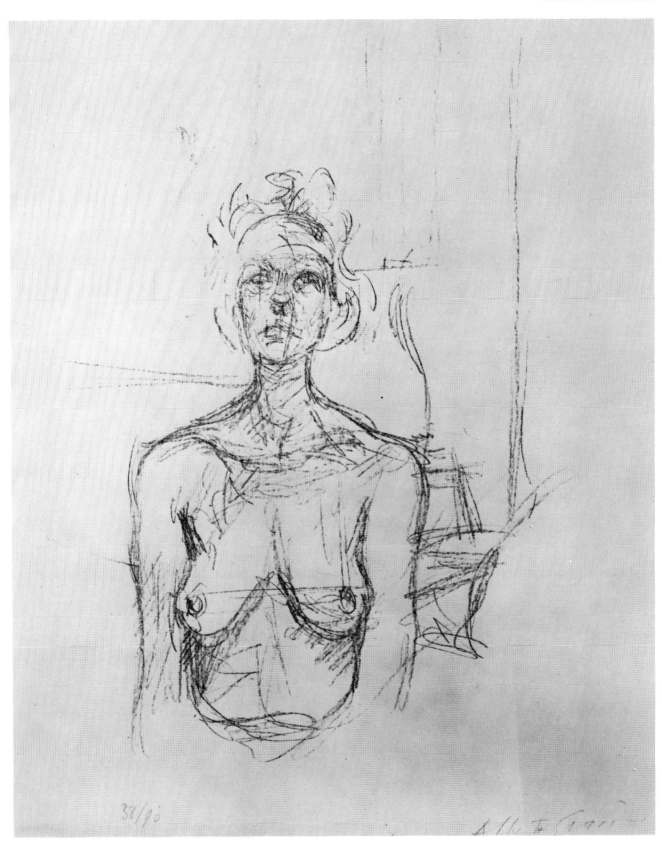

30. BUST I *(Buste I)*. 1960.

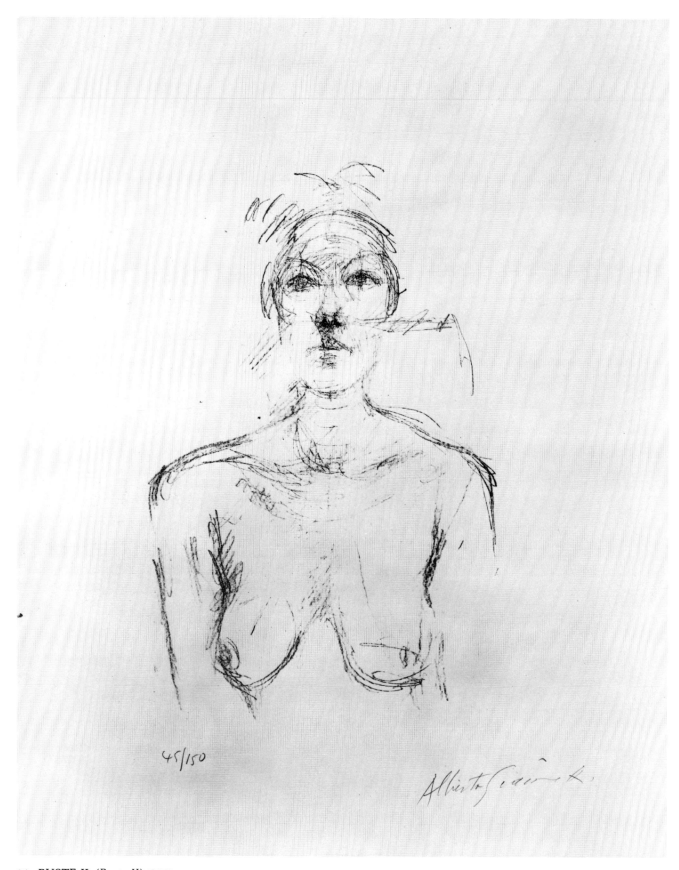

45/150

31. BUSTE II *(Buste II)*. 1960.

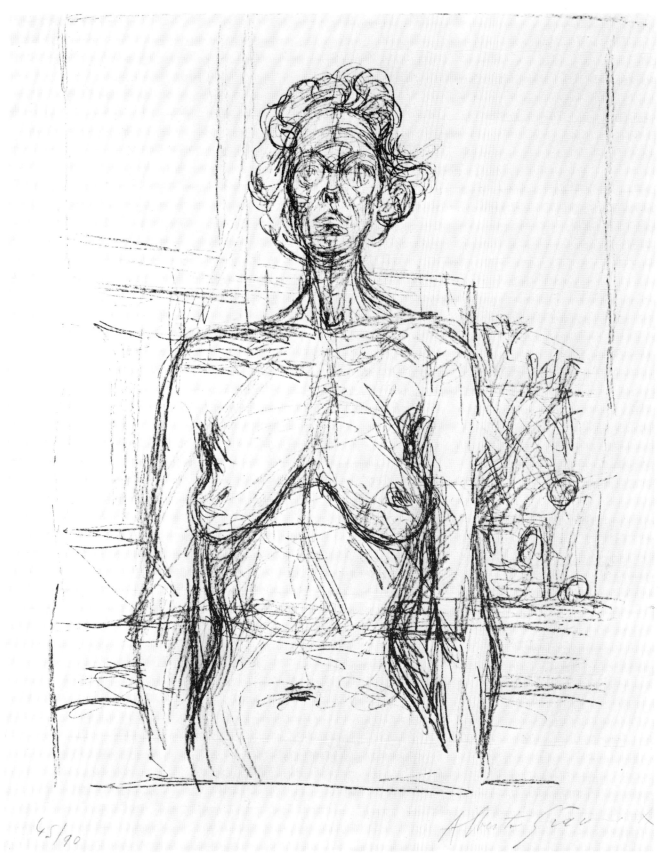

32. NUDE WITH FLOWERS *(Nu aux fleurs).* 1960.

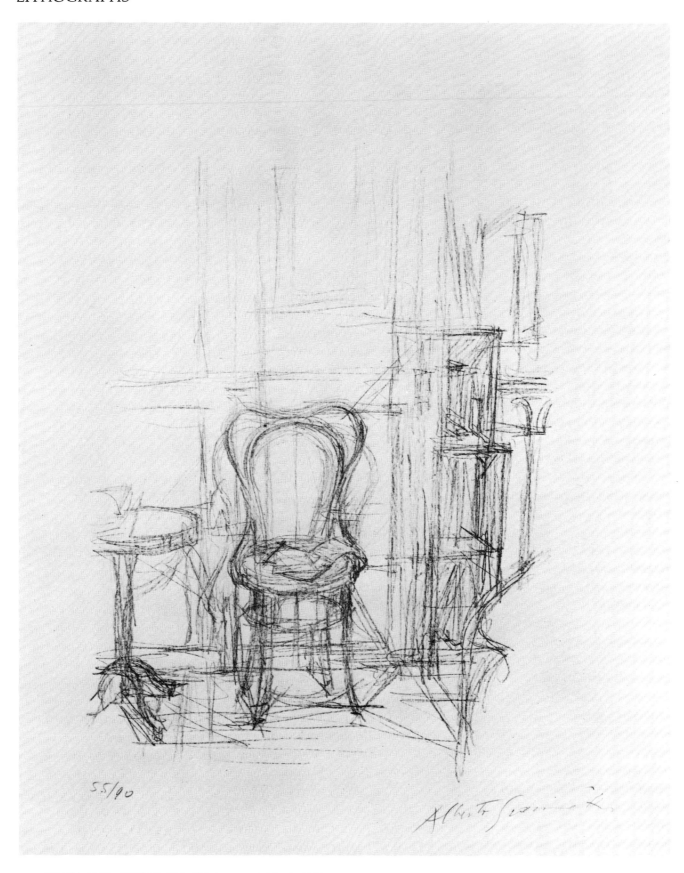

33. CHAIR AND GUERIDON *(Chaise et guéridon)*. 1960.

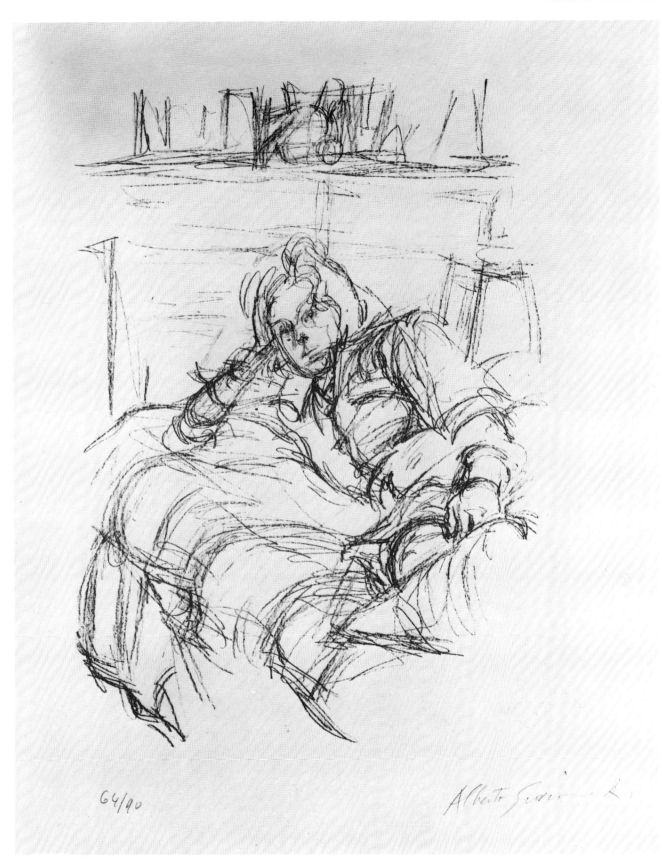

34. RECLINING WOMAN (*Femme couchée*). 1960.

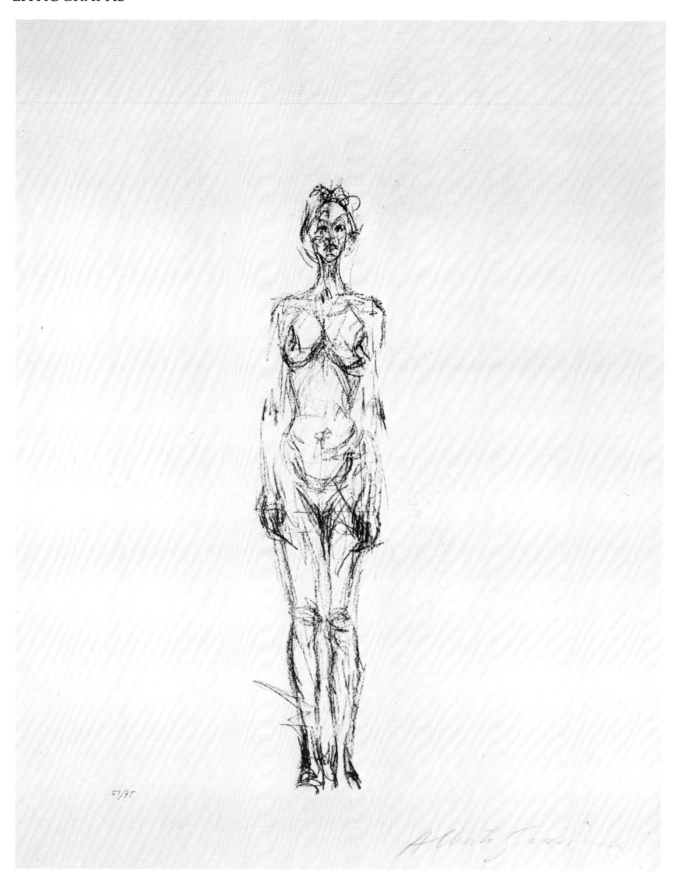

35. STANDING NUDE I *(Nu debout I)*. 1961.

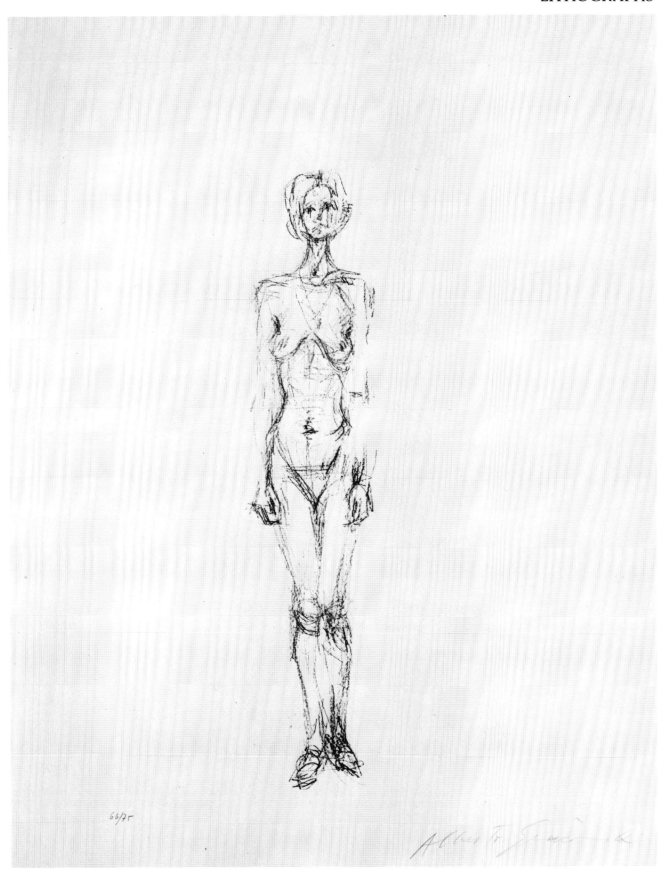

66/75

36. STANDING NUDE II *(Nu debout II)*. 1961.

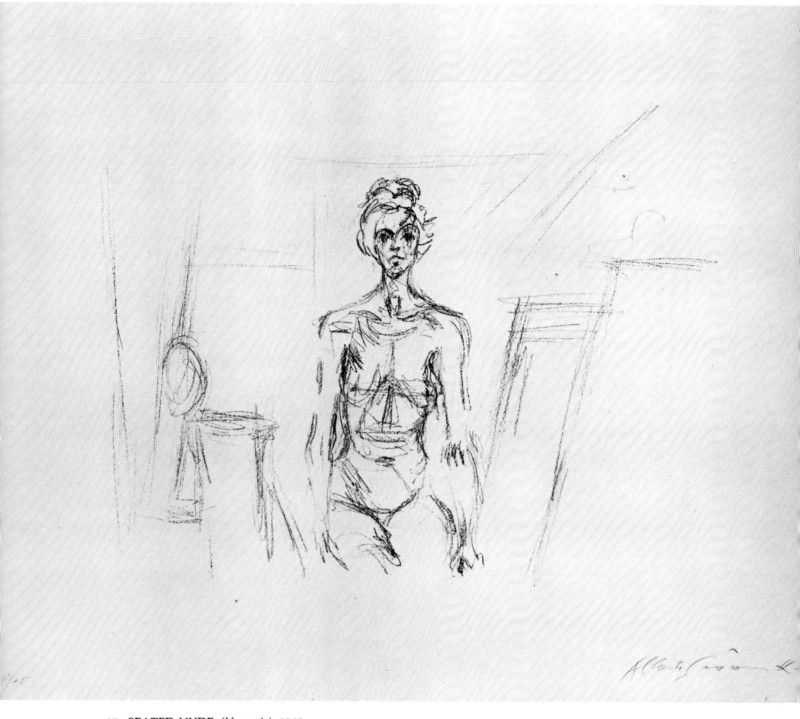

37. SEATED NUDE *(Nu assis)*. 1961.

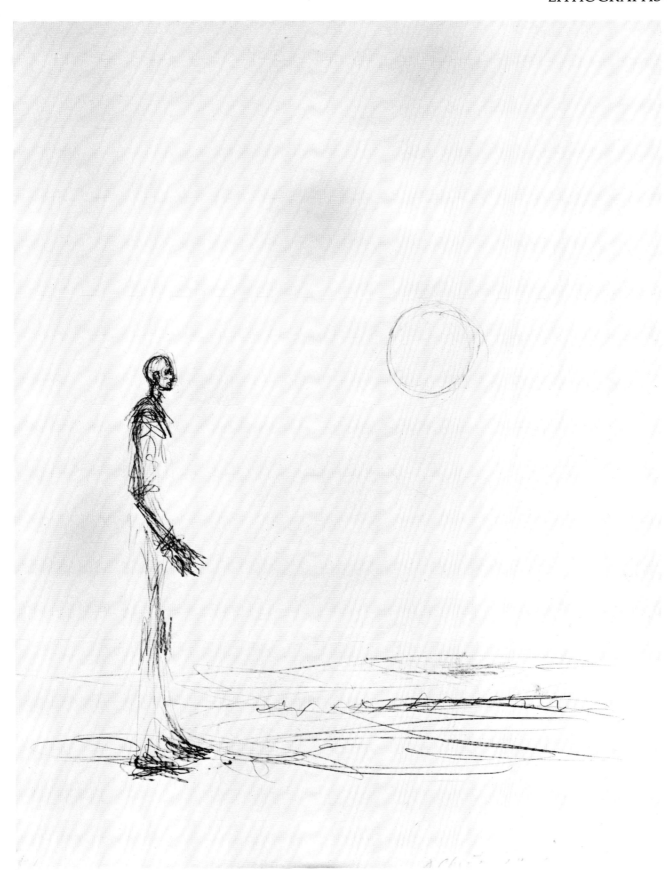

38. MAN STANDING AND SUN (*Homme debout et soleil*). 1963.

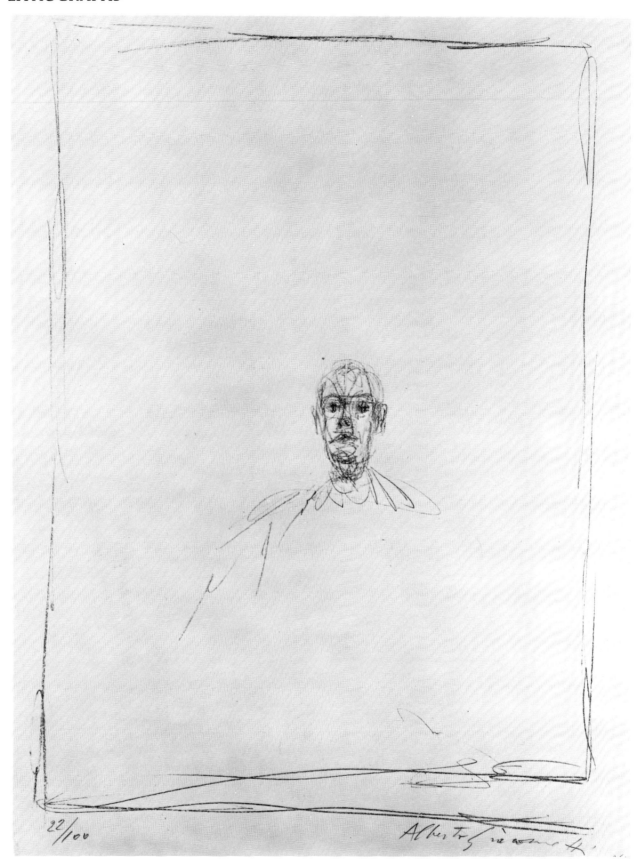

22/100 Alberto Giacometti

39. DIEGO. 1963.

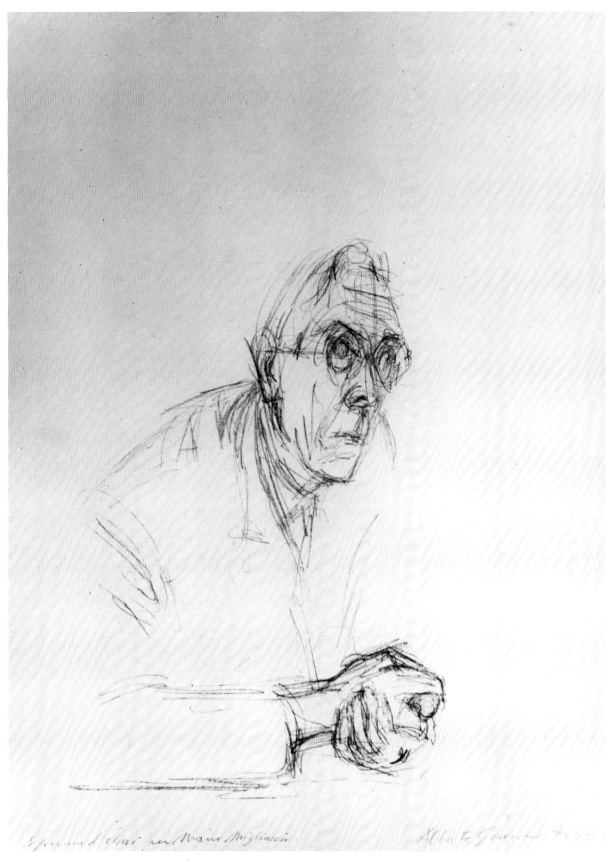

40. PORTRAIT OF LAMBERTO VITALI. 1963.

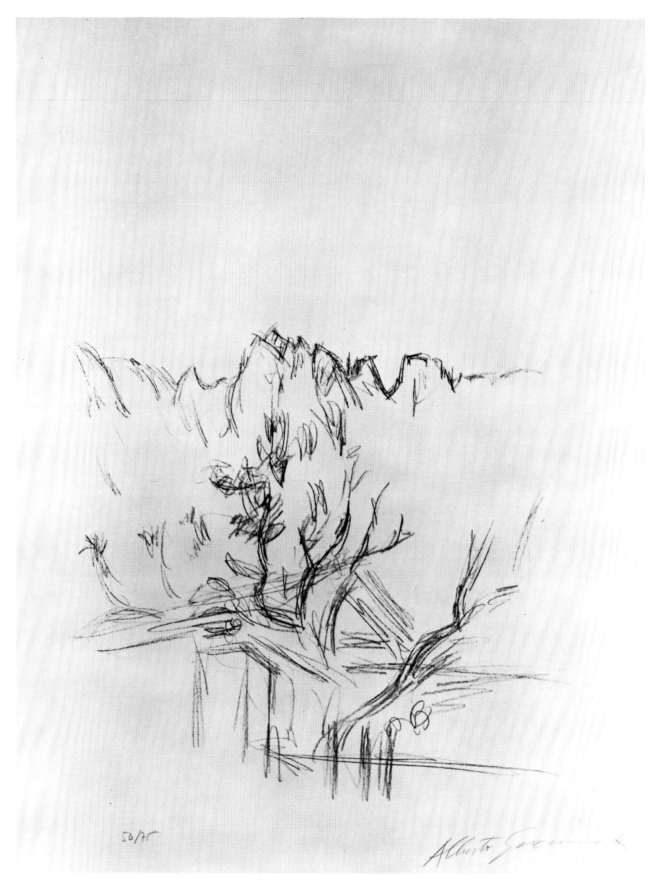

56/75

41. LANDSCAPE WITH TREES *(Paysage aux arbres).* 1964.

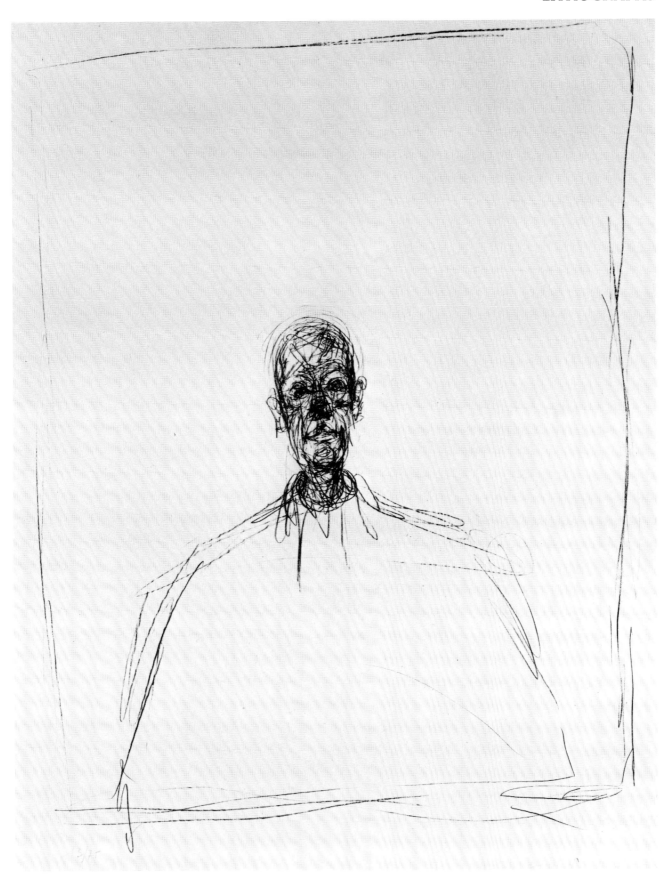

42. BUST OF MAN *(Buste d'homme)*. 1964.

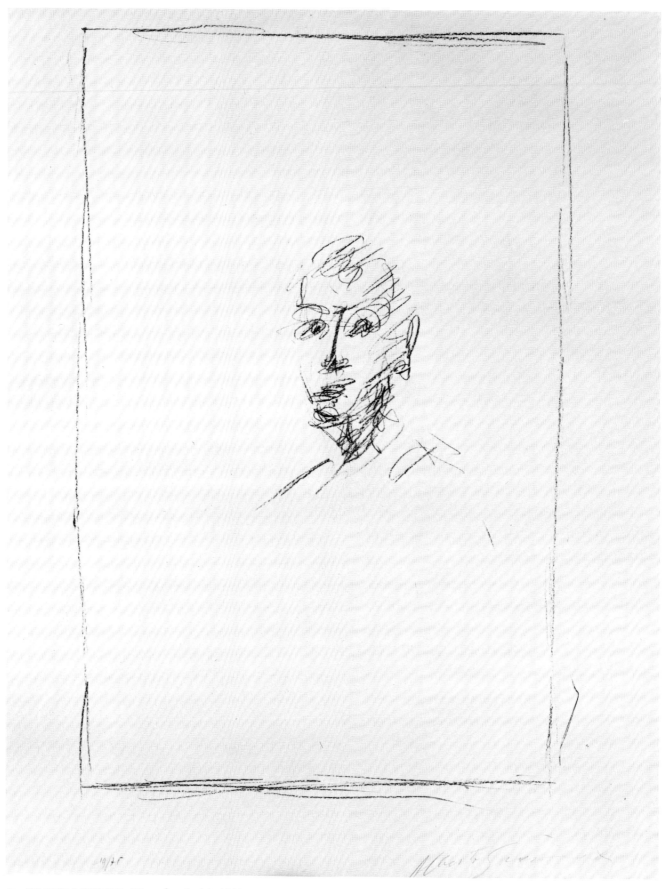

43. IN THE MIRROR *(Dans le miroir).* 1964.

51/75

44. THE ARTIST'S MOTHER READING III *(Mère de l'artiste lisant III)*. 1964.

22/75

45. DISTURBING OBJECT II *(Objet inquiétant II)*. 1964.

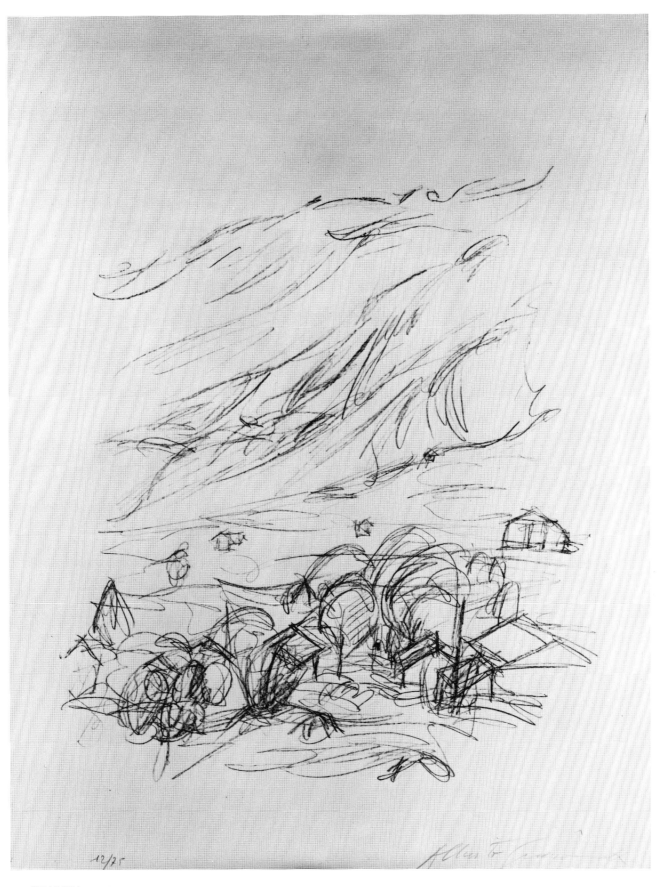

46. STAMPA. 1964.

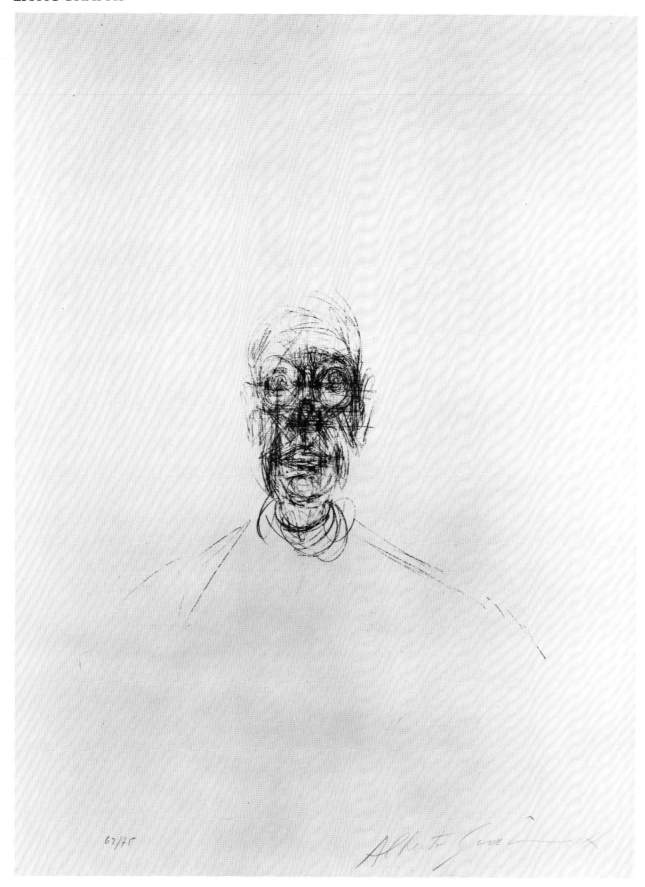

47. HEAD OF MAN (*Tête d'homme*). 1964.

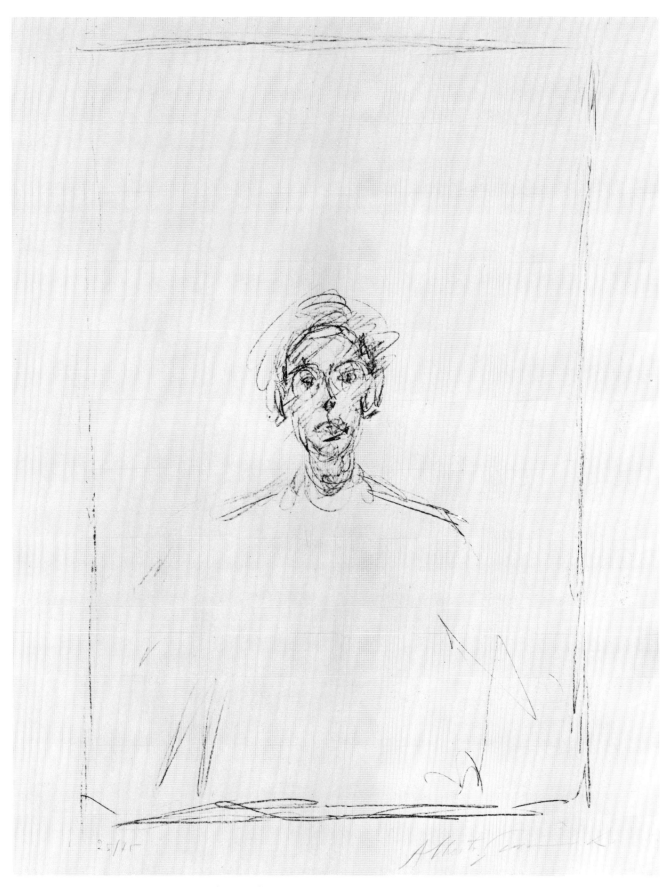

48. HEAD OF YOUNG MAN *(Tête de jeune homme).* 1964.

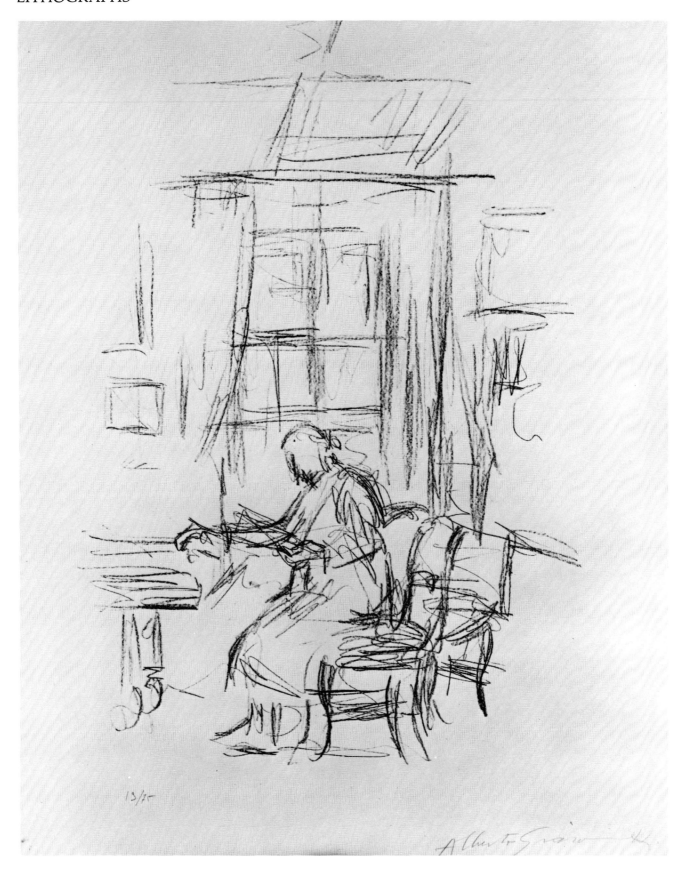

49. THE ARTIST'S MOTHER AT THE WINDOW (*Mère de l'artiste à la fenêtre*). 1964.

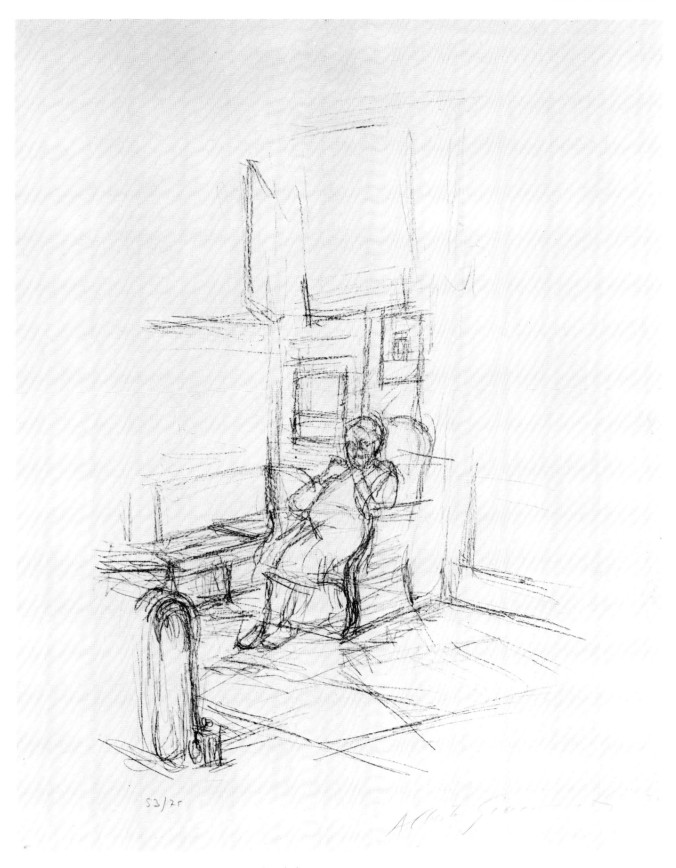

50. THE ARTIST'S MOTHER SEATED I *(Mère de l'artiste assise I)*. 1965.

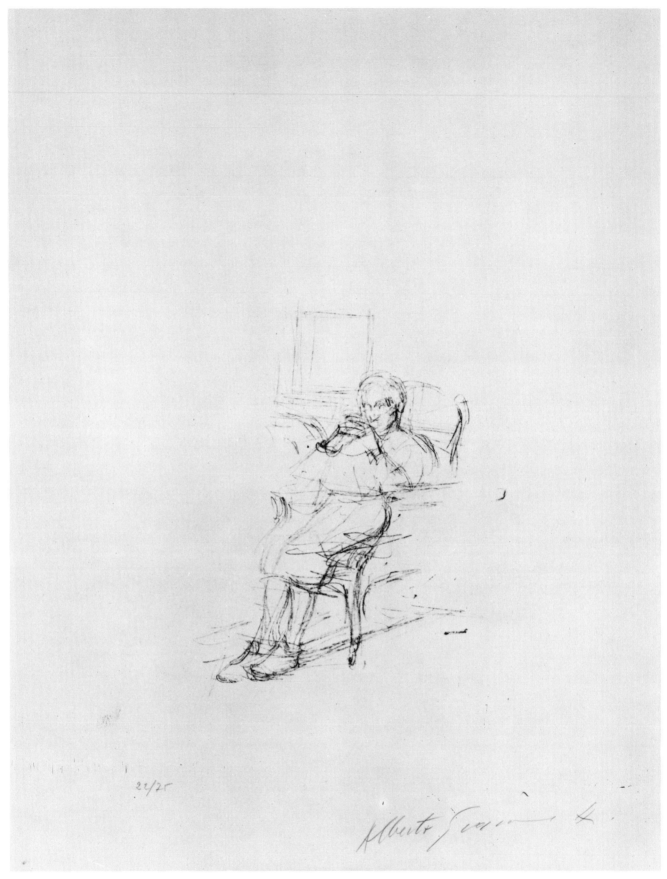

51. THE ARTIST'S MOTHER SEATED II *(Mère de l'artiste assise II).* 1965.

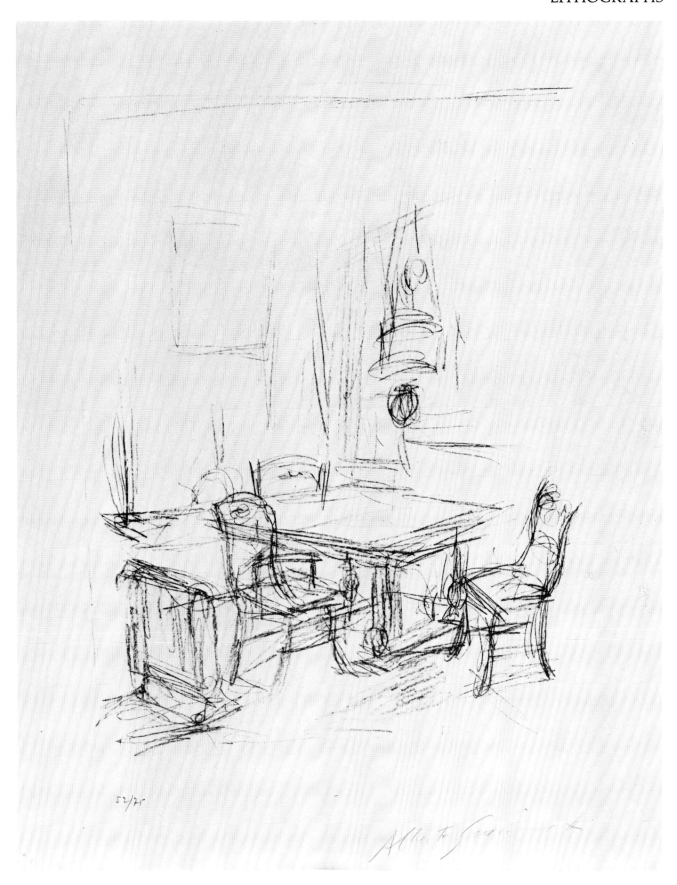

52. INTERIOR *(Intérieur)*. 1965.

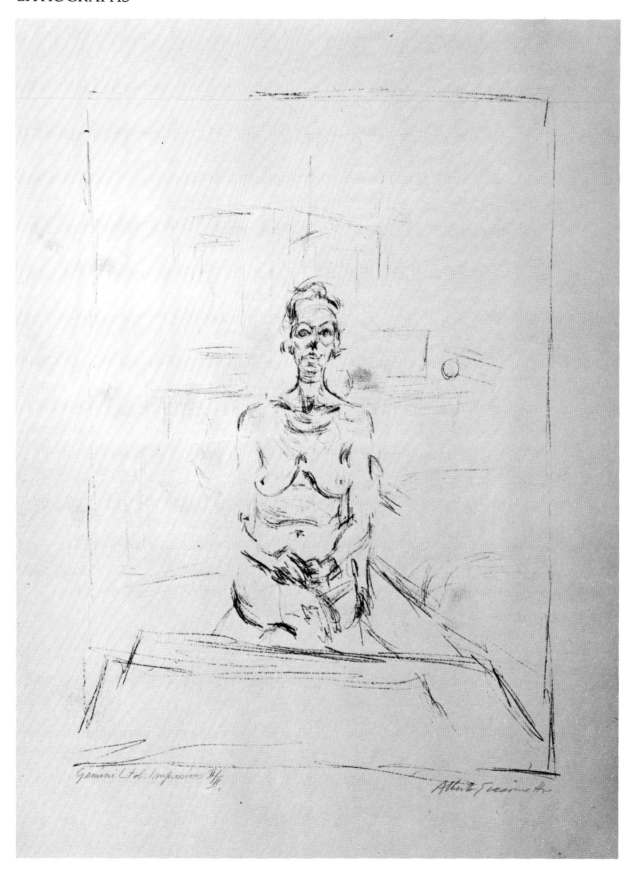

53. SEATED NUDE *(Nu assis)*. 1965.

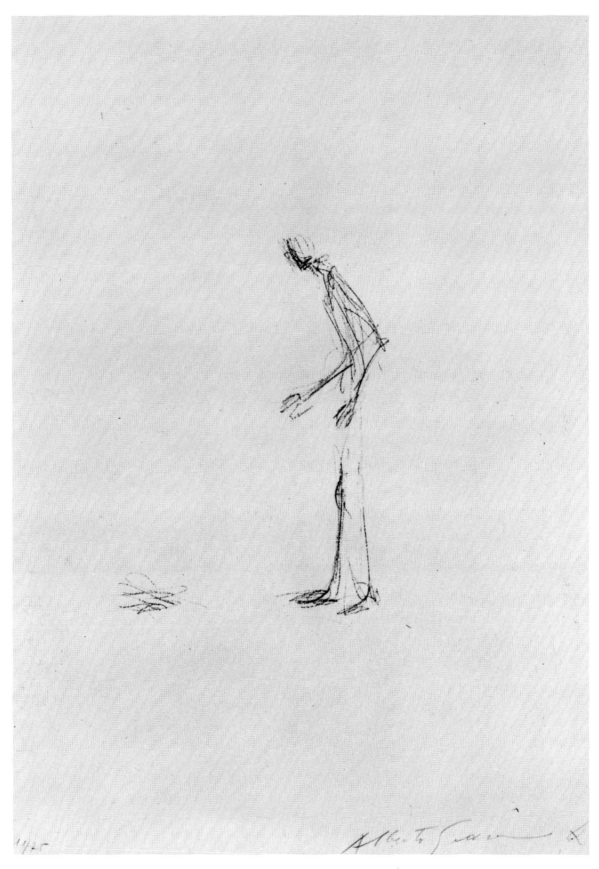

54. DISTURBING OBJECT I *(Objet inquiétant I).* 1965.

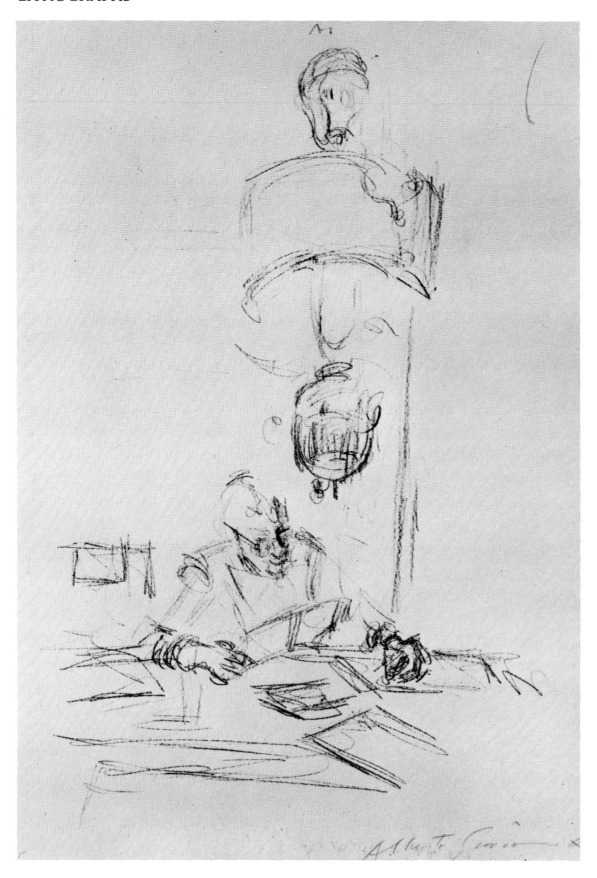

55. THE ARTIST'S MOTHER READING II *(Mère de l'artiste lisant II)*. 1965.

2. Starting to Collect Giacometti Graphics

As a collector, my point of view of Giacometti's graphic work naturally differs from that of the art historian or artist. The very subjective way in which the collection began may therefore be of interest—especially since it illuminates certain aspects of Giacometti's own development.

It all came about in rather an odd way, because there was nothing intentional about my collecting prints, though underlying everything were two factors: my extreme poverty all during my twenties, and my admiration for Giacometti as a man. Often I did not like his prints but I hoarded them because their creator was my hero.

I had arrived in Paris in 1949 at the age of twenty-two, as a student recipient of a Fulbright scholarship from the University of Chicago. I had intended to acquire a major Braque painting, but when I discovered that the price was prohibitive for me ($3,000) I began collecting oils directly from French artists my own age. Toward the end of the year John Russell, now one of our most sensitive art critics, but then more oriented toward literature, introduced me to Giacometti, and from then on I made a weekly pilgrimage to his studio. Like many at the time, I judged Alberto

solely as a sculptor. I tried to buy a bronze from him, but he was all sewed up by Maeght and Matisse. I could have bought a great oil for fifty dollars, but, still under Braque's spell, I thought it ugly. Determined to have something from him I bought a tree done in crayon for twenty dollars (the price he got from his dealers), but I did not think it important enough to frame. Later on, rummaging through a bin at the bookstore-gallery of my friend and future business associate, Marcel Zerbib, I purchased for seven dollars the four etchings (85-88) from the book Alberto had done with Pierre Loeb. If such a small sum seems unusual for four rare etchings the reader will be interested in knowing that nobody wanted them then even at that price. Even ten years later one could buy his greatest 1954 lithographs for fifty dollars, ones which today cost four thousand.

I was ashamed of stooping so low as to buy prints and hid them in a huge Skira art book. Except by accident, when consulting the Skira book, I did not look at them for about four years, when, at last, because of the Studio series of 1954, I realized Alberto's importance as a graphic artist.

Since then hardly a year has gone by when a Gia-

cometti print has not been added to my collection, even though, except for a brief year or two of plenty around 1960, every graphic purchase put a severe strain on my budget. I did this at a time when few thought Giacometti graphics would ever be worth saving. Today, my collection contains nearly all the 350 graphics, as well as two major paintings and fifteen master drawings. In recent years, my judgment has been vindicated, though a good deal of the comfort was lost. Just at the moment victory arrived, Alberto died.

3. The Beginning
(1930-1950)

During the thirties and forties Giacometti, almost by accident, as it were, did a dozen or so etchings, most of them illustrating books by friends such as Breton, Bataille, and Char. While studying at the exciting atelier of Stanley Hayter, he also did occasional etchings. One of the most important of these, a cubist head (56), exists in a unique state which Hayter generously gave to the New York Museum of Modern Art.

Those who prefer the crude and unfinished to the completed and masterful will enjoy these first gropings of Giacometti as a graphic artist. One finds in their spooky mood the first awakenings of a very great genius. For my taste, however, there are just two bona-fide master etchings from this period, *Personnages dans l'atelier II* (88) of 1950, and *Couple Facing Each Other* (84) of 1949, done for the Iliazd book, *Poésie de mots inconnus*.

There is an excellent reason for the mastery attained in the 1950 etching: a prior study (87) of it was done for the book *Regards sur la peinture*, which was published in an edition of fifteen. Giacometti apparently sensed further possibilities in the subject and did a deeper study, which is perhaps why he increased its printing to thirty copies. In every way, this second study is superior. In particular, the awkward vertical statue at the right in the first version is in the second transformed into the airy grace, the vertical magic peculiar to his bronzes at that time. Furthermore, Giacometti was clearly more certain of his subject on this second attempt, and has given the composition greater unity. Indeed, in his graphics, as in all his work, Giacometti enjoyed doing different versions of the same subject, and almost always improved the later versions, as in the case of the Studio lithographs of 1954.

To choose between two such masterpieces as the *Personnages II* and the *Couple Facing Each Other* is no doubt madness; yet I have a strong predilection for the latter. On first sight the former seems more important. But after living with them it becomes apparent that all of the genius of Giacometti's early human bronzes is in the *Couple*. The more one studies the shoulders, arms, and legs of this disembodied pair, and how they swim into the torsos and stances, the more one discovers the same subtleties of motion and magical realism as in the bronzes. No other etching by Giacometti, not even those from the great series done for Maeght in 1955, surpasses this tiny 1949 couple in grandeur and economy of means.

There is also one major lithograph to emerge from Giacometti's surrealist period—the *Objets mobiles et muets* (1) of 1931. In general, Alberto's surrealist drawings do not interest me very much except as documents for the sculptures. And even the surrealist sculptures pale for me when compared to the tragic passion in the late bronzes. Even so, this lithograph is more inventive than the surrealist drawings. In essence it is a prose poem by Alberto written in his handwriting around the sketches of seven of his major surrealist statues. The virile calligraphy of Alberto's handwriting encases the statues to form a quite moving ensemble. Perhaps this is the first poem-lithograph of surrealism. It is certainly one of its few bona fide lithographic masterpieces of the movement's most heroic period.

Here is a free translation of the Giacometti prose poem written around the statue sketches:

All things—further, all those which are past and others before which budge my girl friends—they change (one passes near them—they are far away) others approach, climb up, go down, the canoes on the water, there in space, go up, go down—I sleep here, the flowers of the rug, the water of the leaking faucet, the drawings on the curtains, my pants on a chair.
Someone is speaking in a room way off: two or three people — of what station? the locomotives which whistle, there is no station near here—one might throw orange peelings from the terrace top into the narrow and deep street, the night the mules bawled desperately, toward morning one slaughtered them, she approaches her head to my pillow.

This strange love poem is like a prophecy of the Giacometti bronzes to come. The lithograph itself proves that as early as 1931 the artist used graphics as an important means of commenting on his sculpture, foreshadowing his profound 1954 lithographic studies of works in his studio. For those who depreciate Giacometti as a graphic artist on the basis of his late entry into the field, these rare, early masterpieces have a singular significance.

Concerning the "developing" interest of Giacometti in graphics, it has too often been forgotten that he was not an "instant" genius. As a surrealist he was interesting, but by no means great—except in the famous *Palace at 4:00 A.M.* In the pain and circuitousness of his groping, he might well be compared to Goya, who also blossomed around the age of forty-five.

Giacometti wanted to be a total artist in the tradition of Michelangelo and Picasso. By 1948 he had made his mark in drawing and sculpture, and by 1951 had completed his first series of great oils, which broke down the traditional walls between drawing and painting. It was not until 1954 that he emerged as a major graphic artist with the seventeen lithographs of his studio, though because of the limited editions and poor publicity, the fact went relatively unnoticed. After 1954, however, he was, with Picasso and Matisse, one of the few artists of this century to attain supreme mastery in four different media. Matisse, incidentally, had a decided influence on Giacometti's lithography, and Picasso very much admired his younger colleague and often frequented Giacometti's studio. It is clear from Giacometti's 1947 and 1949 achievements that from the very beginning of his mature phase he was thinking about graphics in a deep way. At the end of his life he completed a book-cathedral of 150 lithographs, *Paris sans fin*, which, though the text remains unfinished, leaves little doubt as to his vast ambitions for his graphics.

4. The Visionary or Dionysian Period (1951-1954)

In the spring of 1951 I witnessed an unusual moment in art history. Entering Giacometti's studio, which was filled with his finest statues, I found the artist peering at some sheets crammed with violent black slashes. The sheet in his hand made me catch my breath. It was a lithograph of the studio (94) with the statue of the *Man Walking* cutting across the center. It hit me like a bomb, like a wild primeval explosion in the earth. It was one of the most dramatic works I had ever seen in black and white.

The lithograph turned out to be the centerpiece for the catalogue of the Maeght show, the finest Alberto was ever to have, and one that embraced almost all of his great statues. Also included were eighteen superb oils which Giacometti had completed in a dionysiac burst of frenzy shortly before the show opened, with the idea of giving more balance to the show and achieving his idea of the total artist.

It was thus 1951 that saw the definite transition toward the later Giacometti, the painter and graphic artist. Indeed, from 1951 on, sculpture was never again to obsess him as it had. And, in some years, as in 1954, the peak in many ways for his painting, drawing and graphics, he did very little sculpture. Although such guesses cannot be accurate, it may well be that from 1951 on Alberto devoted less than half of his working time to his bronzes, and in some years, such as 1954, much less than that.

The catalogue for this show was a text by that austere poet Michel Leiris, published in numbers 39-40 of the art review *Derrière le miroir*, and illustrated by three lithographs (92-94) by Alberto. Thus, it was at the very height of his creative surge, with all his abilities straining at full steam, with his talents turning more and more toward painting, that Giacometti did his first great lithographs, those at which he was peering that spring day.

Little wonder that, given the fevered circumstances and the ideal situation, Alberto never surpassed these particular lithographs, though in 1954 he equalled them. These first drawings on stone represent the collision of his mature sculptural technique with his newly discovered mastery of painting. These four lithographs for the 1951 show concern the studio and portray: a group of standing statues and busts with the catalogue's title printed at the top and bottom (93); his wife, sculptures of a horse and other subjects (92); a panoramic view of the studio with the *Man Walking*

in the center (94); and the poster of that monumental bronze, *Man Pointing*, and the studio (200). The *avant-la-lettre* print of this poster is in certain respects Alberto's greatest print, and those who own it must treasure it because I have been unable to find a copy of it for over a decade. Indeed, the reluctance of collectors to part with Giacometti's early prints is perhaps the prime reason that they are so unknown.

Giacometti for some time before 1951 had been doing magnificent crayon drawings and these first lithographs were fertile extensions of his draftsmanship. The graphic work always maintained this close relation to his drawing, sometimes following, sometimes leading.

Overcome by this Studio lithograph I said, "Alberto, these lithographs are better than anything you've ever done."

"I doubt that," he snapped back, in that icy manner so characteristic of him when he was irritated. "What would you know about it?"

"I know what I feel. I feel their violence and freshness. It's the whole world in motion, not just your studio."

"As always, you get moved very easily."

"You mean to say you don't like them?"

"Oh, I don't know. I worked hard enough at them. I had to think quite a bit about them."

"Well, if I were you I'd think quite a bit more. A lot of people who can't afford one of your drawings would like to have a print like this."

"That's a joke," he said, almost sneering. "There are plenty of my drawings around and they're plenty cheap. Nobody's killing themselves to get them." There was some truth to this. At the time, if he didn't go to a fancy gallery, anyone could have unearthed a good Giacometti drawing for twenty dollars.

"Well," I replied, "this catalogue and the poster will cost just a few pennies. Just right for people who love your work, but who are just poor students like me. Everything you have ever done as an artist is in them. One gets the same feeling from these lithographs as from the actual bronzes."

"I'd hoped to do something like that, but I'm not too sure of the medium yet. I put a lot of work, a lot of work, into that poster."

"Just think if Michelangelo or Donatello had made etchings of their studios with their best statues in them, it would have been their own commentary on their work. How did you feel, drawing your own statues?"

"Sometimes I'm surprised I was so good, and sometimes that I missed the mark so far. But of course when drawing them one sees them in an entirely different way, one sees their mood rather than their form."

"Well, then, you succeeded. The mood is in them. Even if I'd never been in this studio, I would have felt acquainted with it after seeing these lithographs."

"Maybe you're right. Let's go and get some coffee."

Not too long after the show Alberto was to do another lithograph, *The Couple* (3). It was published by Edouard Loeb, a man of great taste and also the brother of Pierre Loeb, one of Alberto's first champions. Although I did not know Edouard then, my friend Marcel Zerbib, who was then Max Ernst's publisher, was aiding him in some way with the technical end of it. Indeed, Marcel ended up with a remarkable trial state of *The Couple* (4) on Japan paper which Alberto had dedicated to him, and which Marcel later gave to me when he discovered my obsessive interest in the prints. This trial state has a crude power, but lacks control. The final state retains this power but has a more organic and subtle form.

On a visit to Paris this past year I sought out Edouard Loeb to ask him to talk about this historic event, and he was kind enough to oblige. "I thought it might be interesting if Giacometti experimented further with lithography. Of course, I admired the etchings he'd done for Pierre. But somehow lithography seemed more in his line, more like his drawing, or at least more to my taste. As you know, art is a very personal thing. So Alberto agreed to do a sketch of me and a girl friend of mine. I had fifty of them printed and tried to sell them for five dollars each, but I don't think we sold more than one or two. At last I gave them away on Christmas and other occasions."

In 1953 I obtained approximately a dozen prints from Alberto. They were prints he intended to publish, or perhaps had published (though I have never seen them up for sale). Most of them were burned in a fire at a framer's in Chicago. Just three, by luck, stayed with me. They are very much like the crayon drawings Alberto did between 1950 and 1954. In fact, experienced collectors have often mistaken them for drawings when they have been framed. Indeed, these particular prints are to the best of my knowledge unique, or nearly so. All three relate to his greatest statues. One (5) is almost a direct replica of *The Cage*, but humanized in a way that bronze could never be— it is one of Alberto's most powerful studies of a face, the lips that tremble like tissue paper, the eyes smashed

with anxiety but still impregnated with a heroic dignity.

Of the other two, *Personnages dans la rue* (6) is of three men walking and has that languid electricity of the great statues on the same subject. The other lithograph (7) is of four standing figures.

These three rare lithographs, the two *Couples* and the four prints done for Maeght in 1951 form the first peak of Alberto's graphic work. The eight of them together establish Giacometti as a supreme master of the stone. Not even in Picasso is there more unified and dynamic composition than in the *Man Walking in the Studio* (94), or a more delicate and tremulous rendering of the skin and lips on a human face than in *The Cage*. However, these eight lithographs were to be but the first daring theme of a symphony in graphics.

I have always felt that this first important period of Giacometti's graphics could be labelled "Dionysian," as the term is used by Nietzsche in his *Birth of Tragedy*. Dionysus provided the violence, the flirtation with the insane, the primeval creative surge, the scream of the sexual, that underlies all great art. Its opposite is the "Apollonian," which provides restraint, control, proportion. The Apollonian, when fused with the Dionysian, creates the Classical, the stream of fire running through a shell of ice.

Given this schema, many schools of taste would consider all of Giacometti's graphics either Classical or Apollonian since in its way, this first great period of the graphics is just as controlled as the final one. And yet these first great lithographs have an elemental fire and theatrical wonder about them that disappears as Giacometti's work progresses. (The theatre, after all, originated in honor of Dionysus.) And one gets the impression that Giacometti, in doing these studio lithographs was "going to," both in the sense of attending and of using as a source, the first explosive performance of the theatre in which his bronzes were the living actors.

Indeed, this is more than mere supposition on my part. If one didn't know that *The Cage* was of a bronze, one would take it for a moving, tragic actor of a human face. But, more significantly, two of the 1950 etchings are entitled *Personnages dans l'atelier* (87, 88). "Personnages" is a very technical French term and refers to the characters in a play. Our English equivalent,

though not so rich in connotation as the French, is "characters." For example, at the head of a play the list of characters is entitled *Personnages*. And who do these "stage characters" of 1950 turn out to be? The bronze figures in his studio. Later on, he used the term again in his *Personnage dans l'atelier* (8) of 1954, in which a huge bronze statue holds out both arms in a dramatic sweep toward another statue, as if they are actors, while a man, the audience, looks on. There is no doubt that Giacometti looked upon his bronzes as suprahumans. And since in 1951 and 1954 he became an audience to his studio, stood in wonder before his bronzes, at times perhaps not believing that he had created them, he became, as he recorded them for history, rather like a chorus in a Greek play in which his statues were the players.

In 1953 I also saw some preliminary drawings for what was to become one of our century's major cycles in graphics—the seventeen lithographs centering on the studio. The artist's main intention in this cycle was to analyze the studio while it was crammed with its greatest statues. It is regrettable that the edition was so limited. I once searched ten years for one particular study without any luck, so it might be said that these 1954 lithographs are almost as scarce as the better Giacometti drawings. Nevertheless, these prints, though first priced at just ten to twenty dollars each, took several years to sell out. Indeed, even as late as 1963, it was possible to find some of them in major print galleries for less than one hundred dollars. Since then, of course, the edition has for all practical purposes disappeared from sight.

The 1954 lithographs received relatively little attention at first as many collectors missed the point of what a new genius was risking—never has a cycle of prints by a major artist been so austere and stark, so devoid of charm and seduction. Giacometti had focused all his efforts on the severe, spare architecture of his heart. Compare these stern cries of Giacometti to such great cycles as the Vollard suite, Chagall's *Bible*, or various Mirós. In these popular cycles, to a greater or less degree, one finds human warmth, charm, sex, and friendly color.

In Giacometti's 1954 plainsong, however, there is no helping hand. Only the black ecstasy of an imagination that is its own prison.

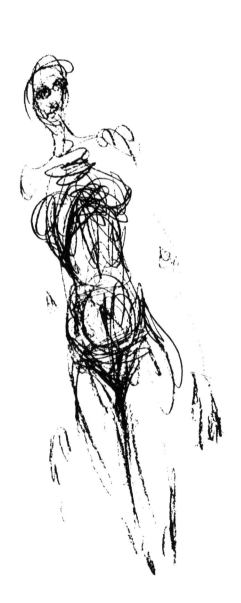

5. The Studio Lithographs of 1954

In the 1954 lithograph cycle Giacometti wanted to concentrate solely on his own studio, to portray the deepest possible witness to his own mind. He was interested in the underlying passion, not the technique. But, as is so often the case, the passion re-created an old, honored form, the black-and-white lithograph. For in the 1954 Studio cycle there is a panoramic composition with an eerie illumination that has never before been achieved in black and white.

Nineteen fifty-four was a memorable year for Giacometti. He had a show at Maeght then which emphasized his painting and drawing. The catalogue for the show featured a long essay by Sartre on Alberto's painting. Sartre had been the first major critic to write on the mature bronzes; now he was doing the same for the oils. From this year on the reputation of Giacometti as a painter was to soar—until now some collectors actually prefer the oils to the bronzes.

The drawings in the 1954 show were the finest Alberto had done, and an analysis of them will be found in Part II below. Here, we will comment on the poster (201) of the 1954 show and the cycle of seventeen lithographs (8-24) that accompanied it.

The show catalogue containing Sartre's essay is adorned with three color lithographs. To my knowledge, though, they were not by Giacometti, but are *"estampes,"* that is to say, lithographs done after the style of the artist. The poster (201) is also an *estampe,* done in color after the 1952 painting *The Street.* It is said that Giacometti, upon viewing the proof of the poster, was so pleased that he added a few flourishes of his own and issued an *avant-la-lettre* edition of 200 copies. I believe this for several reasons: first, and most compelling, Giacometti signed it and authorized a large edition. Second, most experts agree that its quality is superb—despite the unusually large edition, collectors will not part with it. To my knowledge it has not come up for sale more than once a year since it was issued— a remarkable record of collector tenacity.

The subjects in the 1954 cycle will puzzle those who are not familiar with Giacometti's themes. Alberto is best known for his work with the human figure and face. But one could make out an excellent case for his being just as interested in the nonhuman side of the world. Certain inanimate objects he never tired of drawing — apples, bottles, chairs, stools, interiors, flowers, landscapes, and art works. In this 1954 Dionysian cycle his wife and brother make infrequent

appearances. The most common subject is a pair of stools—favorite objects of Alberto, used for such varied purposes as supporting water buckets, statues, or upon occasion human rears. The stools are portrayed ten times with great thoroughness and each study is distinct and individual.

Perhaps as interesting from the philosophical-esthetic perspective are the sculptures Alberto chose to feature. Perhaps he never read Sartre and Genet on his existentialist vision of man because even the human bronzes play a very minor role in the 1954 theatre. The featured bronzes are those most familiar ambassadors from the animal kingdom, *The Dog, The Cat* and *The Horse.*

In this cycle two lithographs (16, 20) are concerned with events on the street near Alberto's studio—the rue d'Alésia. The remaining fifteen are of the studio and statues. They represent the most sustained analysis Alberto ever did of his created world. Only four of his statues are featured more than once: the *Man Pointing* (twice), *The Dog* (seven times) and *The Cat* and *The Horse* (five times each). A brief comment on each of the seventeen prints:

Chien et chat (11) is a serene composition of the dog, cat, cage, and a tall plaster not executed in bronze until 1962. It is one of the few early lithographs to use large splashes of white.

Annette dans l'atelier (10) completes the vision on this subject started in 1951. Many will prefer the 1951 version (92) because of its brilliant lighting, the excitement of its verticals, and the neater portrait of the woman and horse. On the other hand the dress in this later version is perhaps the most pulsating shape ever created by Alberto.

Buste dans l'atelier (12) is a passionate world dominated by *The Hand,* an all-important statue.

Personnage dans l'atelier (8) is a dramatic scene of throbbing verticals in which a huge standing bronze throws out its arms to an armless statue as a human watches this mute appeal.

Chien, chat, tableau (13) is a triptych divided into: (left) a stealthy figure walking near the stove; (center) *The Cat,* perched on a stool, and *The Dog;* and (right) a large canvas.

Sculptures (14) is a lofty study of two tall figures, a stool, and *The Dog.*

Atelier I (23), as marvelous a tangle of bronzes as exists in Giacometti graphics, is the first version of his finest print.

Atelier II (15). Every collector has a favorite work of his favorite artist and this particular print is mine. Of the seventeen prints in this cycle, nine are about twice

as large as the other eight. As wonderful as the smaller ones are, the day must go to these nine. As far as ranking them is concerned, in a strict objective sense they must be considered equal. Each is a sheer miracle. So I preface my remarks on *Atelier II* by saying that my judgment about it is a pure and simple gut reaction. Even if one does not have a bronze or oil by Giacometti, with these large studio scenes one can still have the essence of the artist—and far more so than in some of the smaller bronzes and pale drawings he did in the sixties. With *Atelier II,* as was so often the case, Alberto tackled a subject, then saw further aspects of it, and reworked it. Thus, after completing *Atelier I* (23), he did a drawing (D6), now in my collection, which shows further experimentation, and is virtually a glimpse of the artistic process in full swing. Then, after adding on to or adjusting various figures he arrived at *Atelier II,* which has a contrapuntal swirl not found in its predecessor. No other drawing or print of Alberto's has to such an extent his unique composition, his ability to show turbulence frozen in calm, his peculiar lighting, and the magical ease with which he blended disparate volumes: the *Man Pointing, The Cat, The Dog,* bottles, the two stools, various busts, and *The Horse.* The print in its deepest posture is Man pointing at the world of art.

Rue d'Alésia (16) portrays the main street closest to the studio. Alberto often went there to its modest cafés. The scene has all the magic of a Parisian street, its people, its floating acacias, and even a car (machines are an oddity in the early Giacometti drama). What is more intriguing is the three walkers, for they are a fine version of his statue *Three Men Walking.* The figures are so ethereal as to be almost disembodied and give the impression of being suspended an inch above the pavement.

Tête de cheval I and *II* (17, 18). No finer example of Alberto's imagination exists than in these two contrasting treatments of the same subject, in this case the two horses, the pair of stools, and a leaning beanpole figure. The two prints have an amazing difference in illumination—*II* has a hard, clear lighting, whereas *I* has a hazy luminosity resembling that of the late El Greco oils.

Tête de chat (9) is a great study of the sculpture *The Cat,* no doubt inspired by the cats both Alberto and Diego doted on. Each time a cat would stroll into the studio Alberto's face would light up, and so at last he did a bronze statue of *the* cat.

Buste (19). It is interesting to contrast this study of Diego with the earlier *Cage* (5). In the early study the face is tremulous, the skin a dry leaf tightened over a

metal frame. In *Buste* the pain is more channeled. In both cases the artist treats bronze as if it were warm, living flesh.

Au café (20). A woman is blocked into a plate-glass window of a café on the rue d'Alésia. Before her are cups, saucers and an ashtray, and to her left, her purse. This is a very architectural scene in which the brilliant plate glass is rendered by fluorescent verticals.

Le Chien (21). As in the statue itself, the languid gait and inquisitive droop of the dog's neck is shown. The figures at the sides and foreground nestle around the dog, giving an excellent idea of what a corner of the studio was like in 1954.

Têtes et tabouret (22). A cluster of heads, figurines and a great nude mushrooming above a stool and backless chair. The print has a dance rhythm that carries the eye diagonally from the bottom to the top.

Figurines et poêle (24). Giacometti was fascinated by the ancient stove in his workshop. He did many studies of this old friend, his only source of warmth in the dank, winter days. Here it is related to a huge standing figure of remarkable verve and lightness and the *Three Men Walking*. The print is a fine example of how Alberto could use calligraphic slashes to give a certain sweep to the volumes. In the right-hand corner is an excellent instance of a bold canal of lines Alberto often used to push up the main composition, thus giving it a peculiar stilt.

With this series Alberto attained his temporary goals in lithography. During the following year he would turn to etching and another new phase in his graphic development.

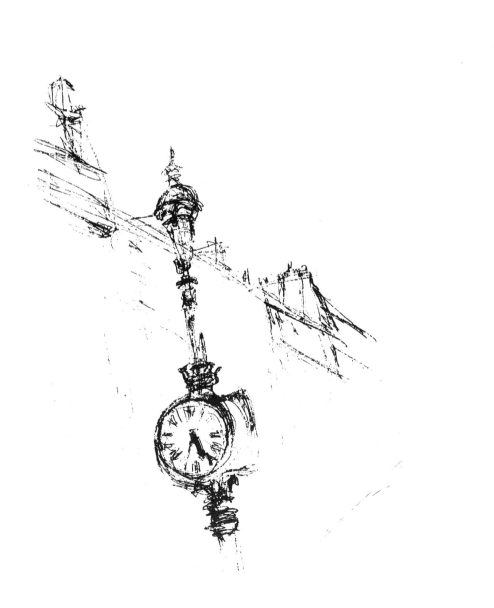

6. The Classical Period (1955-1959) and the Etchings

It is often difficult to talk about dates in graphic works. In this outline only dates of publication are used; however, many of the prints were done some years before.

It seems that Giacometti published no lithographs in 1955. Instead he busied himself with an important series of etchings. These should be discussed in a separate monograph. However, I must confess that on the whole his etchings are very uneven. Many are quite mediocre and some quite sensational. The eight etchings (58-62, 64-66) done for Maeght in 1954-1955 are all masterpieces. No drawing by Alberto surpasses the total delicacy of *Nu de profil* (64), *Annette de face* (62) or *Nu de face* (65). The study of the two stools (58) is remarkable for its creation of shapes. In the two-pails study (66) the lines seem to dance and hover over the paper. The nudes are particularly rich in new visual effects. Such delicate analysis and movement could only be achieved by the fine point of a needle. A diaphanous lighting is attained in the flower studies *Bouquet I and II* (59, 60), and in the portraits in *Bouquet aux deux portraits* (61). When the three flower studies are seen together, they form a triptych of unsurpassable delicacy.

These eight etchings are spectacular examples of an idea that we shall analyze in Part II, namely, Giacometti's surrealist ambition of making boxes with transparent motion in them. The more one knows Giacometti graphics the more one admires these eight Maeght etchings, in particular the ones of flowers.

I am also very fond of three etchings, never published, which I managed to acquire from Alberto in 1956. One (68) is the most detailed analysis of a woman's face he ever did. Another, a little nude (67), upon which he also did some drawing, has all the heroic stateliness of a bronze figurine. The third one (69) is an odd composition of a giant hovering over a frozen figure.

Some of the other etchings which have considerable bounce are the tiny walking woman (96) he did as a Christmas card for Maeght in 1955, the *Intérieur au poêle* (70) of 1956, the bottles (98) in the Eluard book of 1956 (my copy of this work was burned up in the fire already mentioned), the striding figure (106) done for Jacques Dupin's book, *L'Epervier*, the magical head (107) for Du Bouchet's *Dans la chaleur vacante* of 1961, and the very inventive diptych (177) he did for the book published by François di Dio in 1964, Lebel's

interesting *La Double Vue,* which also has a construction by Marcel Duchamp, his last signed work.

In 1962 Giacometti did a weird experiment with Iliazd, *Les Douze Portraits du célèbre Orbandale* (162-173), etchings of twelve views of one man's face. If the twelve are taken out of the book and set side by side and looked at in quick succession, the visual effect is a little like walking around a statue. Thus the work has validity as a book or etching group. However, some dealers have broken up the book and sold the etchings on an individual basis. On this basis the plates, as individual works, without their companions, are somewhat weak.

One can only speculate about the effect that the return to etching in 1955 had upon Giacometti's lithography. It may well be that this activity introduced a certain element of restraint into the new lithographs. For, after 1955, no more will there be that spontaneous flashing forth in black and white, as if the whole world were in upheaval. From now on, an element of measure, even of spareness, will creep into the lithographs until, at the very end, such elements have altogether won over.

However, for a brief period of three years the lithographs retain some of the ancient violence and become an enchanting marriage of primeval force and mature restraint.

All this is apparent in his only 1956 lithograph, *L'Atelier 1955* (25). In the first state the central figure, a bust, has the twisted mouth, the startled, convulsive eyes executed in the virile slash style of the 1954 scenes. But, in one of the more arresting moments in art history, the artist had an afterthought, and in the final state replaced this bust with one far more measured and calm, thus providing a pivot for his graphic universe. Already, then, in the magnificent, final version of *L'Atelier 1955* appears the first hint of his later lithographic style.

One might term this pivotal period, again using Nietzsche's formulation, "Classical," a perfect fusion of the Apollonian and Dionysian forces. Here the flame and the anguish are mated to a total lucidity that results in a celebration of balanced extremes.

In purely visual terms this change will mean that after 1956 there will be an ever increasing tendency to eliminate the black and enlarge the white areas until, at the very end, as in *Mère de l'artiste lisant III* (44) or *Mère de l'artiste assise II* (51), the human figures are like faint gray beacons immersed in a white sea. From the cluttered and tumultuous *Studios* of 1954 the artist traveled to the stark and the sparse, in a dance toward total white, the transition to death.

In 1957 the new tone, the deployment of white as a scenic tool, becomes evident in the four lithographs published by Maeght for the new show. These four are already a total revelation of the sixties. The *Tête d'homme* (102) of 1957 is a tiny head of Diego peering out from the lower right-hand corner of a pure white page, rather like a miniature face engulfed by a white cloud. In *L'Homme qui marche,* also used for the poster (202), the figure is located in the same position as the head was, and the body is dismembered by flowing whites—the hands are amputated from the elbows and the feet from the knees — the whole drawing a marvelous man walking, or, what seems more accurate, a man gliding, flowing.

Nineteen fifty-seven was also notable because it saw the publication of Giacometti's two greatest landscapes. Now Alberto's grand design for his graphic world became quite clear — he wanted to transform it into an intense witness to everything most dear to him. The 1956 etchings of the nudes and still lifes filled in an important gap; all that remained as an important subject was nature. In the late forties and early fifties Alberto had marched out an impressive squad of landscapes in oil, such as those found in the superb collections of Clayeux and Zumsteg, which qualify him as perhaps the most imaginative landscape artist to emerge since World War II. His greatest landscape in oil is perhaps the ecstatic *Garden at Stampa* of 1954. It was at this moment, when he had invented a novel orchestration of color and light for the landscape in oil that he began preparing studies for his two panoramic lithograph landscapes, *Giacometti's House in Maloja* (27) and *Mountain in Maloja* (28). Although I have not seen all of the many landscape drawings by Alberto, it would be difficult to imagine any of them surpassing these two lithographs. In the *Mountain,* perhaps more than in any other Giacometti graphic, one feels the majestic influence of Cézanne; while the *House* is one of the greatest moments in the artist's entire oeuvre, an Alpine valley stirred up by the sun, a shredding of brilliant sunlight and cloud through black lines.

In 1959 Maeght published *La Suspension* (29), the first lithograph version of the great Chandelier drawings (see D5) of 1954. It is the last major lithograph which will load up the page with bold blacks. It has the same classical tone as *L'Atelier 1955* (25) and justly deserves the high esteem in which it is held by Giacometti collectors. Giacometti himself favored it.

The first span of Giacometti's graphic work, which ended in 1959, is, then, a varied period that begins with the crude cubist head and primitive scratchings done

for books by Breton and Bataille, builds with the great 1954 Studio series and culminates in *La Suspension* of 1959. This miraculous galaxy consists of some fifty stars encompassing all the subjects exciting to Alberto. After this heroic period Giacometti will add on yet another 300 prints, most of them done under pressure for book illustration. But except for the twenty black-and-white lithographs he was to do for Maeght, the later deluge of the sixties does little to increase the stature of his graphic world.

Until one has seen in their entirety the fifty important prints done between 1951 and 1959, one might say that the whole point of Giacometti's grand design in graphics is incomprehensible. Yet a decade later, no more than a handful of these prints had ever been shown. At last, the exhibition which originated at the Milwaukee Art Center in May, 1970, displayed these early fifty together for the first time. The record was set straight, and the artist's overarching scheme was seen in all its dazzling extent.

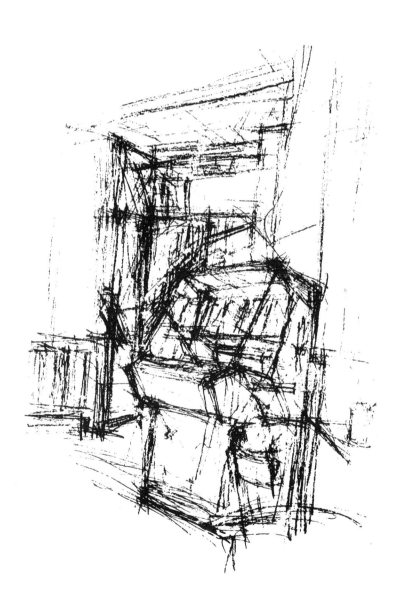

7. The Apollonian Period
(1960-1965)

The last period of Giacometti's graphics is characterized, though not precisely, by Nietzsche's term "Apollonian." It is an art that stresses serenity, restraint, understatement, the calm of composition. The torment that sometimes squeezes to the surface in 1951 is now either crushed down or etherealized. It is an art of logic, majesty, and pruning, rather than one of rebirth, celebration and wonder.

In this later majesty there are several studies which grip me far more than others. One is the *Buste II* (31), which has become, due to its surface sentimentality, one of Alberto's most popular prints. There are also a number of unusual facts concerning this print: (a) Of the five lithographs issued in 1960, four were published in editions of 90, but for this one the artist increased the issue to 150, one of his largest printings. Why? (b) This print remained a favorite of Giacometti. He chose it for illustration in the important book on him by Jacques Dupin. (c) In 1959 Alberto made the acquaintance of Caroline, a pretty young Parisian woman, who soon became his mistress. *Buste II* is one of the first occasions on which Caroline modeled for Alberto. Later on he was to build a great series of oils around her.

This is neither the time nor the place to recount the full details of Giacometti's domestic situation and the enormous effect it had on his development. We should note, however, that Alberto felt the need to the very end for the friendly love of Annette as well as of Caroline's companionship. This fact contributes an added glow to *Buste II*. In its enigmatic sweetness and tender wound it can be compared to the *Mona Lisa*. It is also a superb example of drawing in Alberto's late manner—the uneven slopes of the shoulders flow with amazing realism into the neck, the breasts full and rich relate to the shoulders by faint strokes that render to perfection voluptuous flesh. Nowhere else—not even in *Man Walking* (202) of 1957—is there a better instance of Giacometti's famous economy of means.

Of the late lithographs one might notice in particular *Chaise et guéridon* (33), done with such delicacy and grace that even experienced observers at first glance sometimes mistake it for a pencil drawing; *Homme debout et soleil* (38), the artist's final statement on man's relation to nature; *Nu assis* (37), *Nu debout I* and *II* (35, 36); *Stampa* (46), a last testimony to his native village; and *Mère de l'artiste assise II* (51),

where the seated woman is little more than a smudge on a huge glare of pearl.

In 1964 Alberto published several fine lithographs of his brother Diego, including his best full-face study in any medium, the *Tête d'homme* (47) of that year. It is an extension of the splendid full-face drawing of Diego of 1956, described in the following essay. The 1956 drawing has numerous erasures, giving a luminous X-ray structure to the head. In the 1964 lithograph the artist, though, deprived of the subtlety inherent in pencil drawing, obtained a similar neutral effect. However, in essence, the 1964 lithograph is quite different from the drawing. It is more expansive, more architectural, and has a brighter lighting. Furthermore, while the general tone of the drawing is serene, that of the lithograph is not. In the lithograph the eyes are strained and anxious, almost horrified, as if the face is about to be smashed by the imagined proximity of death.

Every one of these Apollonian lithographs is important. Each is an interesting experiment in spacing. For those collectors preferring the calm and the stately to the turbulent, these late graphics will have a lasting appeal.

8. *Paris Sans Fin*, Giacometti's Last Testament

The posthumous book, *Paris sans fin*, composed for the most part between 1957 and 1962, represents a new graphic triumph for Giacometti, the re-creation of the illuminated book.

True, most of his graphic work had been done for books, but his book illustrations tended to be rather shoddy. Furthermore, most of them were etchings, a medium with which he never felt quite at ease. It was therefore a wise, sure choice that for his greatest graphic endeavor Alberto chose the medium he knew best: drawing—more specifically, drawing with crayon on transfer paper.

As we mentioned at the start, Alberto was an ambitious artist, ambitious in the same sense as Picasso and Matisse were. He wanted to do battle on all fronts. After he succeeded in sculpture, painting, drawing and graphics, there remained but one more field to conquer, the illustrated book, that wonderful shape that can flower only in the most creative civilizations (America still has not produced a superb example of this form). Before 1960 Alberto had established himself as a graphic artist. However, he had not yet created a great book such as had Chagall, Matisse, Bonnard or Picasso. With *Paris sans fin*, for which he did both the text and the 150 lithographs (204-353), he not only amended this situation, but created in many respects the most beautiful book of this century.

This magical work completes the task set forth by the artist's very first lithograph, the *Objets mobiles et muets* (1) of 1931—the commingling of his own words with his own images. The text of *Paris sans fin* is a poignant cry to the eternal orders. It provides a perfect psychological and esthetic background for the pictures. Other modern artists had tried this marriage for their own writings and images, but in a fragmentary way. *Paris sans fin* structures the written with the scenic into an epic book. It is the artist's last testament to his own art and to modern life. As fate would have it, and no doubt the artist would have given his ironic approval, a few pages of the text were withheld because of his death, thus leaving a small portion of the epic structure incomplete, as was so often the case with medieval cathedrals.

That Alberto wanted this marriage between text and image is evident for two reasons: (a) his own statements on the subject, and (b) the very structure of the book itself—it cannot be split up, because the lithographs are either imprinted on both sides of a leaf or

on the back of a page bearing the text. Thus the book is an organic whole, a book illustrated in the traditional manner. This organic thrust is opposed to that end of most modern books illustrated by major artists—for example, the *Bible* by Chagall, or *The Divine Comedy* by Dali, books meant to be destroyed, split up, with the plates sold on an individual basis.

This book represents the artist's passionate witness to the place he loved most, Paris. It also testifies to his most ardent esthetic quest, the exploration of space. Thus the book is a dual commentary on his two greatest loves, Paris and space. This is evident from the first pages of his handwritten text:

> *Paris now reduced for me to an attempt at slightly understanding the root of a nose in sculpture. I feel all her space outside around me, her streets, her sky, I see myself strolling in her neighborhoods, a little everywhere, my portfolio under my arm, stopping, drawing. . . .*
> *Oh! the desire to do pictures of Paris a little everywhere, there where life has led me, or would lead me, the only way for all this my lithograph crayon, not painting or drawing, just this crayon for capturing on the spot, with no chance of ever erasing or revising, my first impressions. . . .*

Though one must attribute the splendor in this book to this dual space-city quest, one should not ignore the great importance Giacometti attached to its instant drawing technique. He seems to be saying, "There is a certain visual truth obtained only with a drawing pencil. One can erase and change a subject until it becomes what one thinks one has seen; but, since all this takes place over a period of time, one might well lose what one first saw—the original emotional freshness around the insight. For by reworking a subject one gains one truth but loses a more primitive one." This explains why *Paris sans fin* is a supreme experience in instant drawing—by using a medium not capable of much revision and by choosing locales that, for the most part, could not be duplicated, he was obligated to serve sheer immediacy. Indeed the 150 lithographs sparkle like the first flowers bursting forth in spring, fresh, crisp, vibrant. *Paris sans fin* is an impulsive quest for a primordial truth.

The book then has a quadruple thrust: the re-creation of a traditional art form (historical), a testimony to the artist's beloved home (psychological, autobiographical), an adventure into immediacy (stylistic), and a study of space (esthetic, metaphysical).

The title indicates the sense of mystery and love

Paris inspired in Giacometti. Instead of choosing "eternal" Paris, which would have conveyed a static idea, Alberto chose the dynamic *Paris Without End*, which in French connotes a Paris always re-creating herself, Paris as an endless adventure, an endless creative space. "I feel all her space outside around me, her streets, her sky. . . ."

Paris is a beloved woman whose body must be explored, her every space venerated. This love is indicated by the frontispiece (204)—a svelte, voluptuous nude swimming toward infinity.

The book is organized like a movie. After this introduction by the female nude the reader is plunged into the whirlpool of the streets of Paris. Each lithograph creates a certain tempo—above all, Parisian life in outer space, the streets; then life in internal space, the studio or various bars; then a number of studies of models, with the scenario climaxing in that subject so rare in Giacometti, the erotic, a rather odd group orgy, with a dissipated woman leering at that rarest object in the Giacometti universe, male genitals. Man and his artifacts dominate the book. Nature plays almost no role except for the few trees along the streets.

At first, what struck me most were the exciting outside spaces—the expressways, the sky above church spires, the jammed streets, the spreading vistas from Seine bridges. One *breathes* Parisian air. The book opens with a wonderful series of street-*with*-car scenes balanced by a group of street-*without*-car scenes; then the two are mixed together—altogether there are about sixty street scenes. Yet the more one swims into the book one realizes that the old Giacometti obsessions are very much intact. Balancing the outside vistas are many splendid interiors and indoor objects—bars, a printing shop (Mourlot's), a cigarette machine, the museum of natural history with prehistoric skeletons and stuffed rhinos, full-scale studies of tables, chairs, trays with food, railroad-station lobbies. There are also some epic views mixing inside and outside space— drawn as the artist looks across a room through the plate glass into the street.

There are so many fine pictures one hesitates before singling out the magnificent frontispiece, *Paris*; plate 58, *Cars, Motorcycles, Tree*; plate 93, *The Clock*; plate 123, *Man at Outside Café*; plate 140, *The Tilted Table*; plate 143, *Nude Prostitute*; plate 144, *Orgy*; plate 146, *The Dance.* (Plate numbers in book are given.)

This city of Paris is the opposite of Baudelaire's. Nor is it for the rich and elegant. There are no swank rooms. It is very much the spot for the ordinary guy on the move, the man in the street, the man in the modest room. It is the city of everyman.

Paris was a city as well as an artistic quest for Giacometti. He said all this so well himself it is proper to end this section with the last paragraph from *Paris sans fin:*

Silence, I am alone here, outside it is night, everything is stopped and sleep possesses me again.
I don't know who I am or what I am doing, or what I want, I don't know if I'm old or young, I have perhaps a million years to live before my death, my past loses itself in a grey abyss.
I was a snake and I now see myself a crocodile, the jaws open; it was me the crocodile crawling with his mouth wide open.
To scream until the air shakes, lighting matches spotted on the earth like warships on a grey sea.

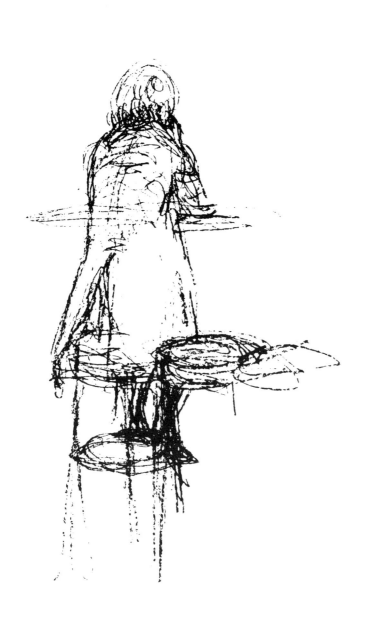

9. Conclusion

In looking back over Giacometti's graphic work I must confess to having a particular love for those twenty-odd lithographs, most of them of the studio, done between 1951 and 1956. In my own private fancy they have been named the "black" lithographs, because they contain some of the most exhaustive use of deep black in the history of lithography.

Concerning their significance to Alberto himself we must remember that although he had found a unique style prior to 1946, it is nonetheless his postwar work that makes him a milestone. The first explosion of this new style, as is so often the case with new thrusts, remains the most valid part of Giacometti. The black lithographs are one of the artist's chief testimonies to that first heroic explosion.

It was, then, in the glare after D day, as the shrouds lifted, that Giacometti began celebrating the renaissance of civilization. Today this work from his late forties strikes us as a giant thanksgiving to light. And if the postwar flowering became the final mirror to his long search, so did the black lithographs later on become the mirror within that mirror. One might almost say that Giacometti's Studio lithographs are psychoanalytical in the sense that they are about his own bronzes, those deepest reflections from his own self.

The black lithographs are the sustained witness to his first great decade. Coming near that decade's end they result from his meditative surprise before his own creations. They are the fullest synthesis made by the artist, the one systematic commentary upon his best work. They are dark, glowing icons grafting on new dimensions to the pared bronzes, just as a house of mirrors does to the human body. This group is the autobiography of a box near the rue d'Alésia where plaster ghosts once sprouted near attenuated bronzes and battered stools. A magician named Alberto Giacometti infused them all with a life of their own and turned them into a fable for our time.

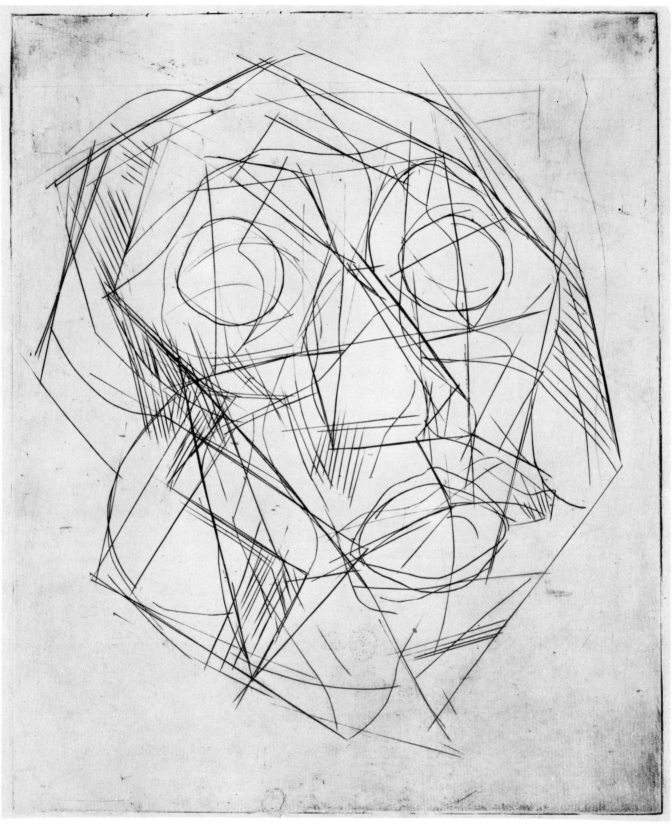

56. CUBIST HEAD. 1933.

Collection, The Musum of Modern Art, New York. Gift of Stanley W. Hayter.

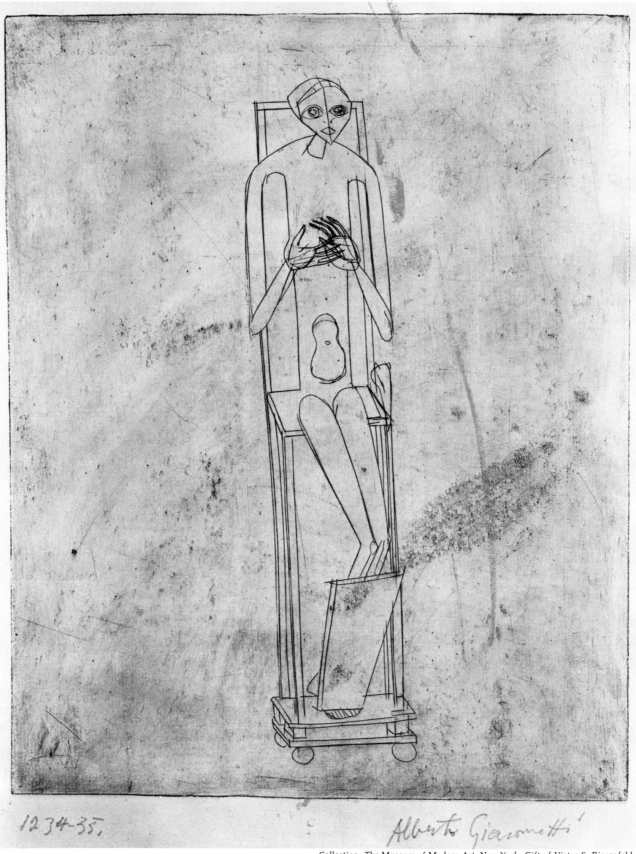

1234 35,

Alberto Giacometti

57. HANDS HOLDING A VOID. 1934.

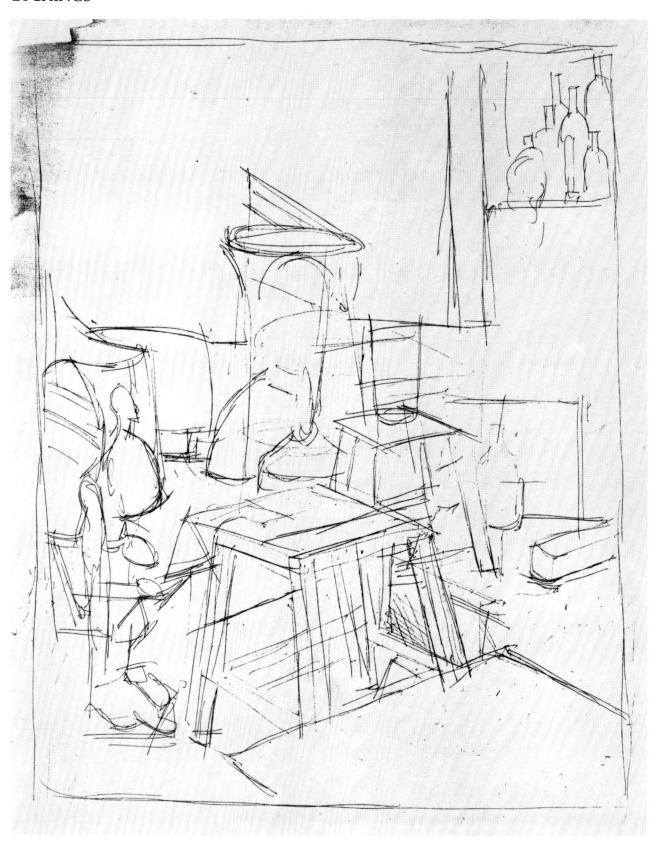

58. THE TWO STOOLS *(Les Deux Tabourets)*. 1954.

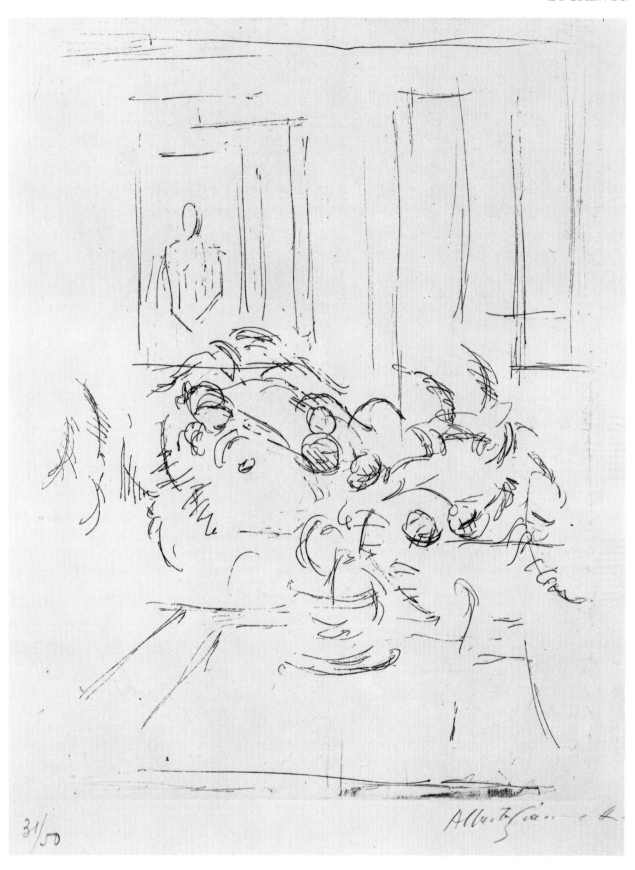

31/50

59. BOUQUET I. 1955.

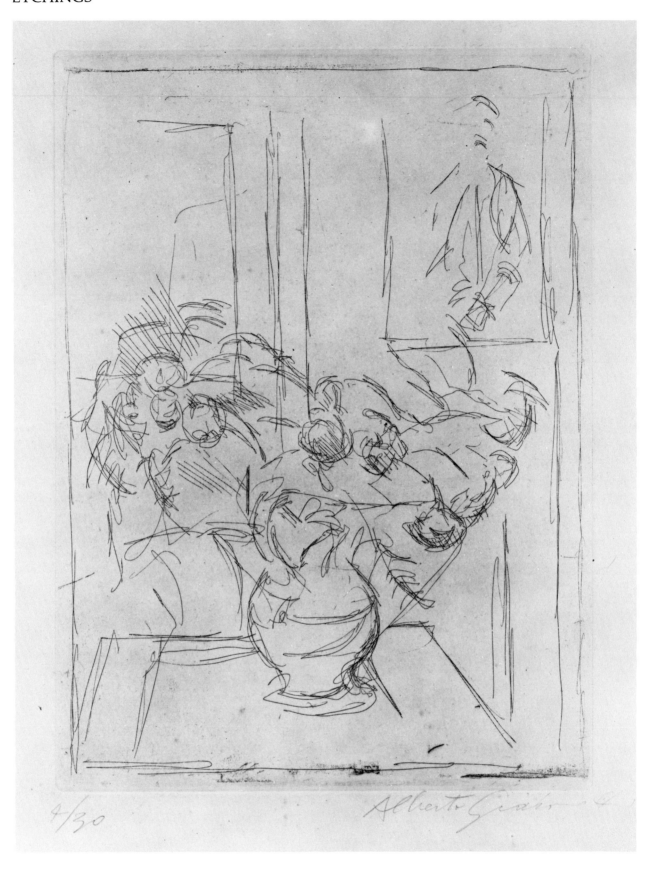

4/30

60. BOUQUET II. 1955.

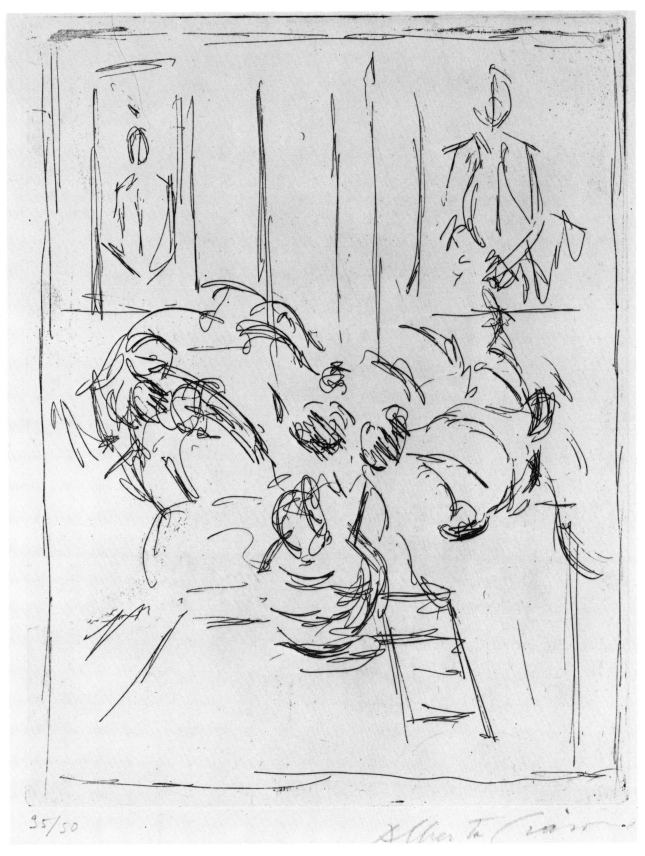

95/50

61. BOUQUET WITH TWO PORTRAITS *(Bouquet aux deux portraits). 1955.*

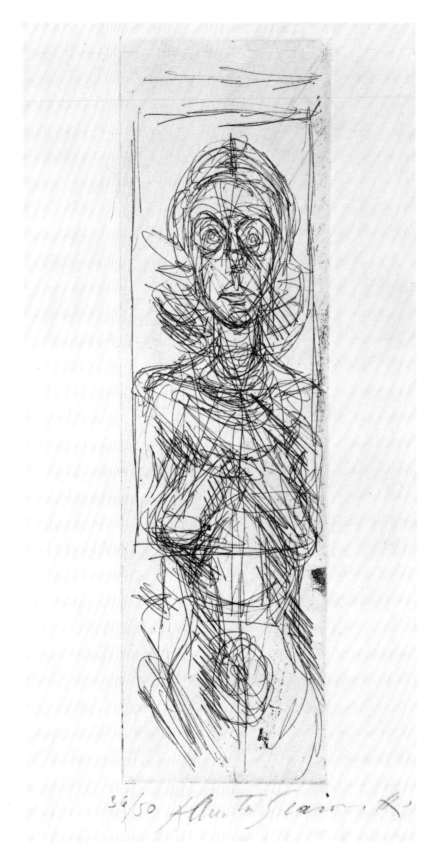

62. ANNETTE FACING FRONT (*Annette de face*). 1955.

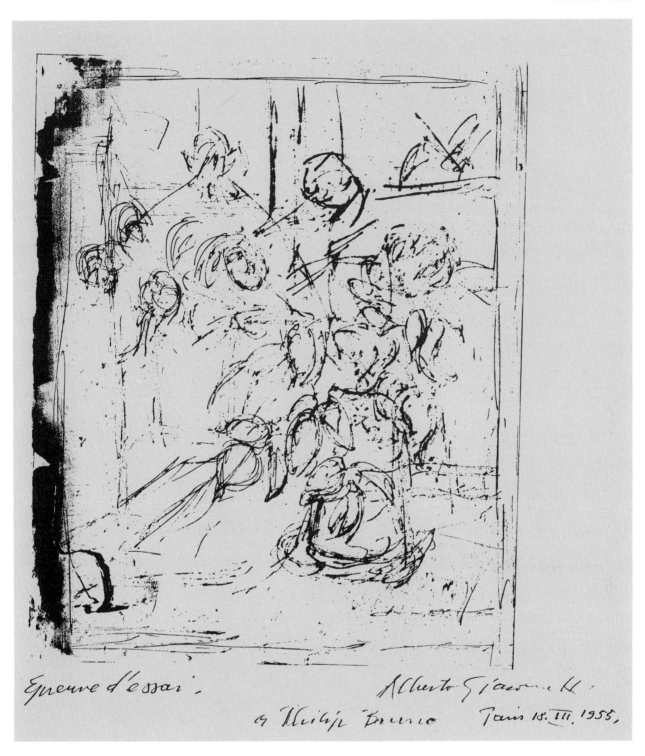

Epreuve d'essai. Alberto Giacometti.
cg Philipp Bruno Paris 18. III. 1955,

63. BOUQUET. 1955.

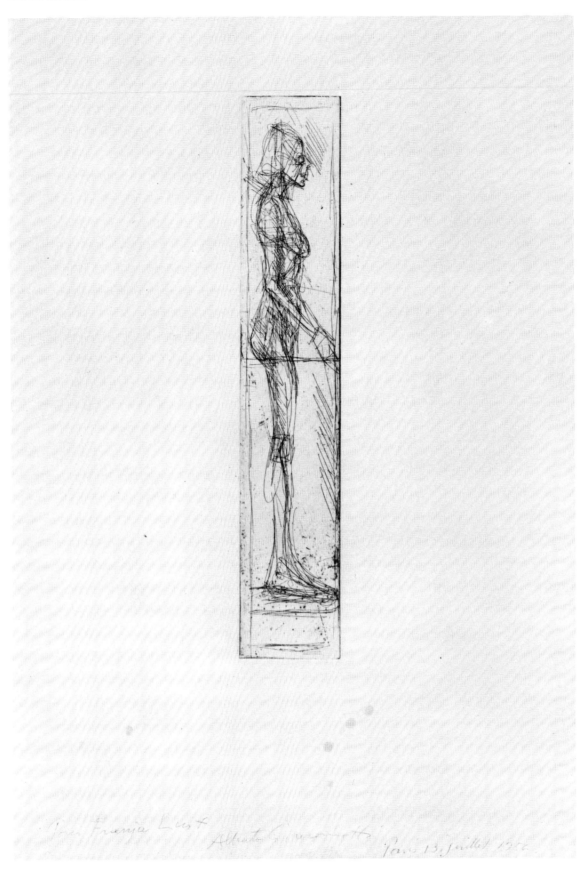

64. NUDE IN PROFILE (*Nu de profil*). 1955.

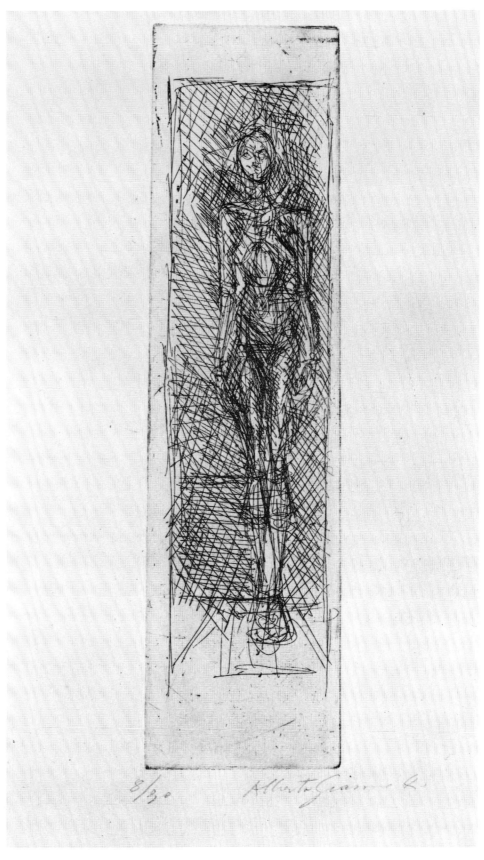

65. NUDE FACING FRONT *(Nu de face)*. 1955.

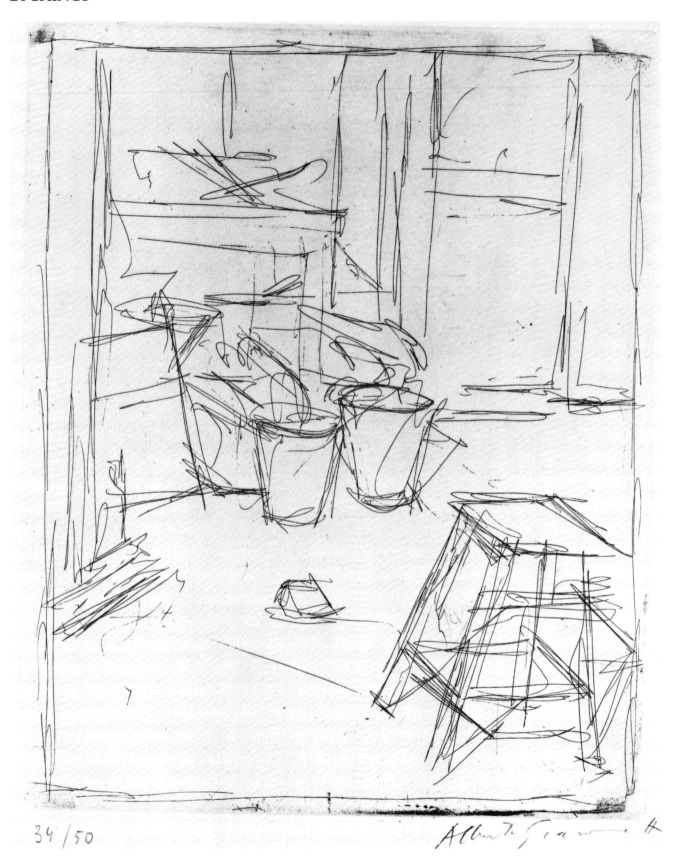

34/50

66. STUDIO WITH TWO PAILS (*Atelier aux deux seaux*). 1955.

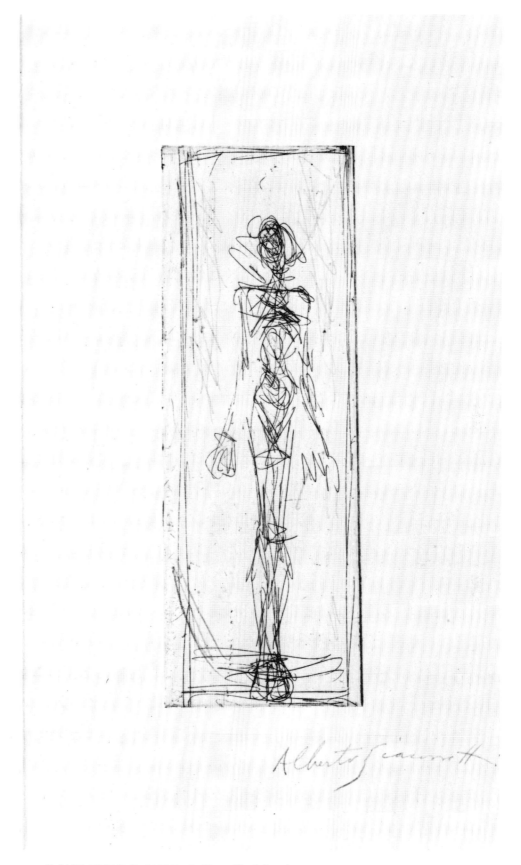

67. SMALL NUDE STANDING (*Petit Nu debout*). 1955.

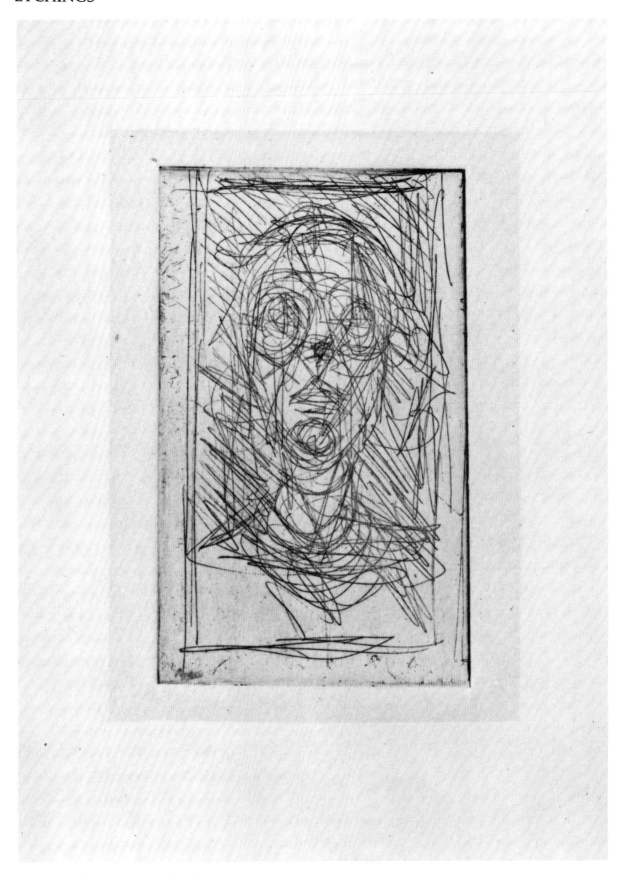

68. HEAD OF WOMAN *(Tête de femme).* 1956.

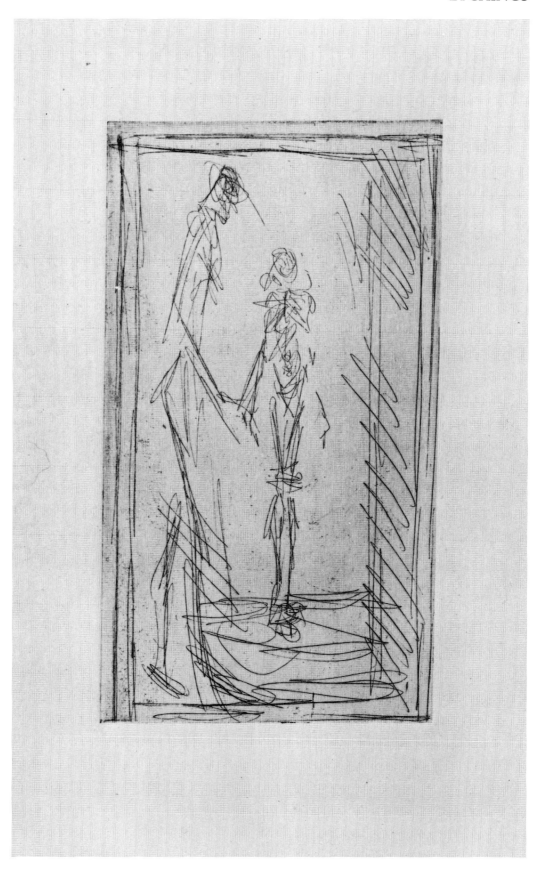

69. STANDING FIGURE IN THE STUDIO *(Figure debout dans l'atelier)*. 1956.

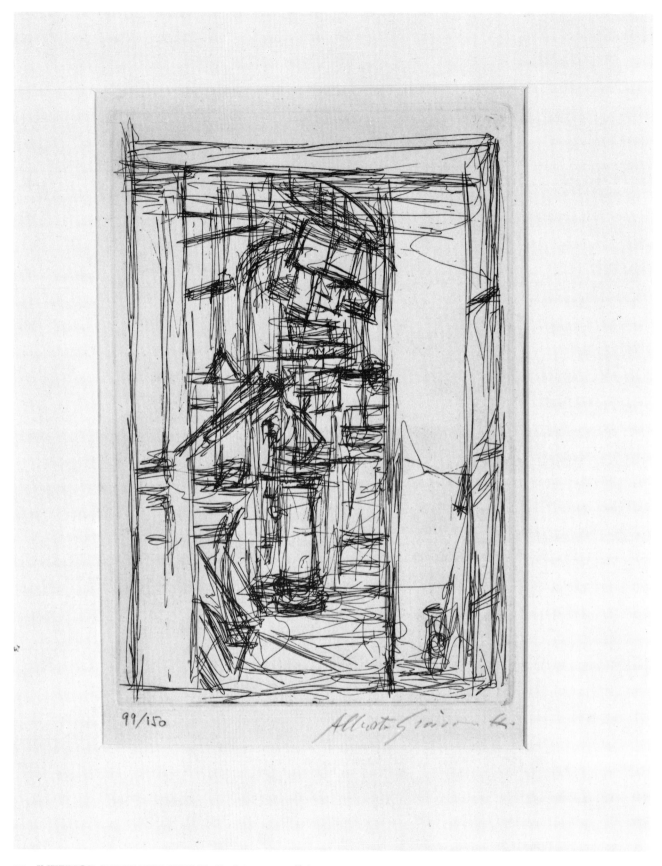

99/150

70. INTERIOR WITH THE STOVE *(Intérieur au poêle)*. 1956.

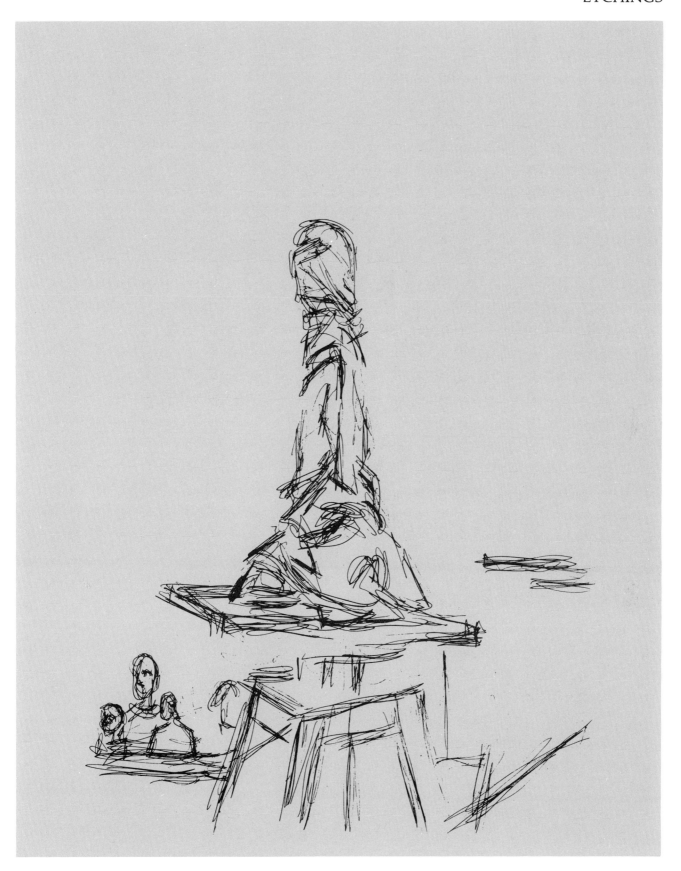

71. STUDIO WITH THE TURNTABLE *(Atelier à la sellette)*. 1964.

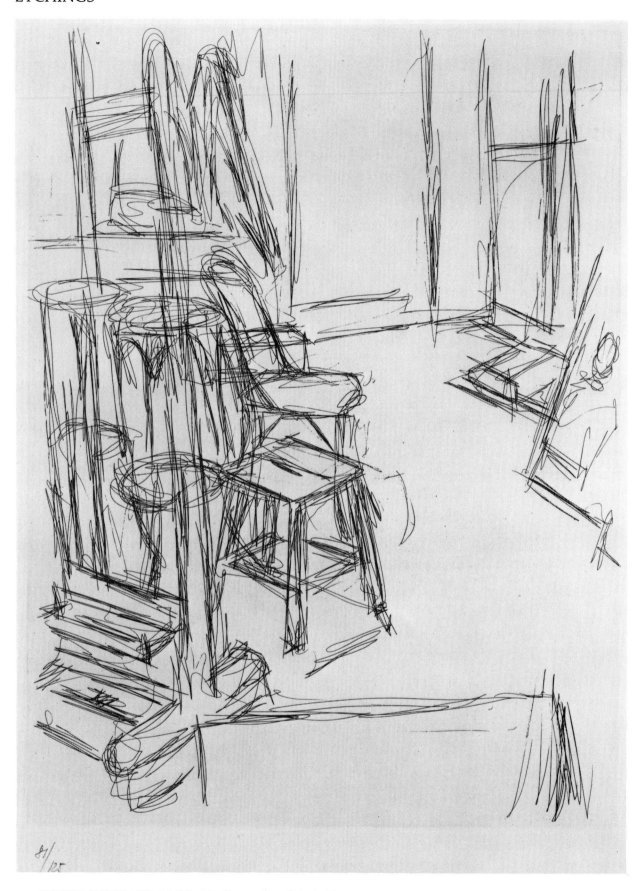

72. STUDIO WITH THE EASEL (Atelier au chevalet). 1965.

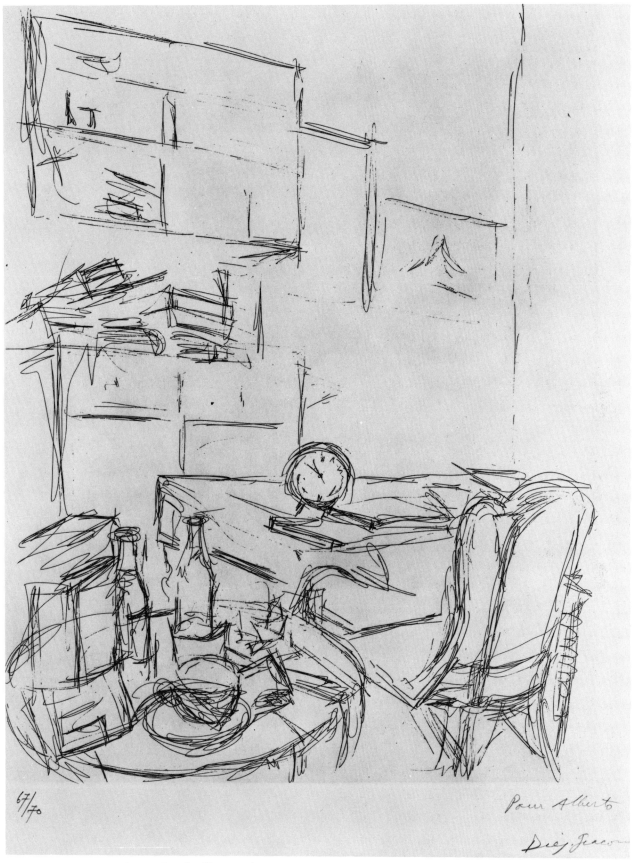

67/70

Pour Alberto

Diego Giacometti

73. THE ALARM CLOCK *(Le Réveille-matin)*. 1965.

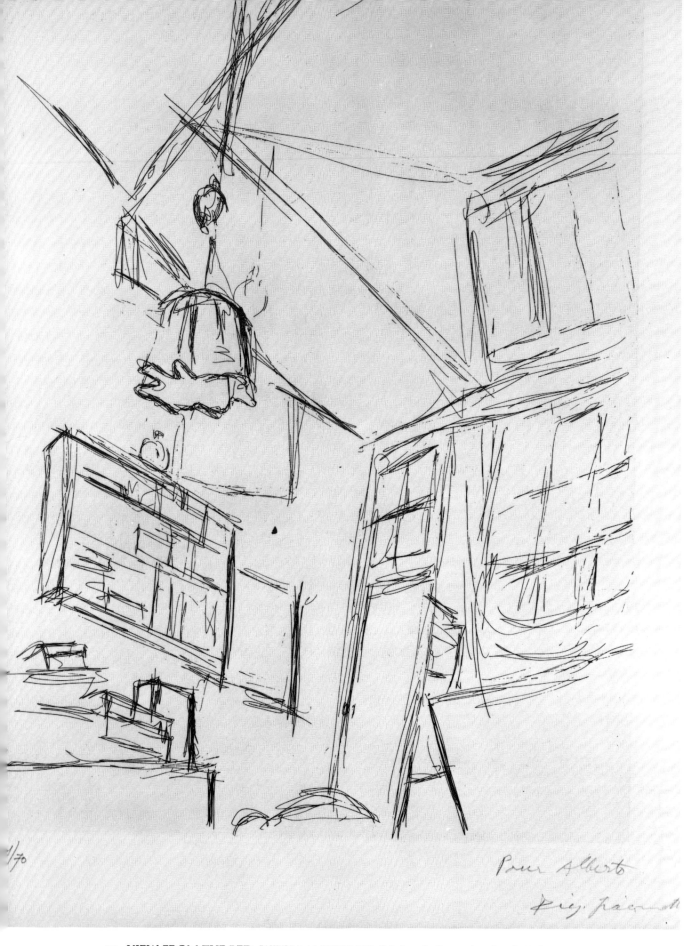

1/70

Pour Alberto

[signature]

74. VIEW FROM THE BED, WITH LAMPSHADE *(Vision du lit et abat-jour)*. 1965.

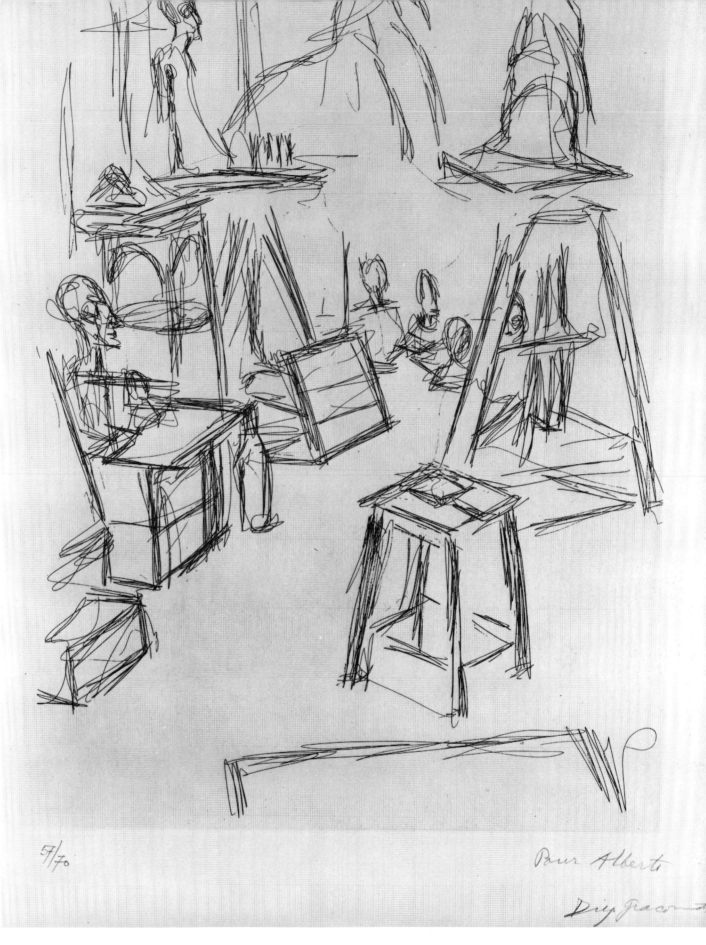

75. SCULPTURES (Les Sculptures). 1965.

76-79. From *L'Air de l'eau*, by André Breton. Paris, 1934.

76.

77.

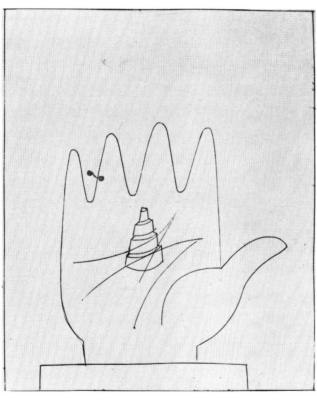

78.

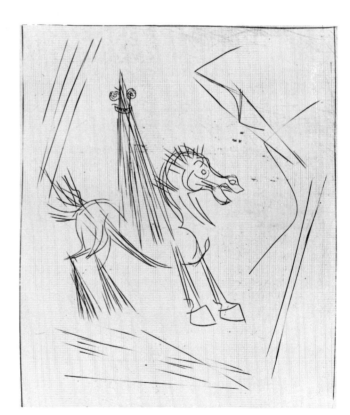

79.

23/50 Alberto Giacometti

80. From *23 Gravures*, by Anatole Jakovski. Paris, 1935.

Collection, The Museum of Modern Art, New York.

81-83. From *Histoire de rats*, by Georges Bataille. Paris, 1947.

81. 82. 83.

114

85-91. From *Regards sur la peinture*, by Pierre Loeb. Paris, 1950.

84. COUPLE FACING EACH OTHER.
From *Poésie de mots inconnus*,
published by Iliazd. Paris, 1949.

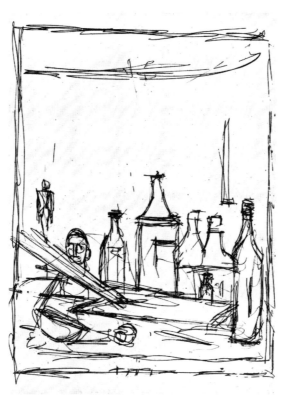

85. BOTTLES IN THE STUDIO
(*Bouteilles dans l'atelier*).

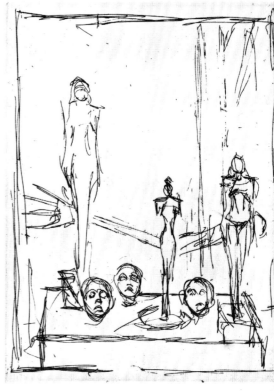

86. THE HAND (*La Main*).

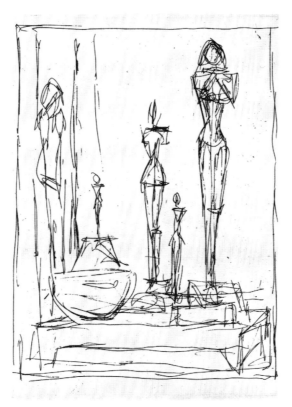

87. CHARACTERS IN THE STUDIO
I (*Personnages dans l'atelier I*).

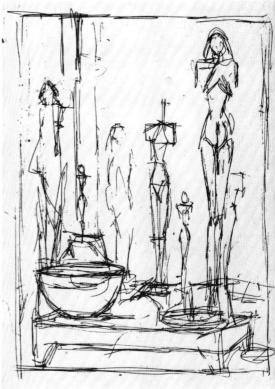

88. CHARACTERS IN THE STUDIO
II (*Personnages dans l'atelier II*).

89.

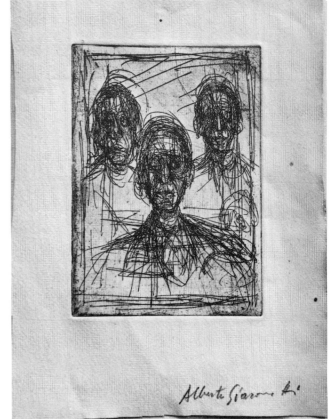

90.

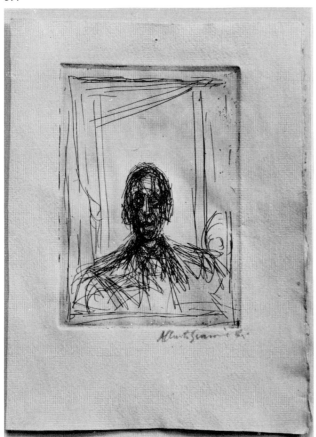

91.

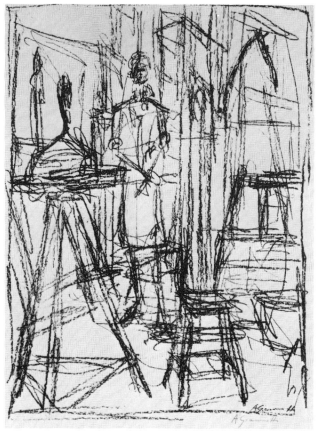

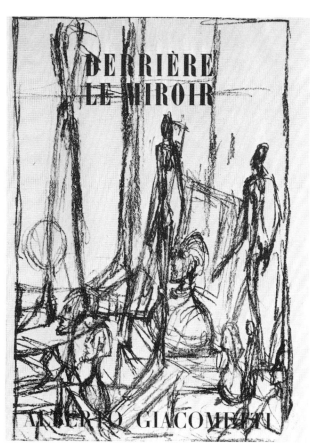

92. ANNETTE, HORSE, STOOL.

93. STANDING STATUES IN STUDIO.

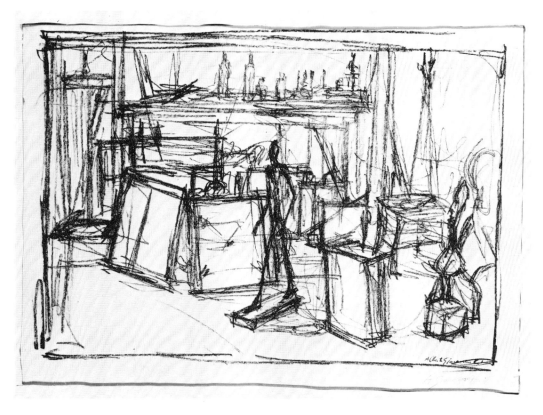

94. MAN WALKING IN THE STUDIO.

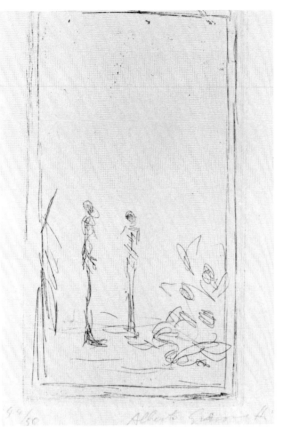

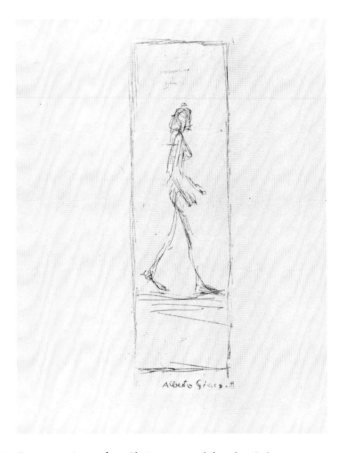

95. From *Poèmes des deux années, 1953-1954,* by René Char. Paris, 1955.

96. *Femme qui marche.* Christmas card for the Galerie Maeght. 1955.

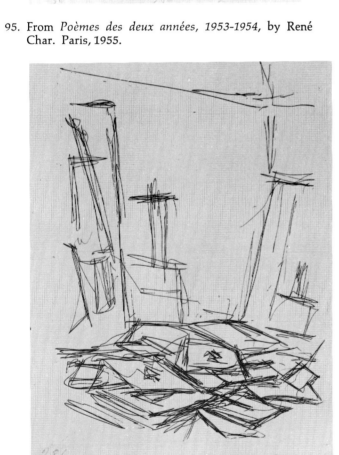

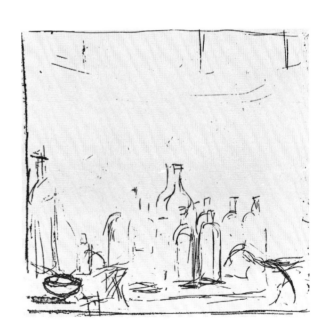

97. From *Le Moteur blanc,* by André Du Bouchet. Paris, 1956.

98. From *Un Poème dans chaque livre,* by Paul Eluard. Paris, 1956.

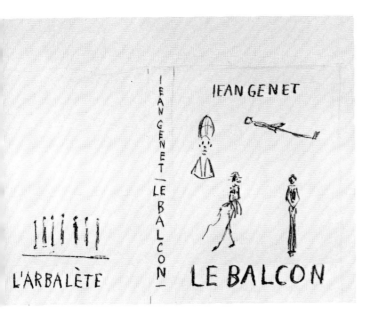

99. From *Le Balcon,* by Jean Genet. Décines, 1956.

101. MAN STANDING *(Homme debout).*

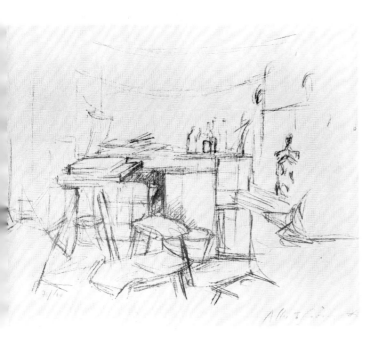

100. THE STUDIO WITH BOTTLES *(L'Atelier aux bouteilles).*

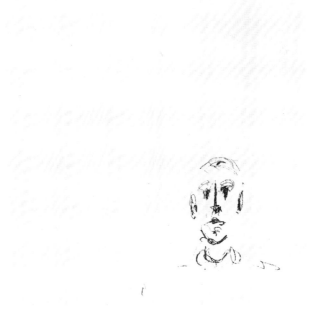

102. HEAD OF MAN *(Tête d'homme).*

ILLUSTRATED BOOKS

103. From *La Folie Tristan,* by Gilbert Lély. Paris, 1959.

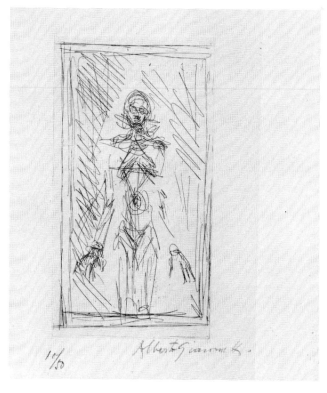

104-105. From *Catalogue Kornfeld & Klipstein.* Bern, 1959.

104. SMALL STANDING NUDE *(Petit Nu debout).*

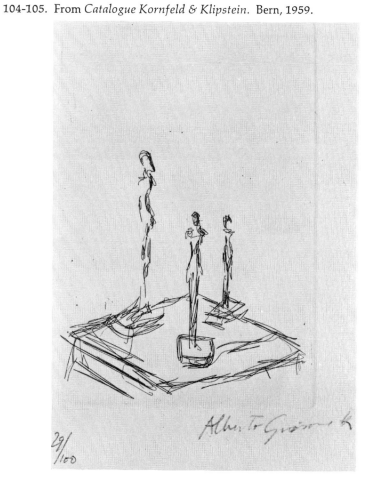

105. THREE FIGURINES *(Trois Figurines).*

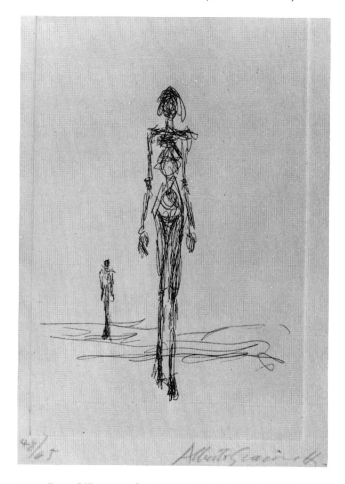

106. From *L'Epervier,* by Jacques Dupin. Paris, 1960.

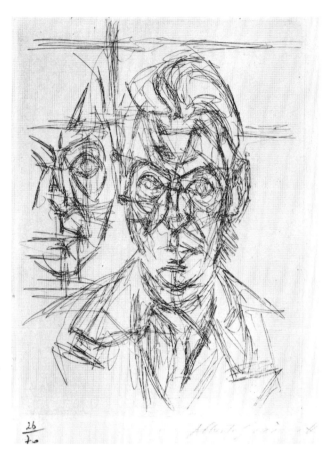

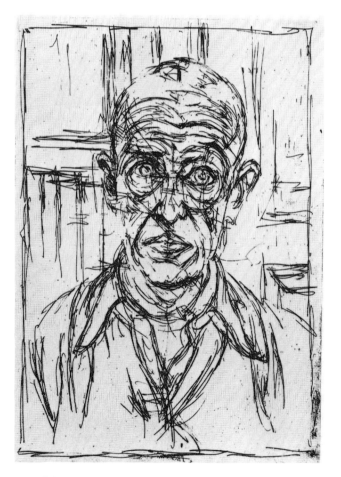

108-126. From *Vivantes Cendres, innomées,* by Michel Leiris. Paris, 1961.

107. From *Dans la chaleur vacante,* by André Du Bouchet. Paris, 1961.

108. HEAD OF A MAN.

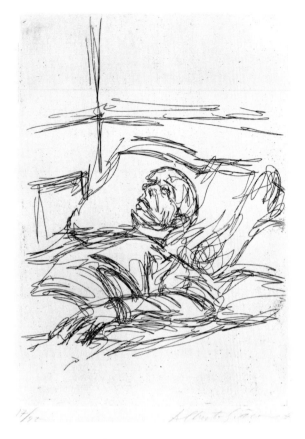

109. MAN IN BED I.

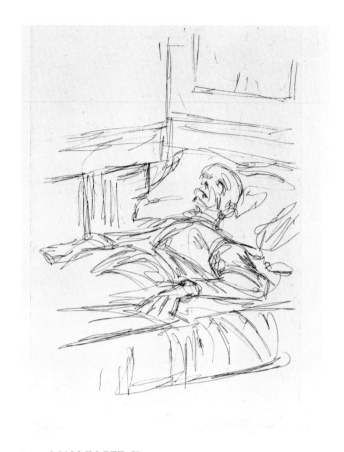

110. MAN IN BED II.

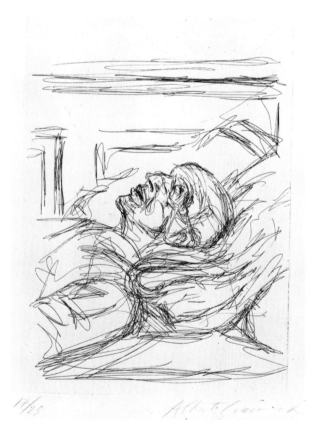

111. MAN IN BED III.

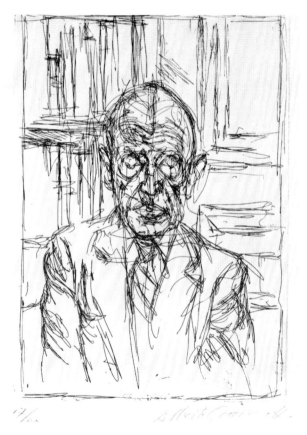

112. HEAD OF A MAN.

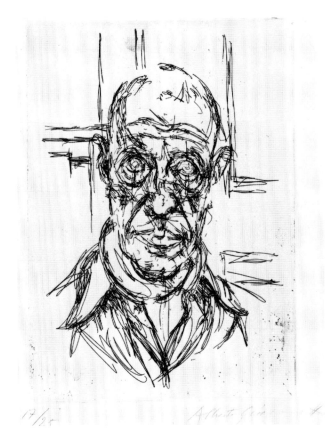

113. HEAD OF A MAN.

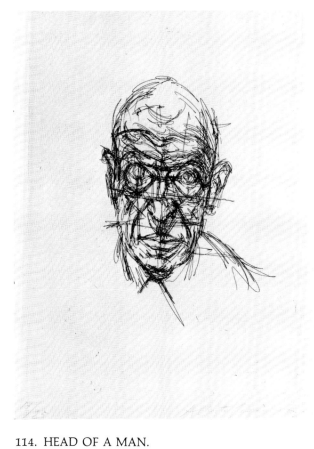

114. HEAD OF A MAN.

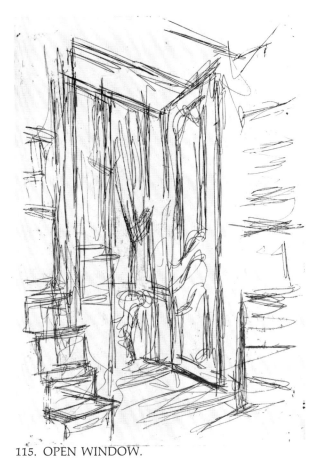

115. OPEN WINDOW.

116. BAROQUE DETAIL.

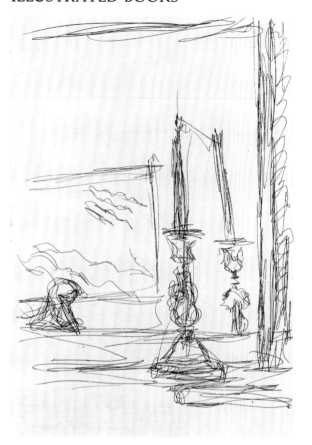

117. CANDLESTICK AND MIRROR.

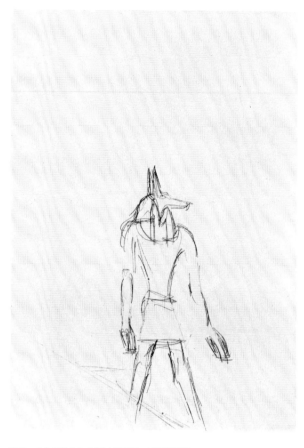

118. JACKAL-HEADED ANUBIS.

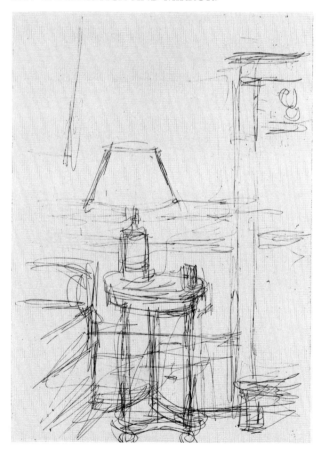

119. LAMP AND TABLE.

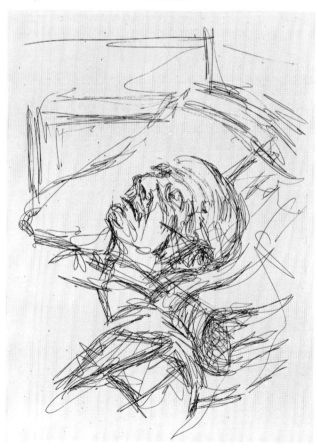

120. RECLINING HEAD OF A MAN.

121. ROOM INTERIOR.

122. DETAIL.

123. ROOM INTERIOR WITH TABLE.

124. ROOM INTERIOR WITH CHAIR.

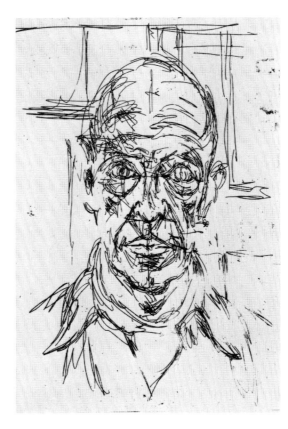

125. HEAD OF A MAN.

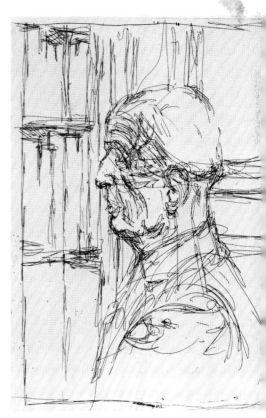

126. PROFILE OF A MAN.

128-147. From *Pomme endormie*, by Léna Leclercq. Décines, 1961.

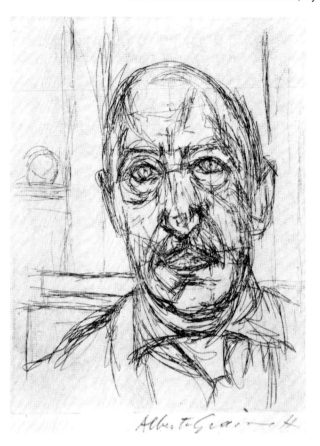

127. From *Sentence sans paroles*,
published by Iliazd. Paris, 1961.

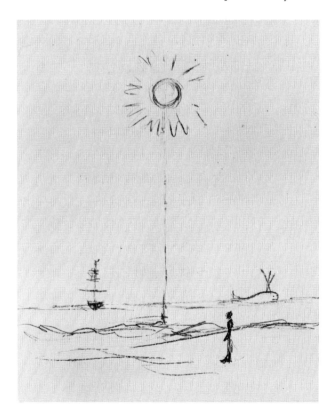

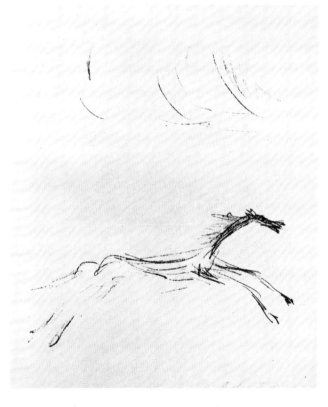

128. WHALE, SUN, SHIP, AND STANDING MAN
(*Baleine, soleil, bateau, homme debout*).

129. GALLOPING HORSE (*Cheval galoppant*).

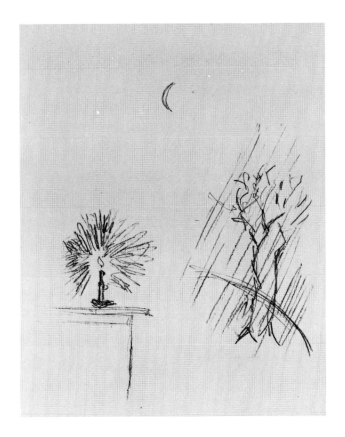

130. THE CANDLE *(La Bougie)*.

131. SLEEPING APPLE *(Pomme endormie)*.

132. THREE APPLES *(Trois Pommes)*.

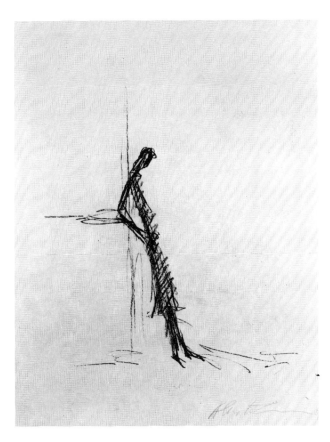

133. LEANING WOMAN *(Femme s'appuyante)*.

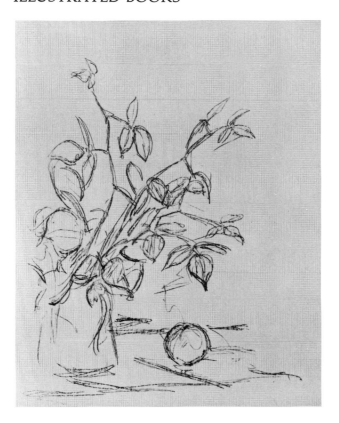

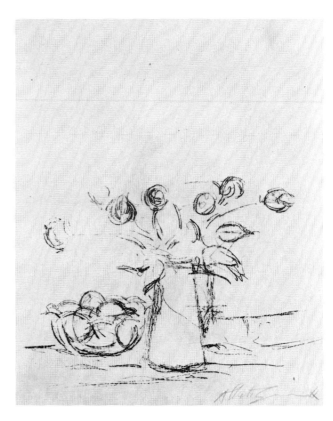

134. BOUQUET AND APPLE *(Bouquet et pomme).*

135. BOUQUET AND BOWL OF FRUIT *(Bouquet et bol de fruits).*

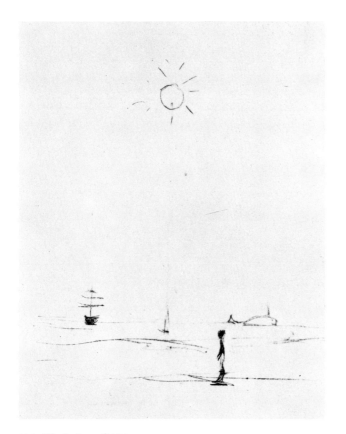

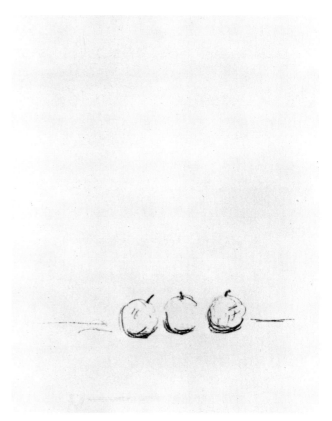

136. Variation of 128.

137. Variation of 132.

138. EYE AND TREE (*Oeil et arbre*).

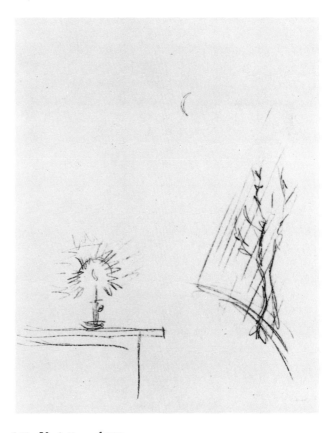

139. LANDSCAPE WITH FIGURES (*Paysage avec figures*).

140. Variation of 139.

141. Variation of 130.

142. COUPLE SEARCHING FOR EACH OTHER (*Couple se cherchant*).

143. Variation of 135.

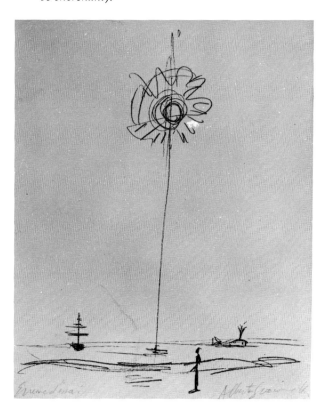

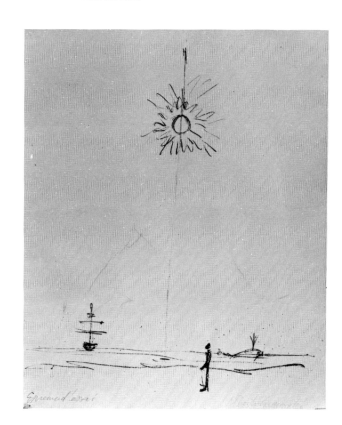

144. First trial proof of 128.

145. Second trial proof of 128.

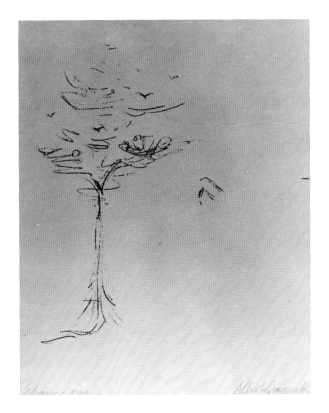

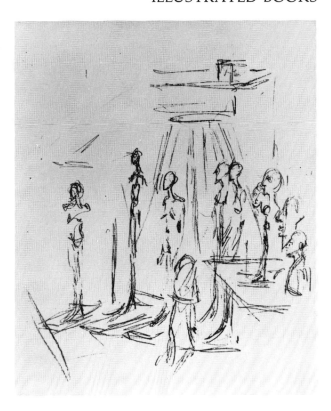

146. Trial proof of 138.

147. BUSTS, SCULPTURES STANDING IN THE STU-
DIO *(Bustes, sculptures debout dans l'atelier)*.

148-161. From *Derrière le miroir*, no. 127. Text by Isaku Yanaihara and others. Paris, 1961.

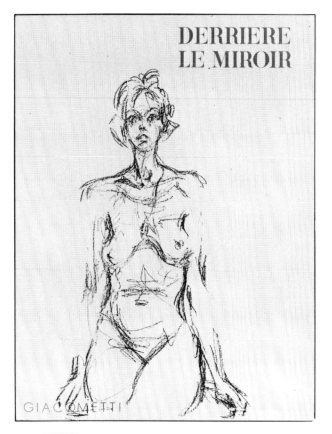

148. NUDE.

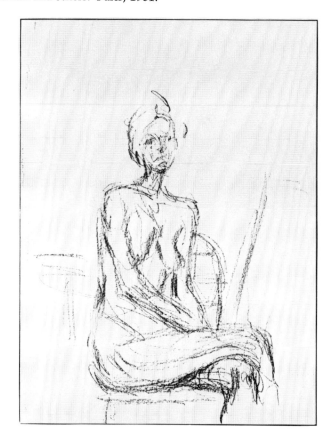

149. NUDE IN PROFILE.

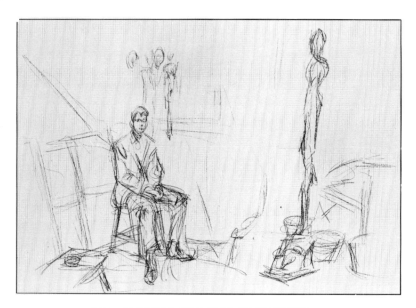

150. SEATED MAN AND SCULPTURE.

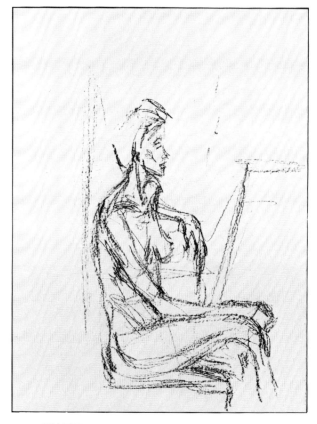

151. SEATED NUDE.

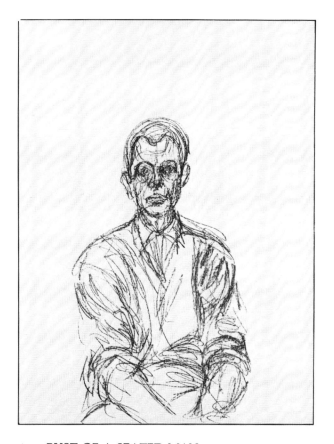

152. BUST OF A SEATED MAN.

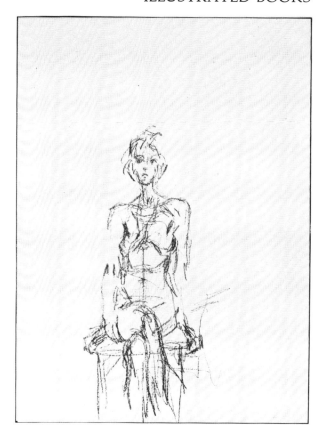

153. SEATED NUDE.

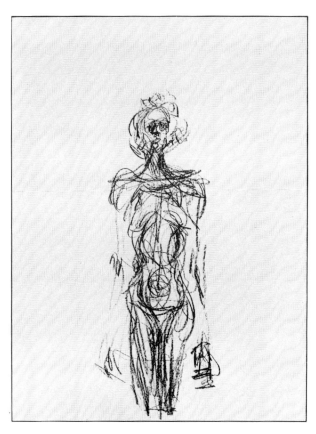

154. NUDE.

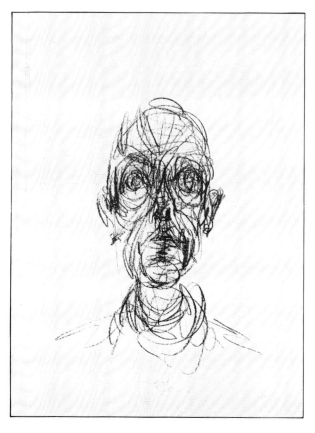

155. HEAD OF A MAN.

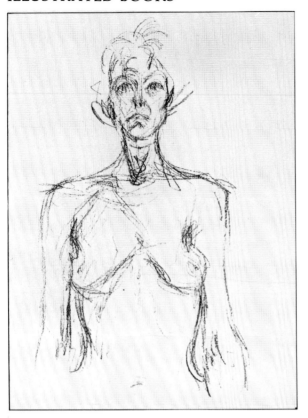

156. BUST OF A NUDE.

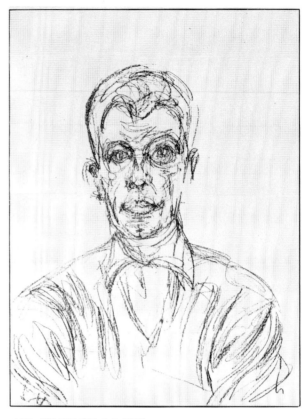

157. HEAD OF A MAN.

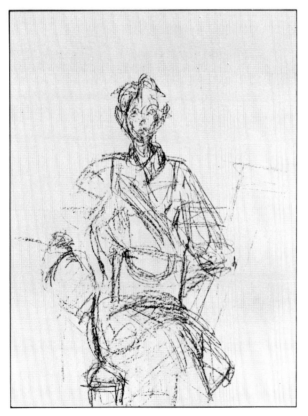

158. SEATED FIGURE.

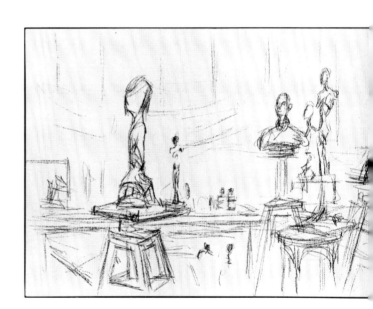

159. STUDIO WITH SCULPTURES.

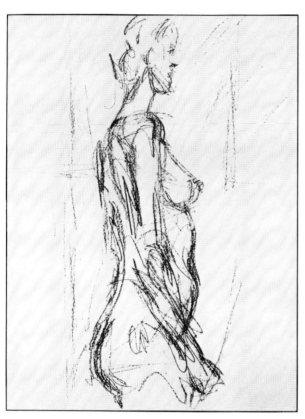

160. NUDE IN PROFILE.

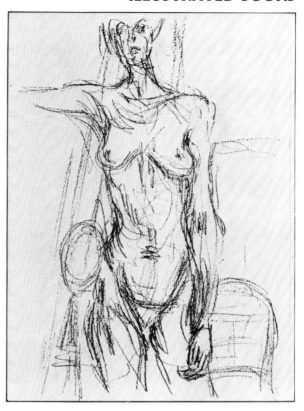

161. NUDE.

162-173. From *Les Douze Portraits du célèbre Orbandale*, published by Iliazd. Paris, 1962.

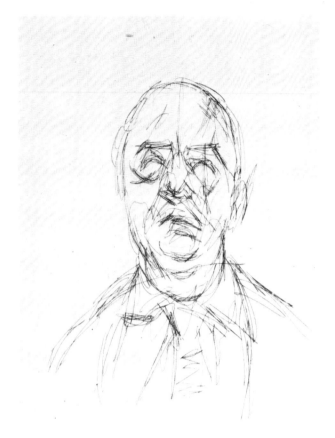

162.

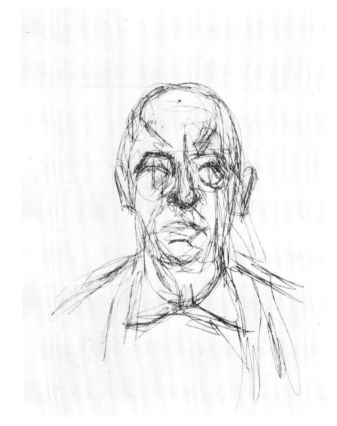

163.

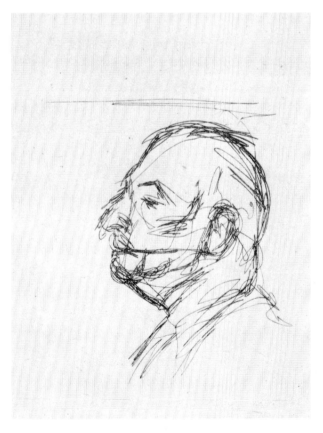

164.

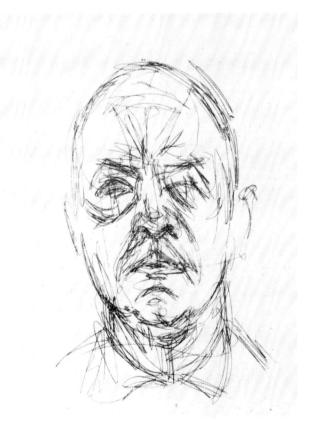

165.

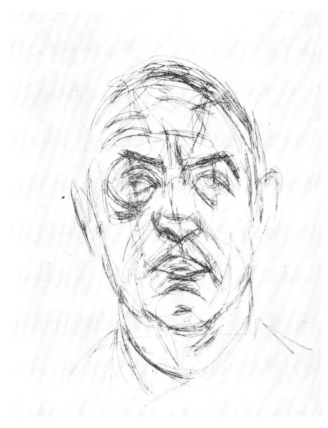

166.

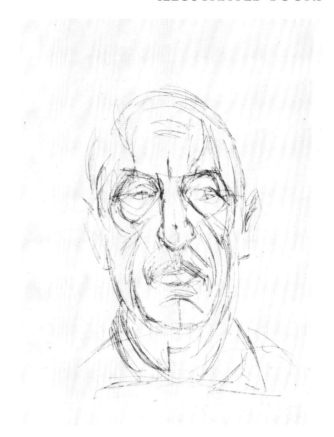

167.

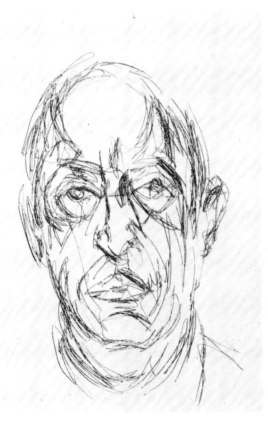

168.

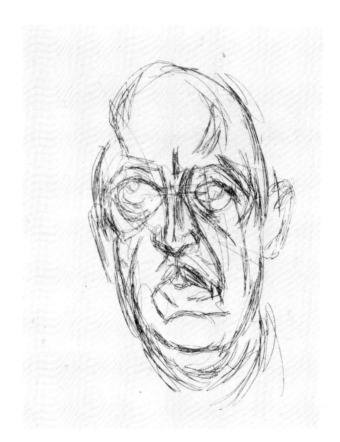

169.

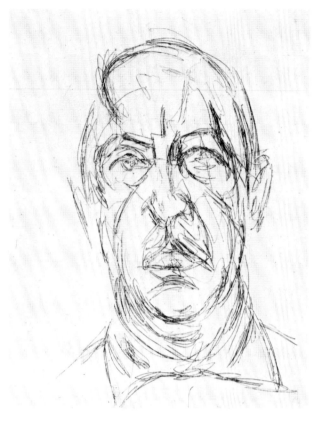

170.

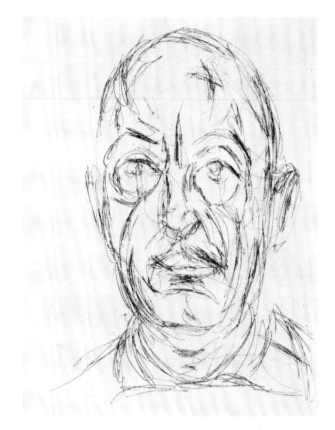

171.

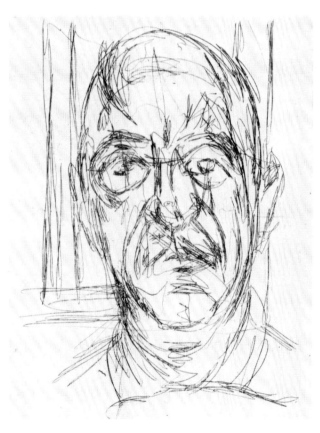

172.

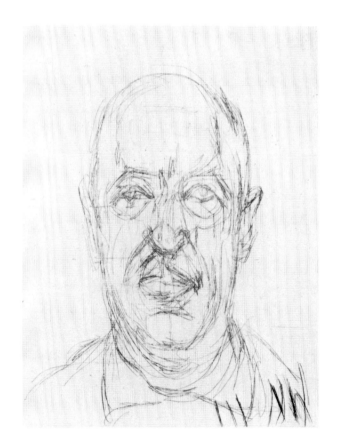

173.

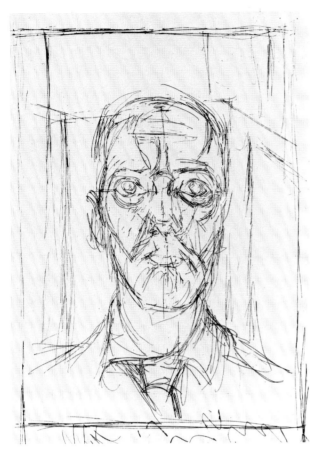

174. From *La Danse du Château,* by Miguel de Cervantes. Paris, 1962.

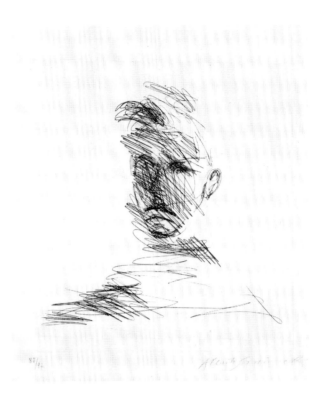

175. From *Rimbaud vu par les peintres.* Paris, 1962.

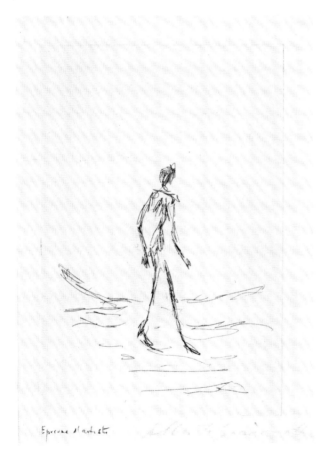

176. From *Bibliographie des oeuvres de René Char de 1928 à 1963,* by Pierre-André Benoit. Ribaute-les-Tavernes, 1964.

177-183. From *La Double Vue,* by Robert Lebel. Paris, 1964.

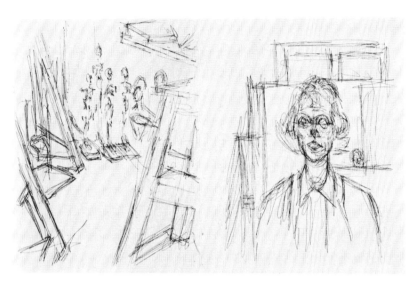

177. STUDIO WITH ANNETTE (DIPTYCH).

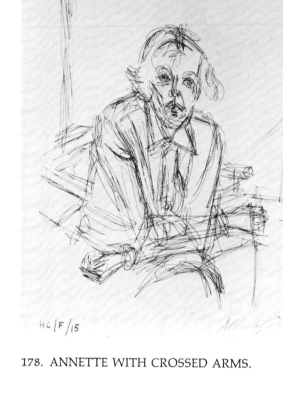

178. ANNETTE WITH CROSSED ARMS.

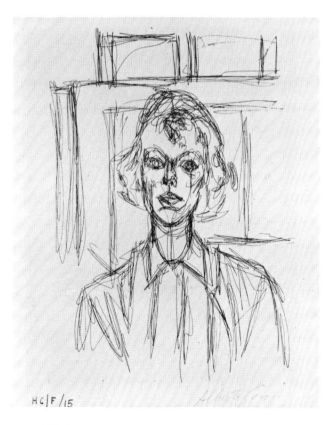

179. ANNETTE I.

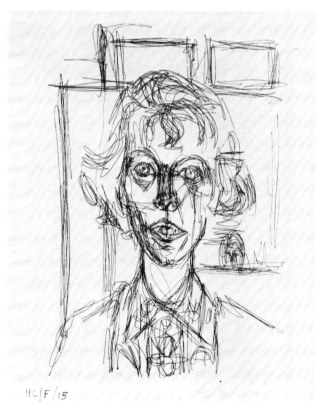

180. ANNETTE II.

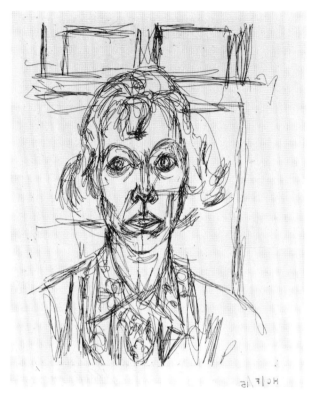

181. ANNETTE III.

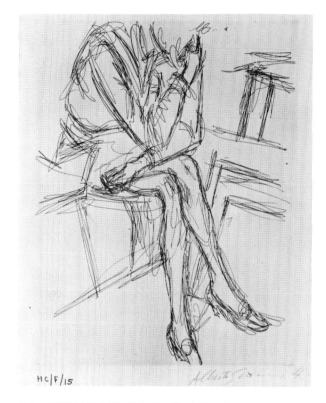

182. WOMAN WITH CROSSED LEGS.

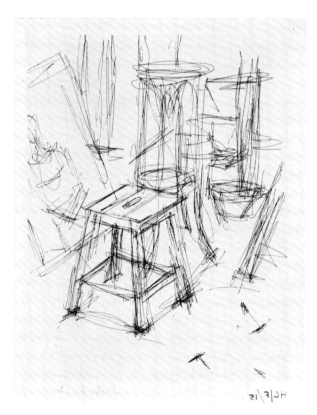

183. STOOL AND PICTURE.

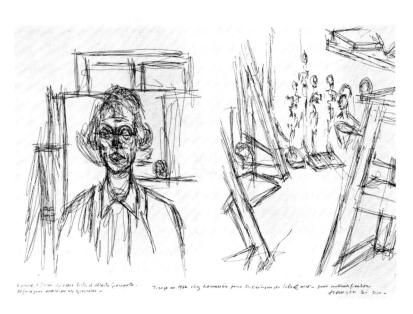

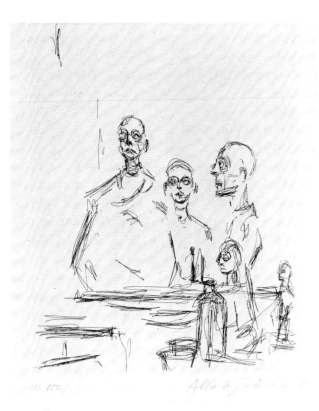

184. From *La Double Vue*.

185. From *Catalogue Galerie Beyeler*. Basel, 1964.

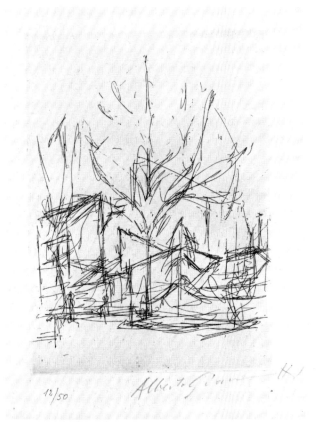

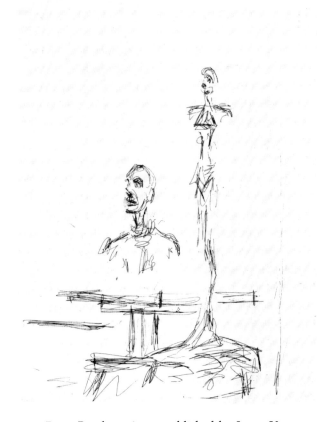

186. From *Feuilles éparses*, by René Crevel. Paris, 1965.

187. From *Paroles peintes*, published by Lazar-Vernet. Paris, 1965.

188-191. From *Retour Amont*, by René Char. Paris, 1965.

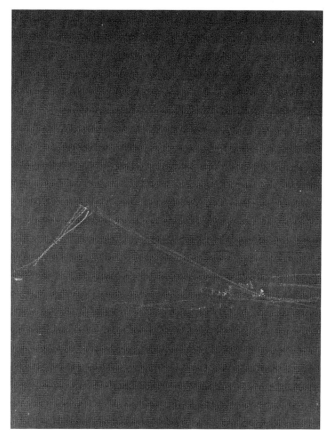

188.

189.

190.

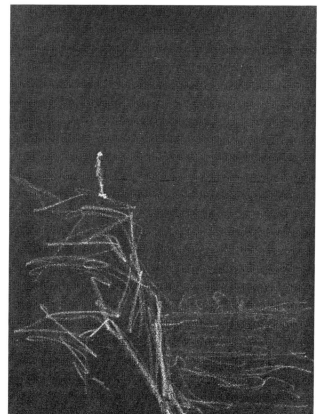

191.

192-193. From *La Magie quotidienne.* Paris, 1966.

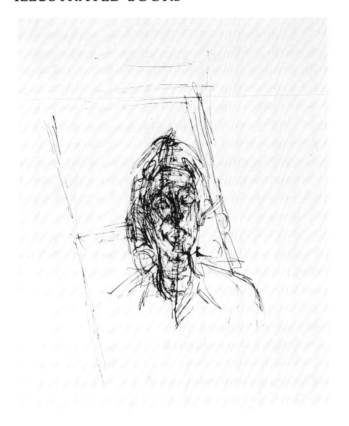

192. YOUNG WOMAN.

193. FIGURINES IN THE STUDIO (*Figurines dans l'atelier*).

194-199. From *L'Inhabité,* by André Du Bouchet. Paris, 1967.

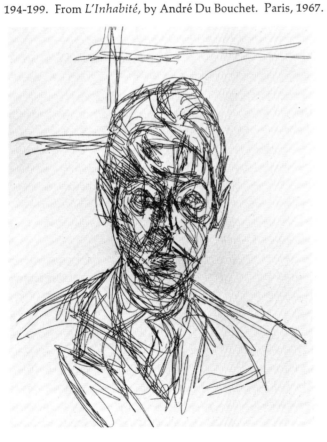

194. HEAD OF A MAN.

195. ROADWAY.

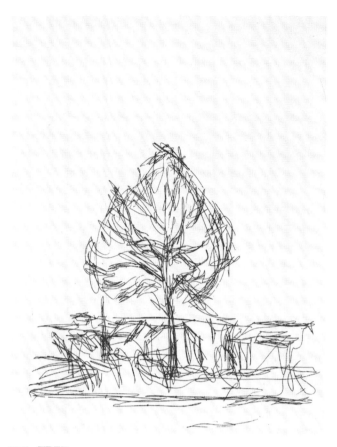

196. TREE.

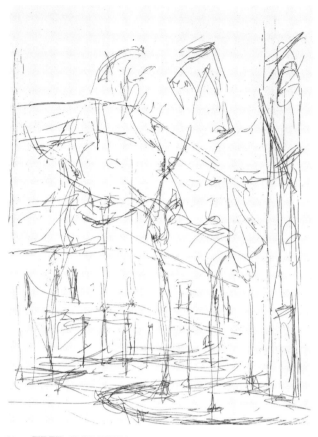

197. TREE AND BUILDINGS.

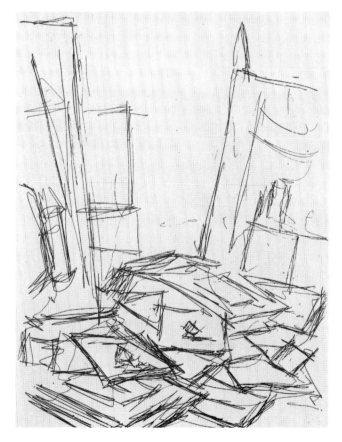

198. PILED-UP PICTURES.

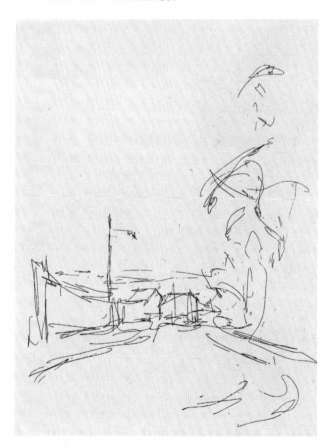

199. ROADWAY.

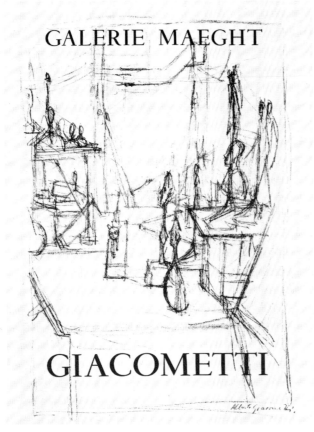

200. SCULPTURES IN THE STUDIO. Paris, 1951.

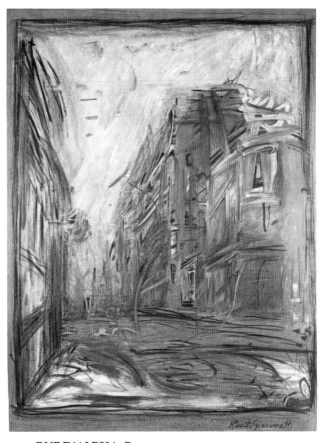

201. RUE D'ALESIA. Paris, 1954.

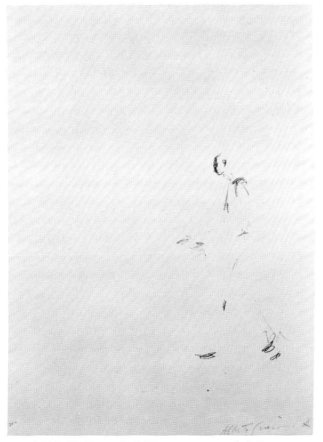

202. MAN WALKING (*L'Homme qui marche*). Paris, 1957.

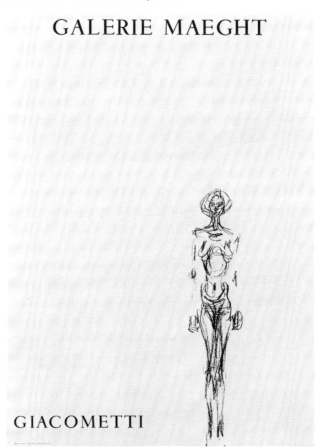

203. WOMAN STANDING (*Femme debout*). Paris, 1961.

Paris Sans Fin

(Catalogue items 204-353. Numbers in parentheses
are plate numbers used in the book.)

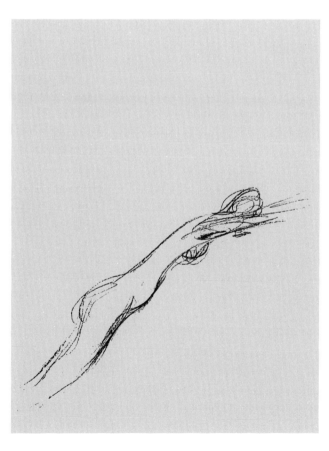

204. *Frontispiece*

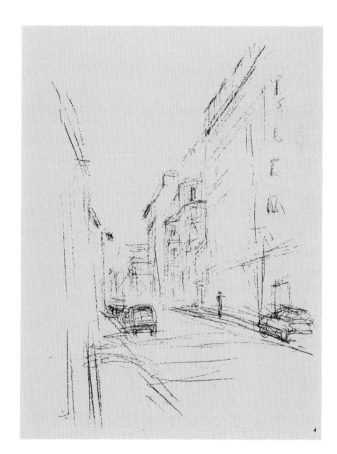

205. (1)

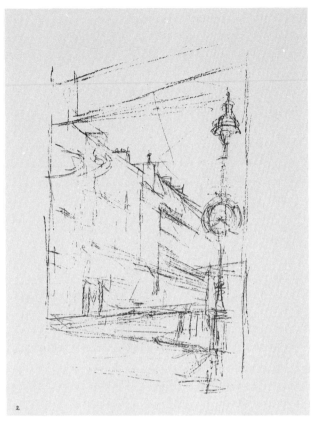

206. (2)

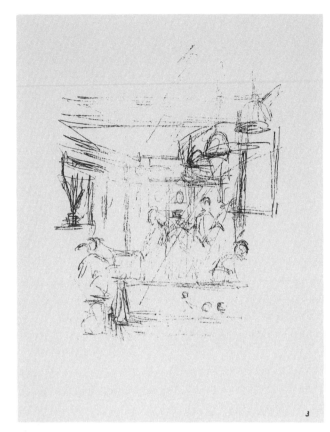

207. (3)

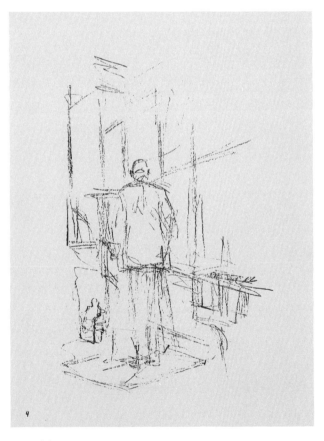

208. (4)

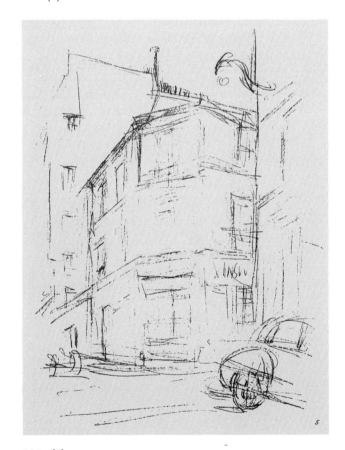

209. (5)

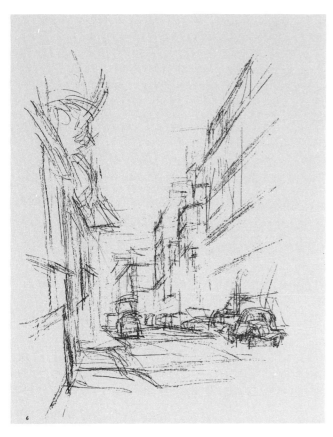

210. (6)

211. (7)

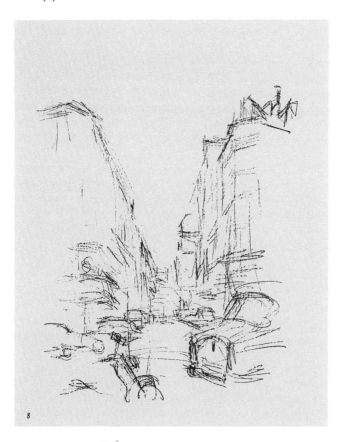

212. (8)

213. (9)

214. (10)

215. (11)

216. (12)

217. (13)

218. (14)

219. (15)

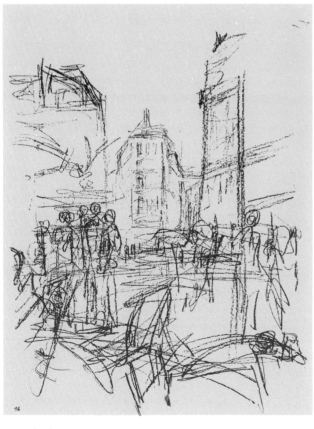

220. (16)

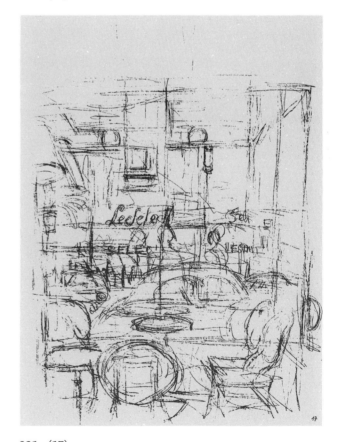

221. (17)

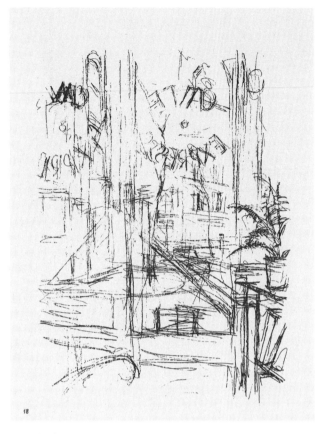

222. (18)

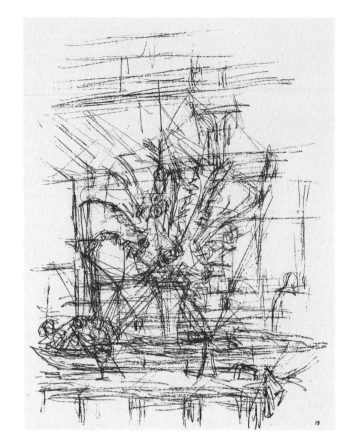

223. (19)

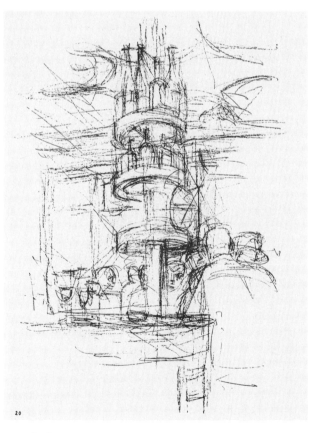

224. (20)

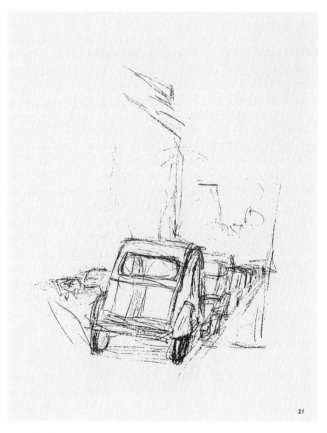

225. (21)

226. (22)

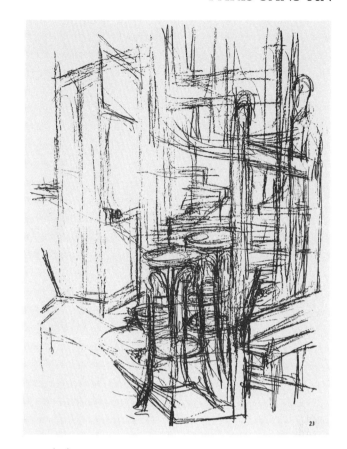

227. (23)

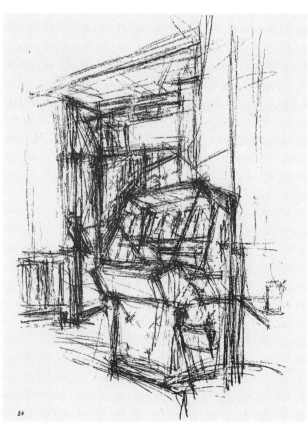

228. (24)

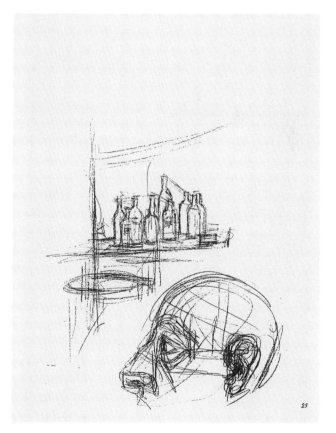

229. (25)

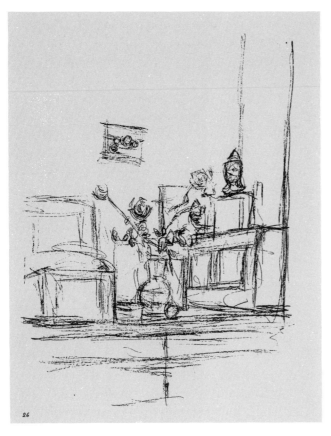

230. (26)

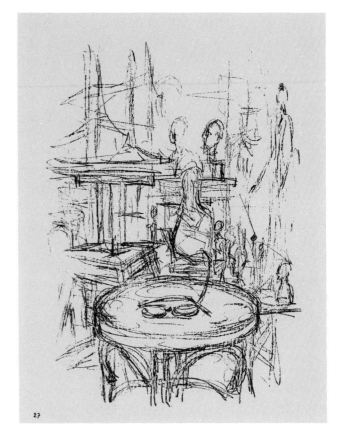

231. (27)

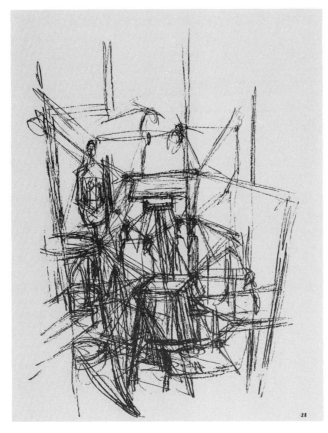

232. (28)

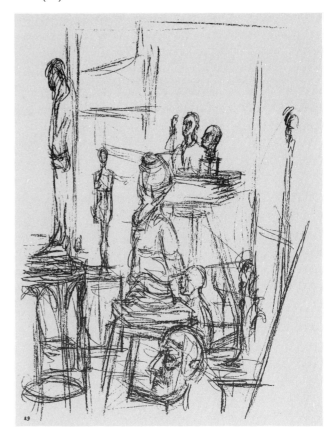

233. (29)

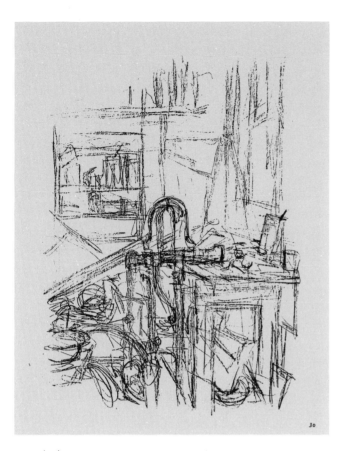

234. (30)

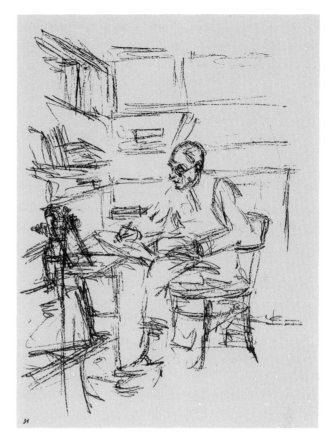

235. (31)

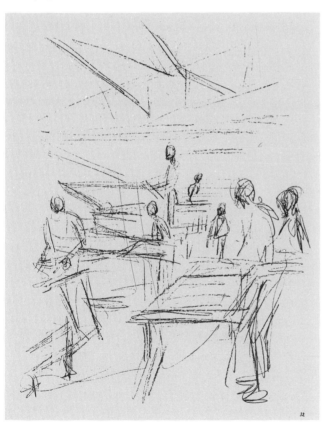

236. (32)

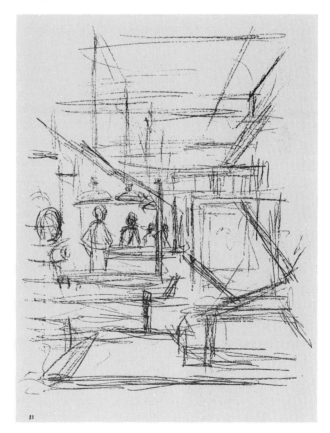

237. (33)

238. (34)

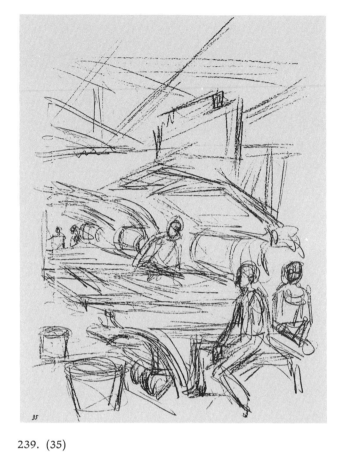

239. (35)

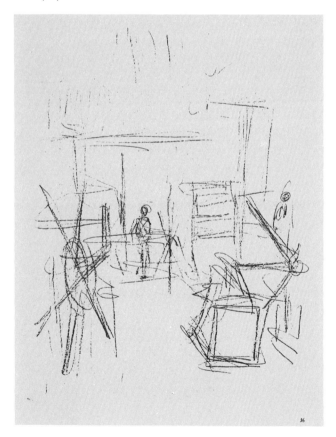

240. (36)

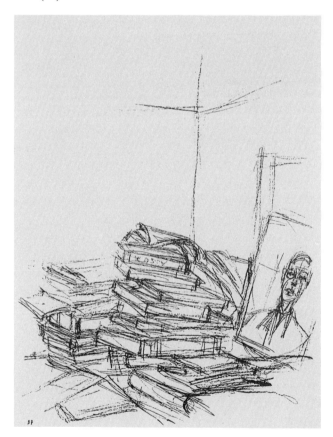

241. (37)

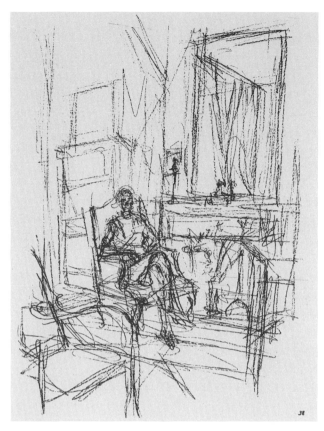

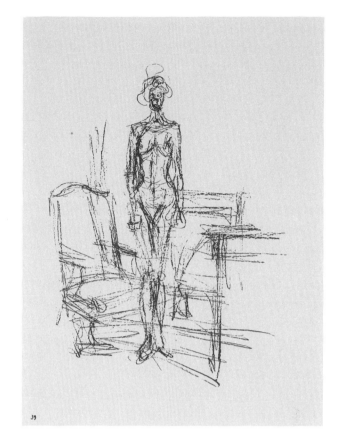

242. (38)

243. (39)

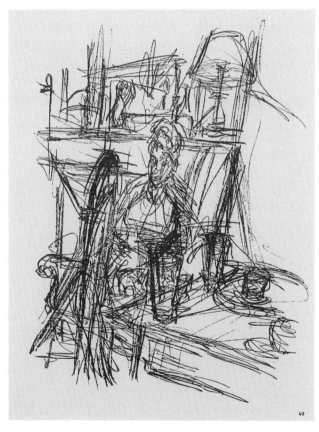

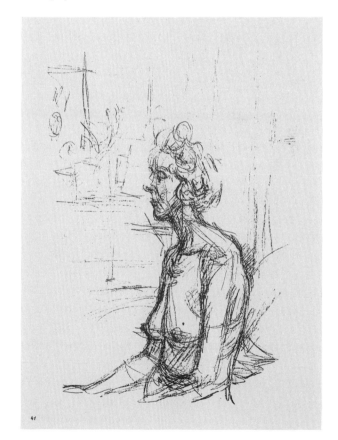

244. (40)

245. (41)

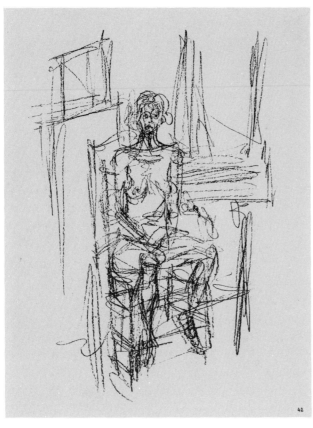

246. (42)

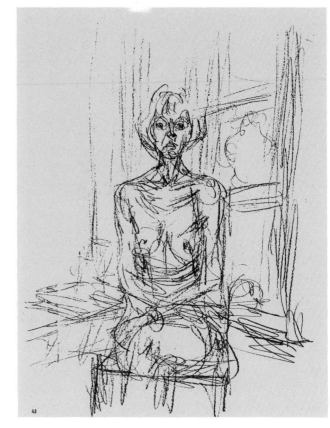

247. (43)

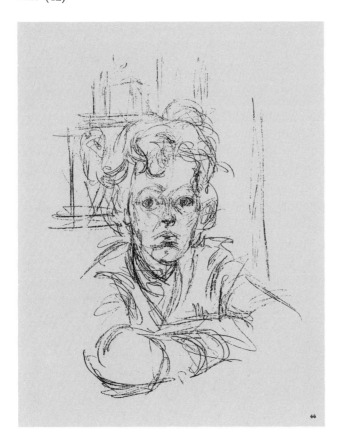

248. (44)

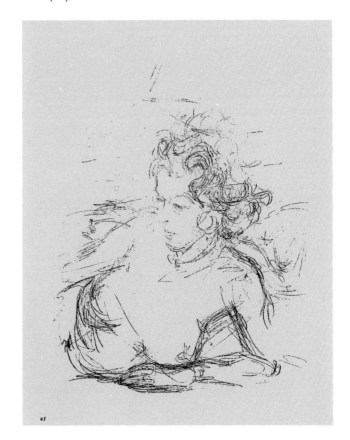

249. (45)

250. (46)

251. (47)

252. (48)

253. (49)

254. (50)

255. (51)

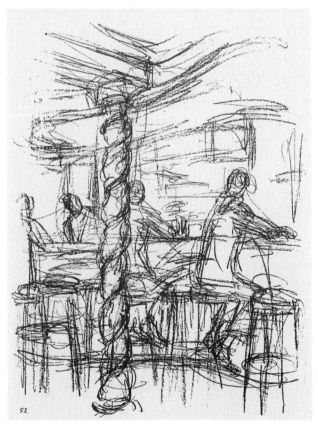

256. (52)

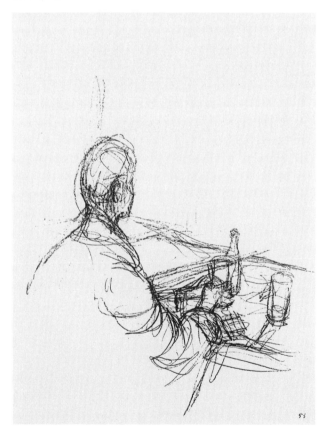

257. (53)

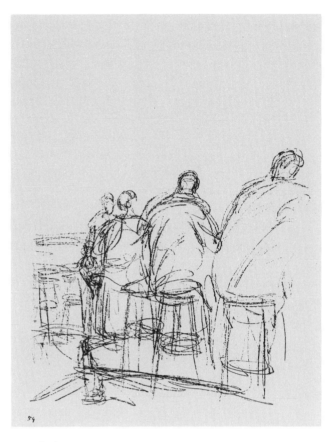

258. (54)

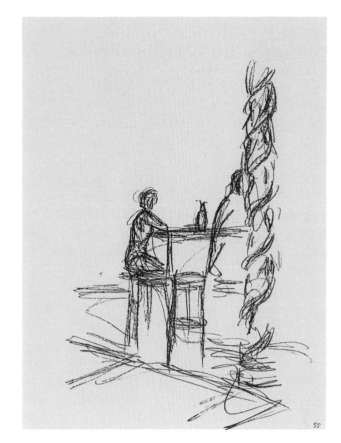

259. (55)

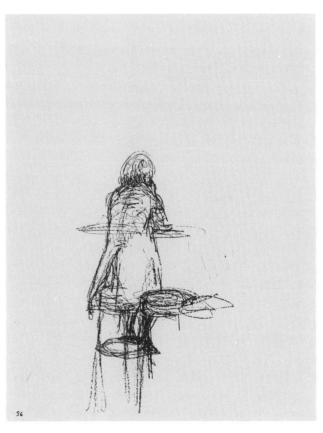

260. (56)

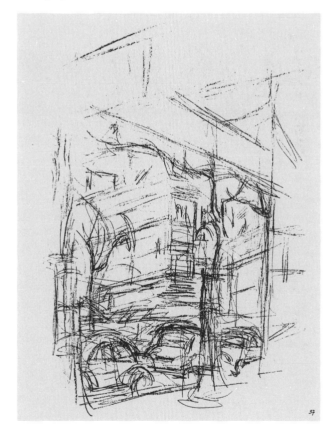

261. (57)

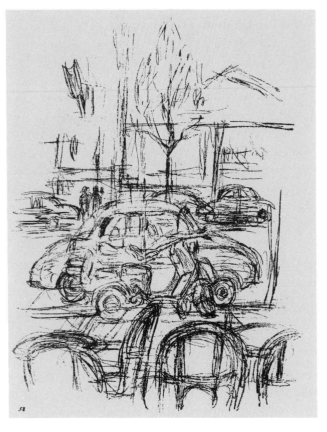

262. (58)

263. (59)

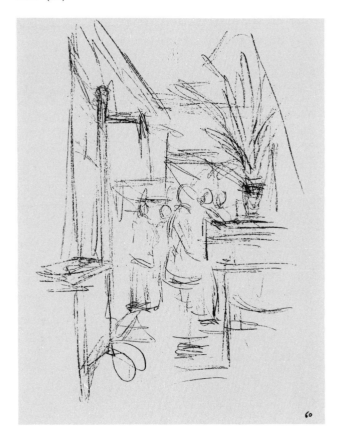

264. (60)

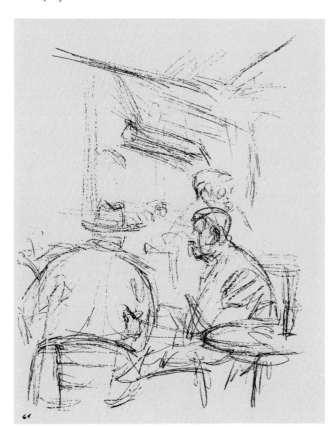

265. (61)

266. (62)

267. (63)

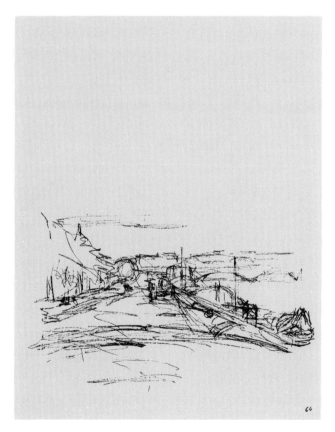

268. (64)

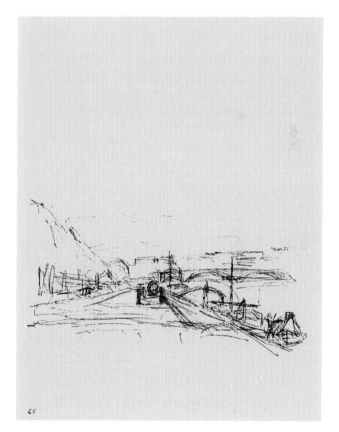

269. (65)

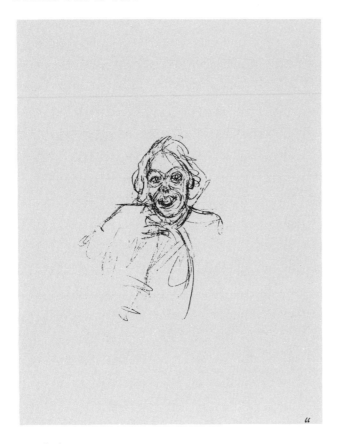

270. (66)

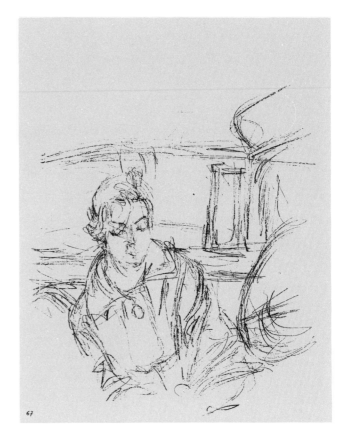

271. (67)

272. (68)

273. (69)

274. (70)

275. (71)

276. (72)

277. (73)

278. (74)

279. (75)

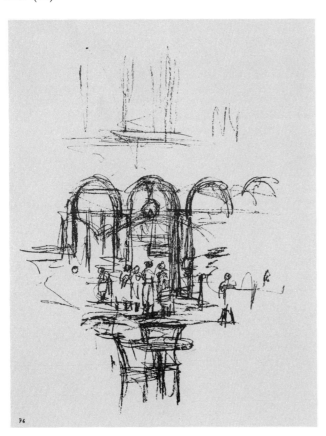

280. (76)

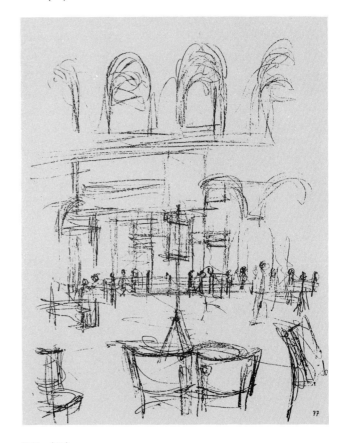

281. (77)

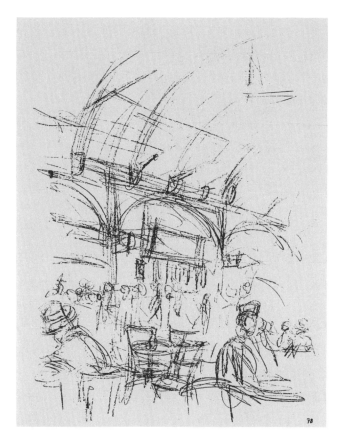

282. (78)

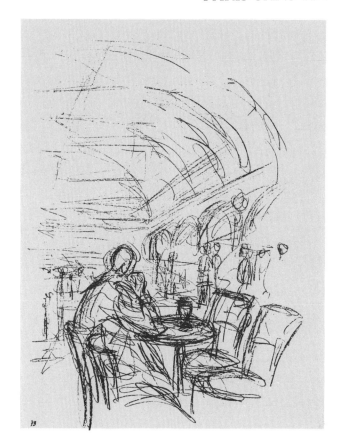

283. (79)

284. (80)

285. (81)

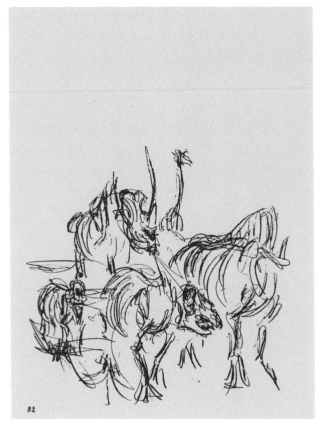

286. (82)

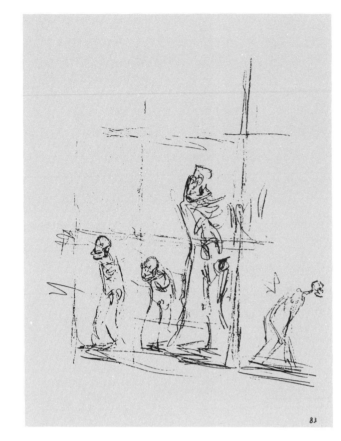

287. (83)

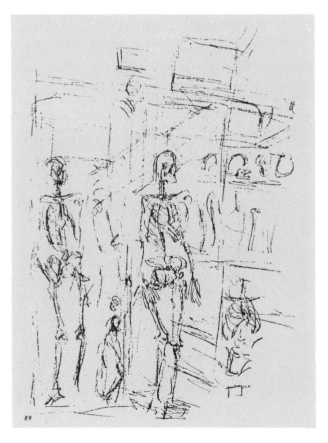

288. (84)

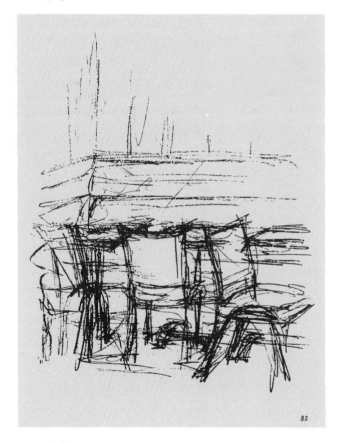

289. (85)

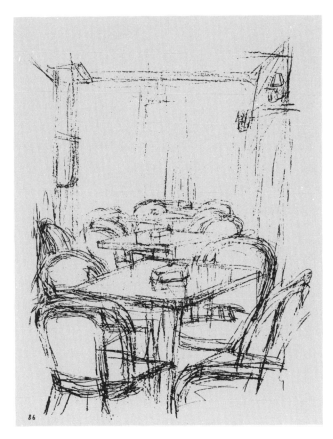

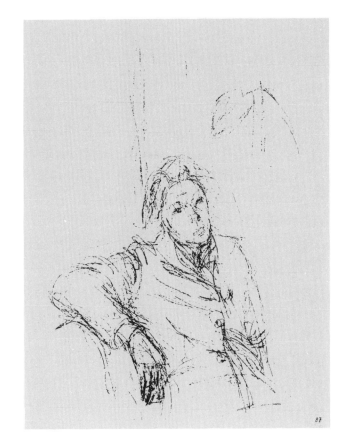

290. (86)

291. (87)

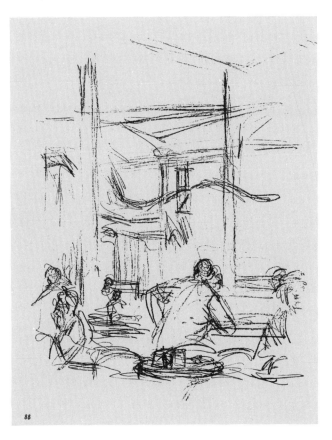

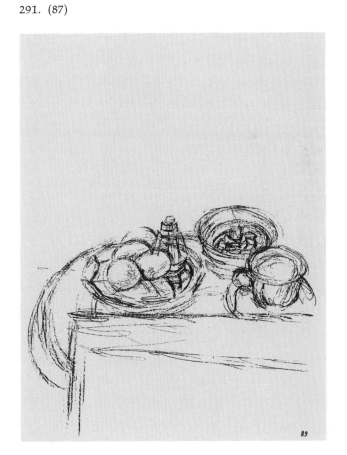

292. (88)

293. (89)

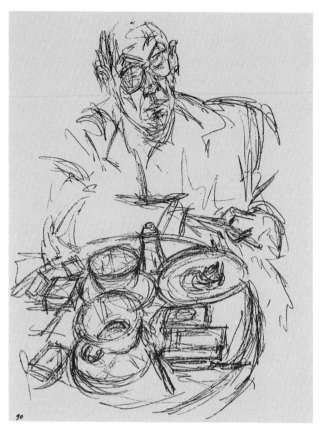

294. (90)

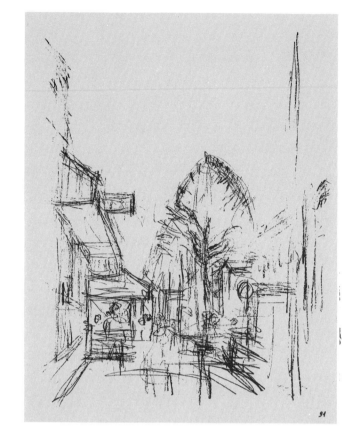

295. (91)

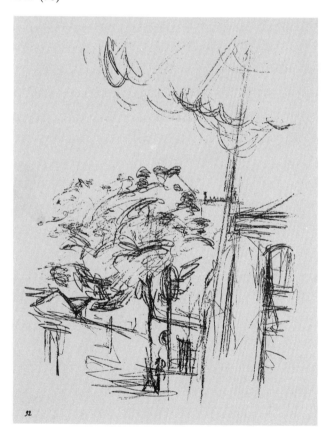

296. (92)

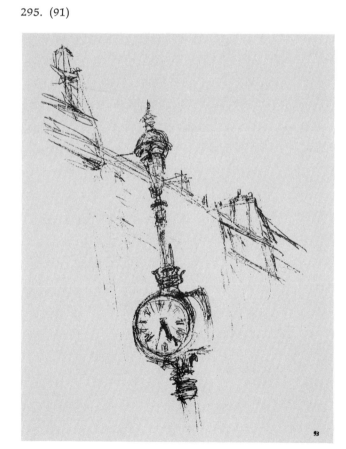

297. (93)

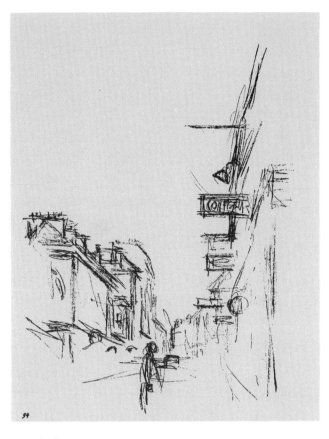

298. (94)

299. (95)

300. (96)

301. (97)

302. (98)

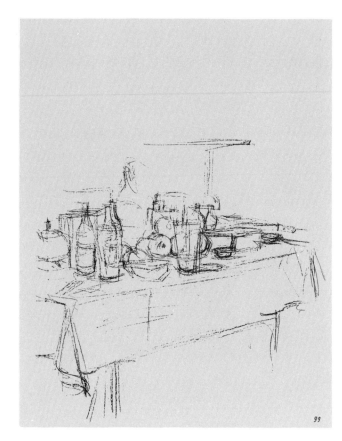

303. (99)

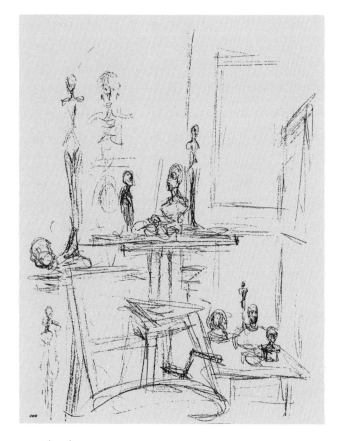

304. (100)

305. (101)

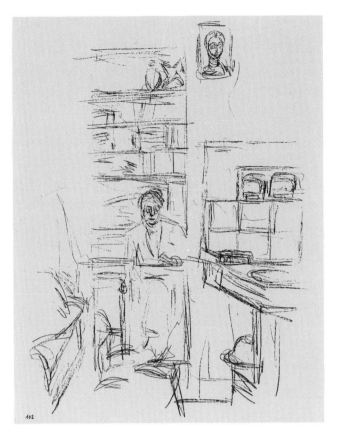

306. (102)

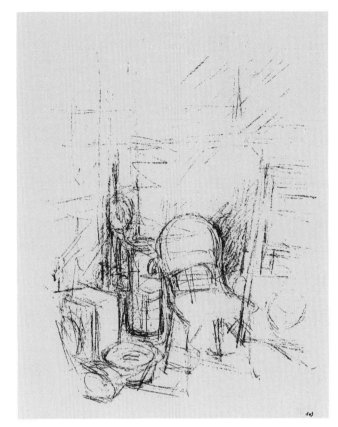

307. (103)

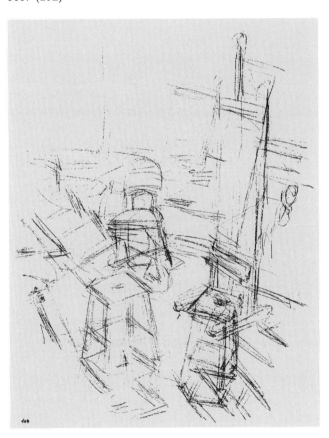

308. (104)

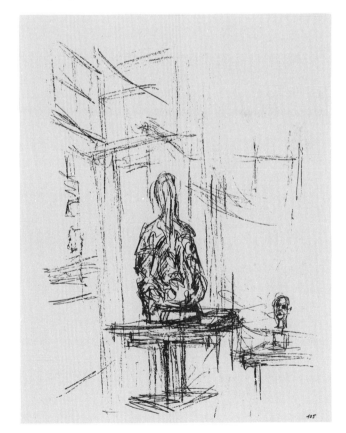

309. (105)

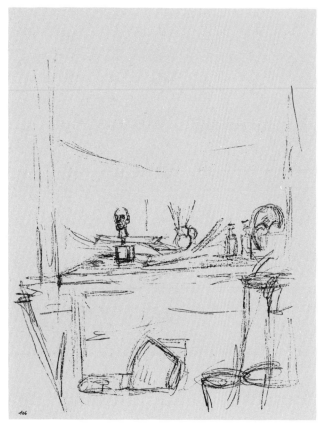

310. (106)

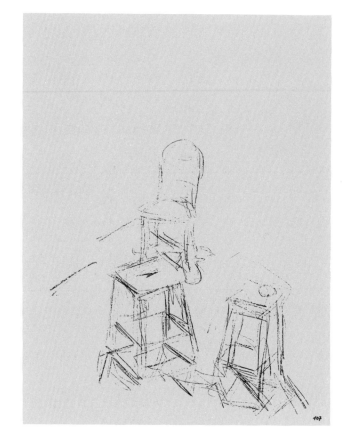

311. (107)

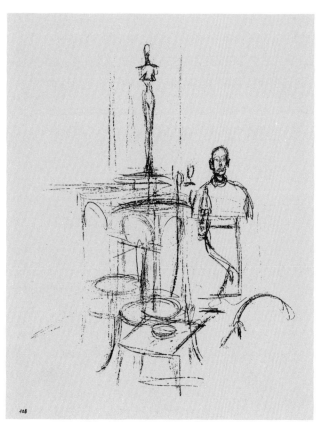

312. (108)

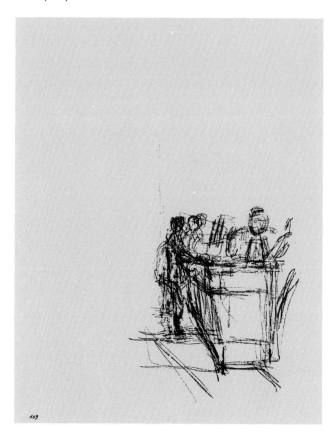

313. (109)

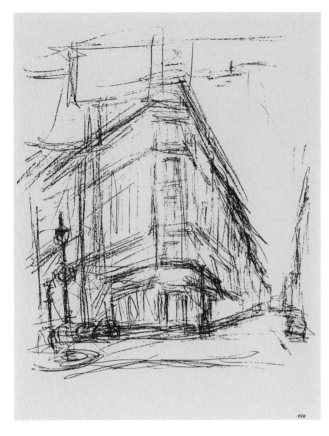

314. (110)

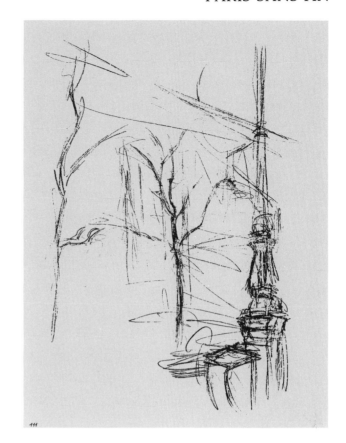

315. (111)

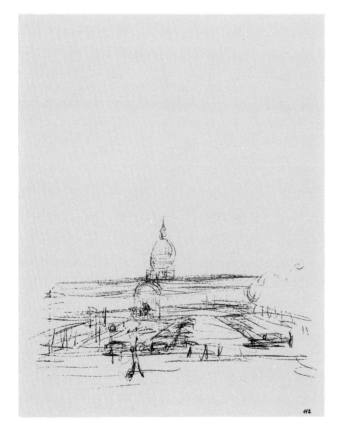

316. (112)

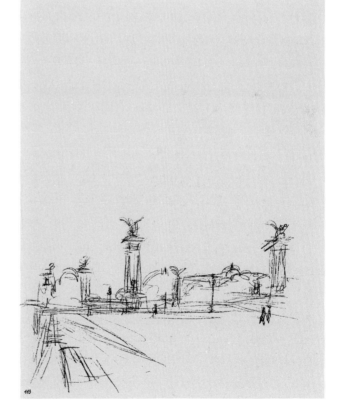

317. (113)

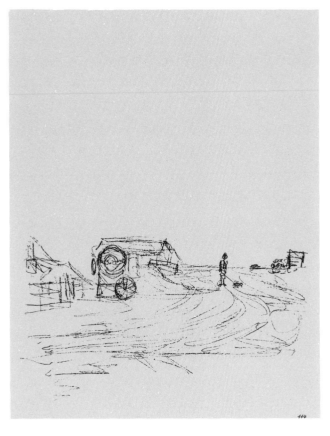

318. (114)

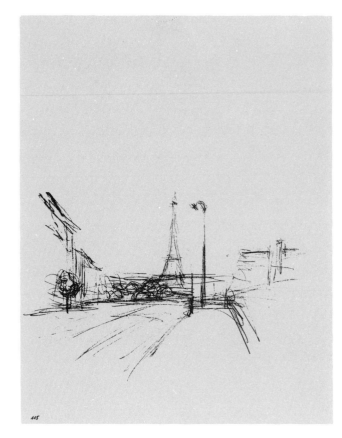

319. (115)

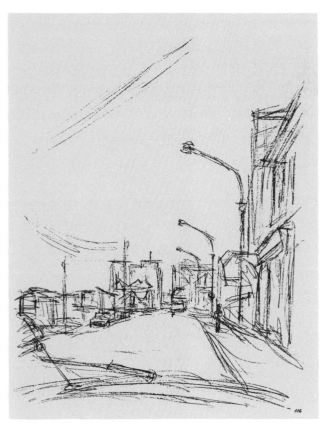

320. (116)

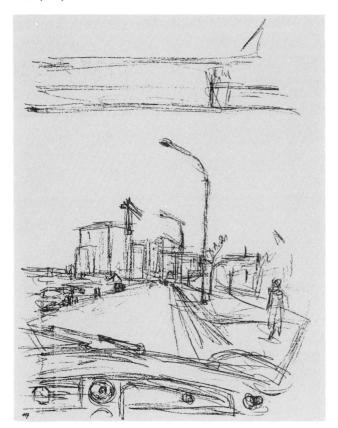

321. (117)

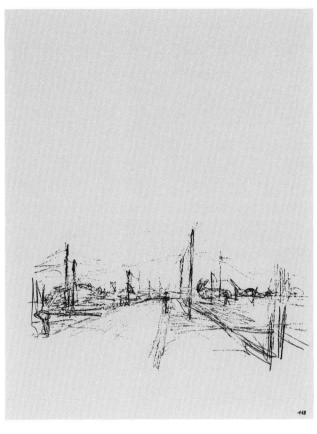

322. (118)

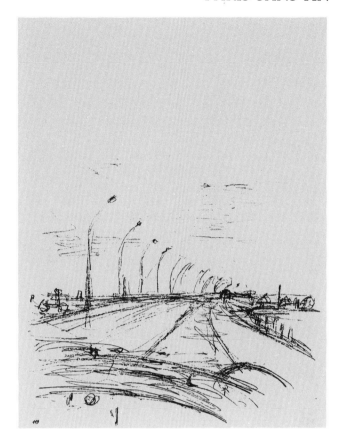

323. (119)

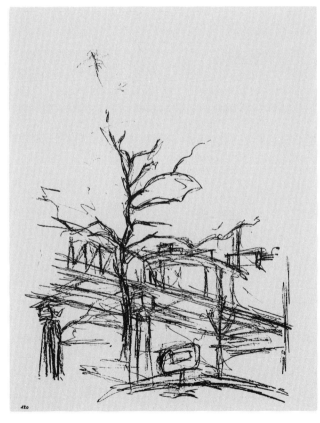

324. (120)

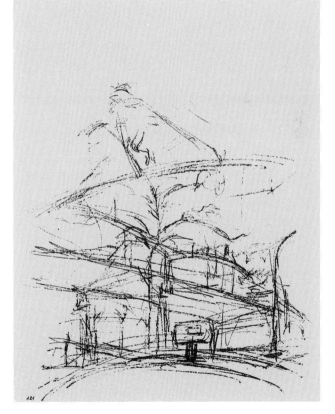

325. (121)

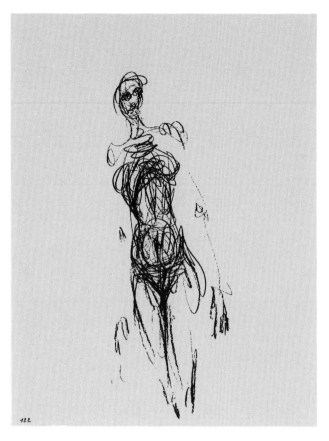

326. (122)

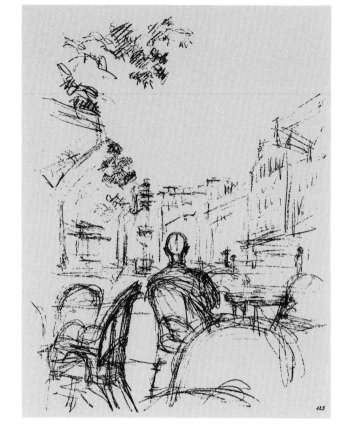

327. (123)

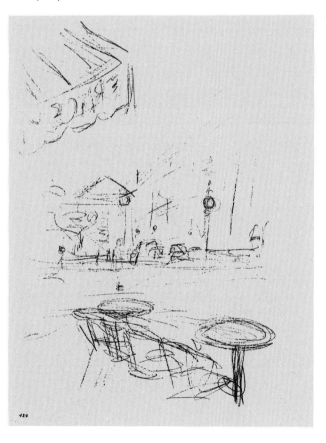

328. (124)

329. (125)

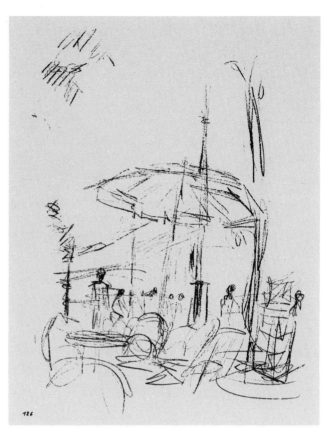

330. (126)

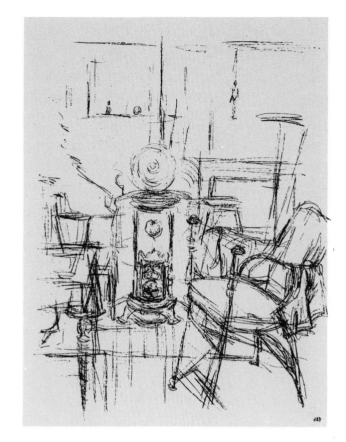

331. (127)

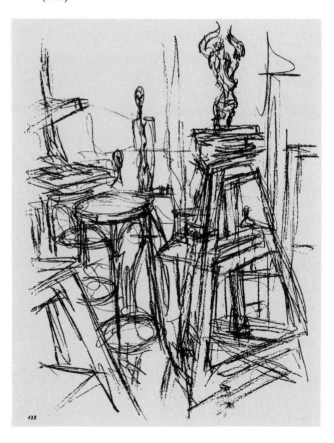

332. (128)

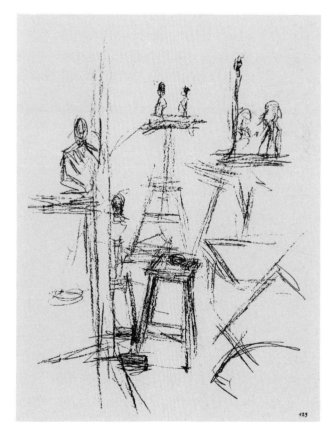

333. (129)

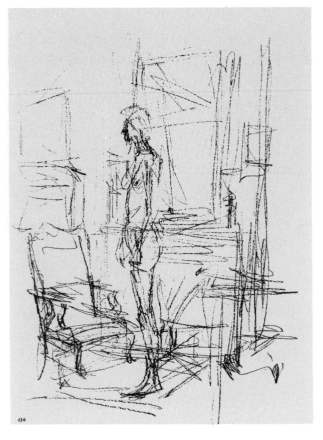

334. (130)

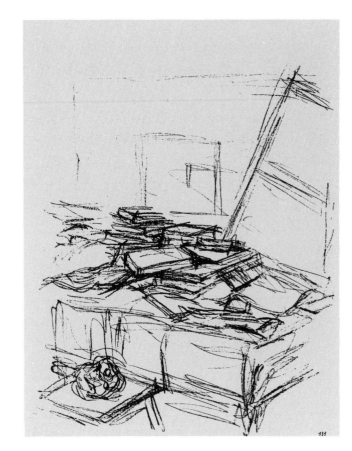

335. (131)

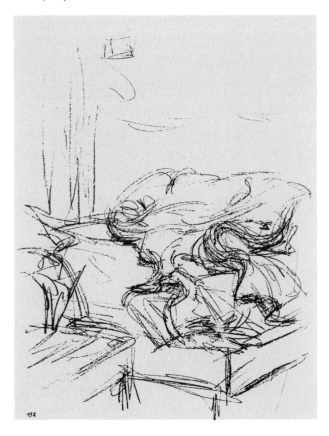

336. (132)

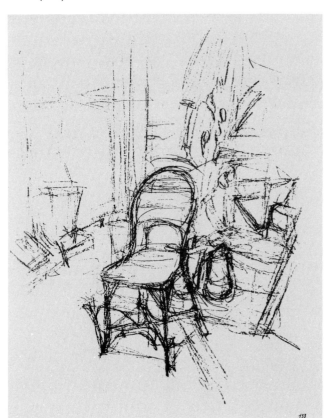

337. (133)

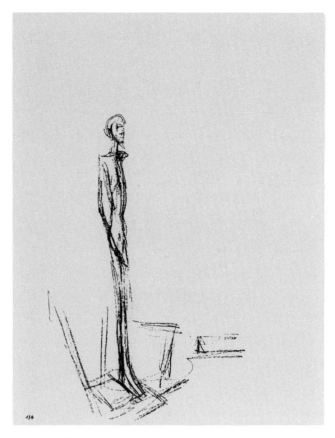

338. (134)

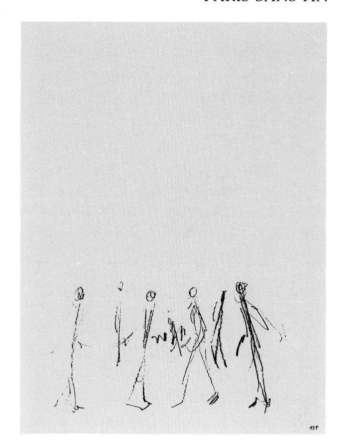

339. (135)

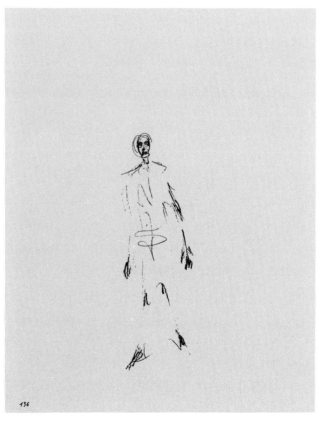

340. (136)

341. (137)

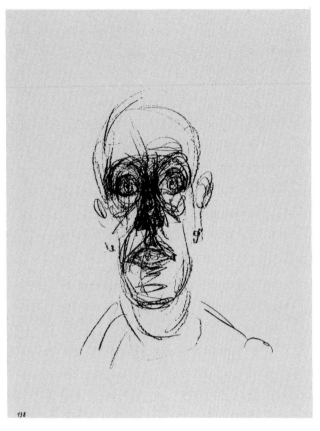

342. (138)

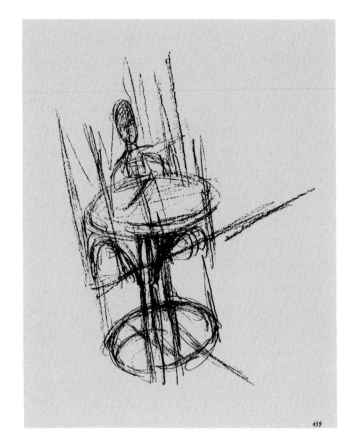

343. (139)

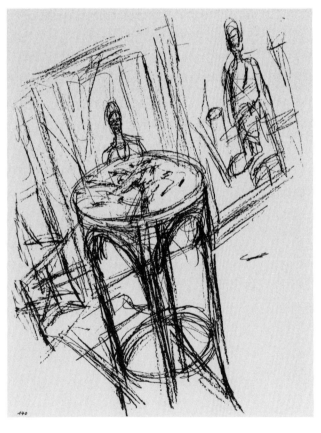

344. (140)

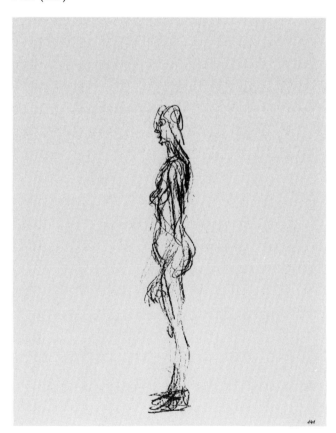

345. (141)

346. (142)

347. (143)

348. (144)

349. (145)

350. (146)

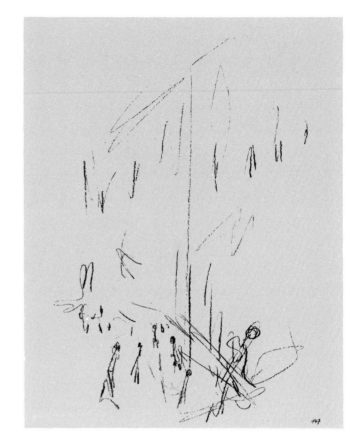

351. (147)

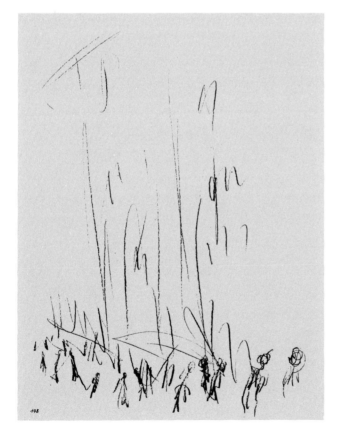

352. (148)

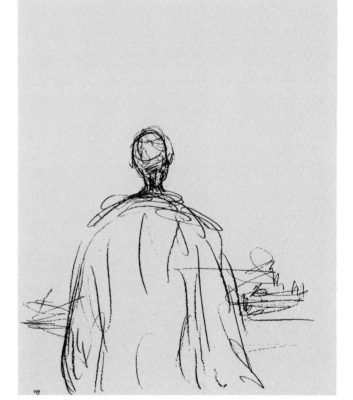

353. (149)

PART II.

Giacometti's Drawings

1. The Geography of Giacometti's Drawings

Giacometti has always been a controversial figure. Not even his admirers agree on the importance or validity of his various phases or media. Most Giacometti enthusiasts would admit, though, that his drawings are exciting. Of course, even about this medium there is some controversy and while this essay may only add to it, at least we will attempt to push aside all the philosophy associated with Alberto and try, for the most part, to describe in a straightforward way the various physical aspects and styles of his drawing.

Giacometti's drawings may be likened to the log of a mountain climber: they start in the valley of Bourdelle, mount the slopes of surrealism, cubism, and abstraction, and at last reach the summit between 1946 and 1952, the period also of his greatest bronzes. The very peak itself for the drawings would be the following years 1953-1955, after which there was a long descent into new valleys. This descent became so pronounced that one might say that at the very end Alberto became the tragic prisoner of his own mannerisms.

(Text continued on p. 203)

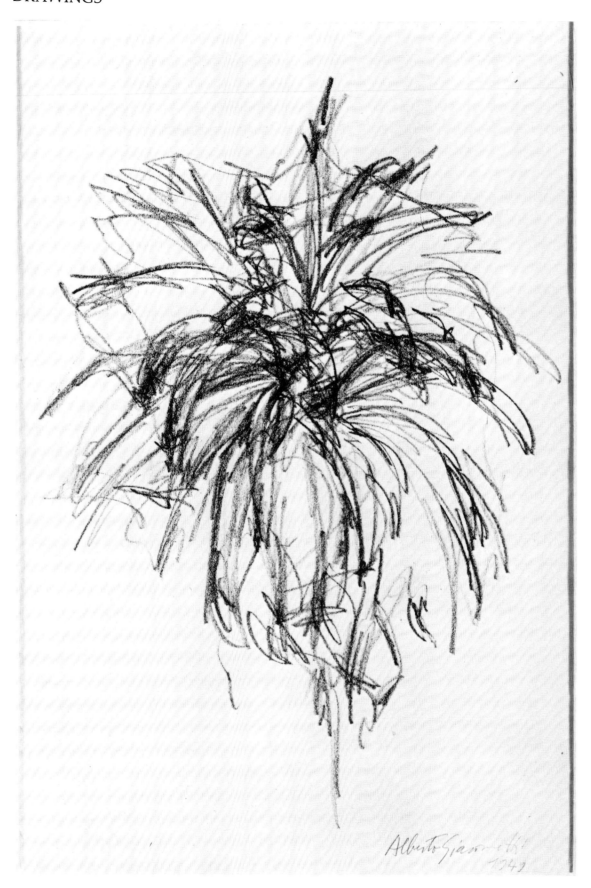

D1. TREE SEEN FROM ABOVE. 1949. Crayon.

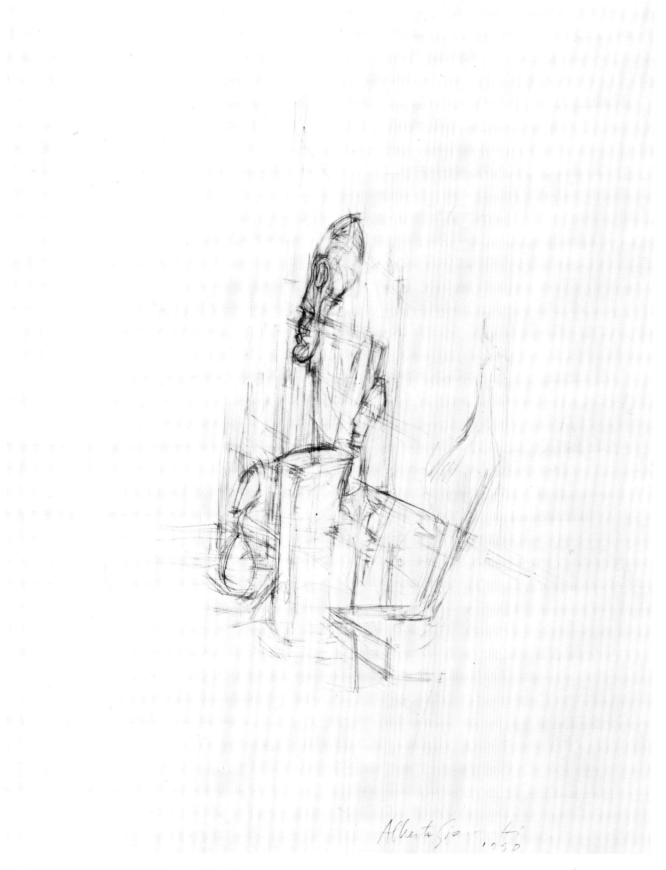

D2. HEAD IN THE STUDIO. 1950. Pencil.

D3. STATUES IN THE STUDIO. 1950. Pencil.

Photo: P. Richard Eells

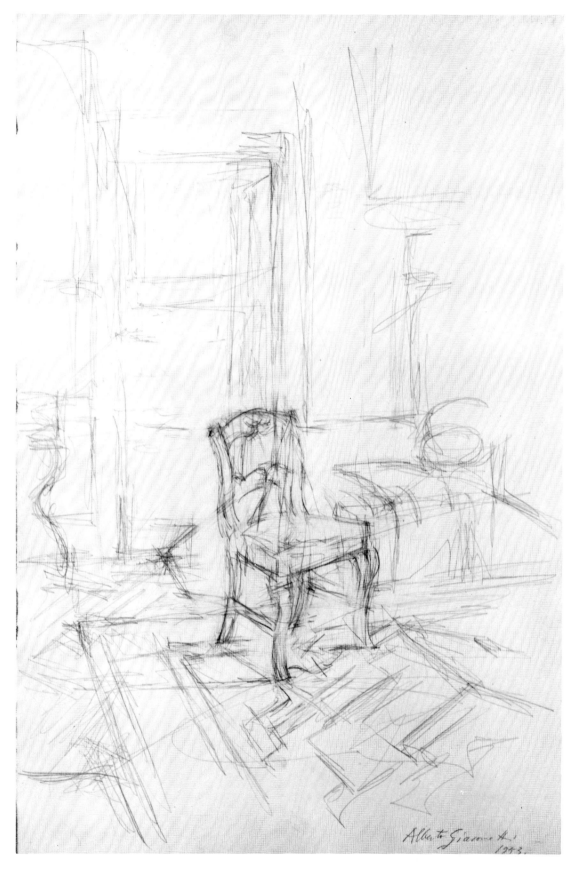

D4. CHAIR AND FLOOR. 1953 (signed 1954). Pencil.

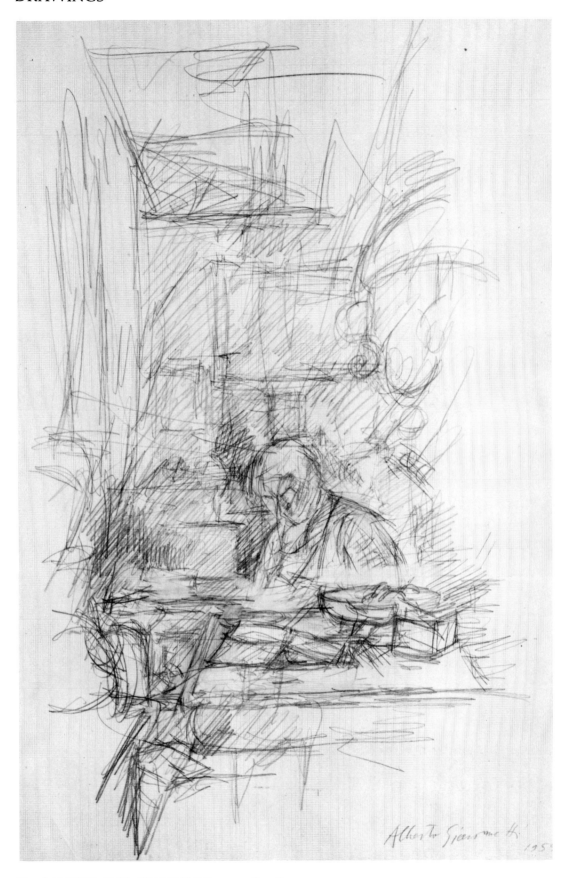

D5. MOTHER AND CHANDELIER. 1954. Pencil.

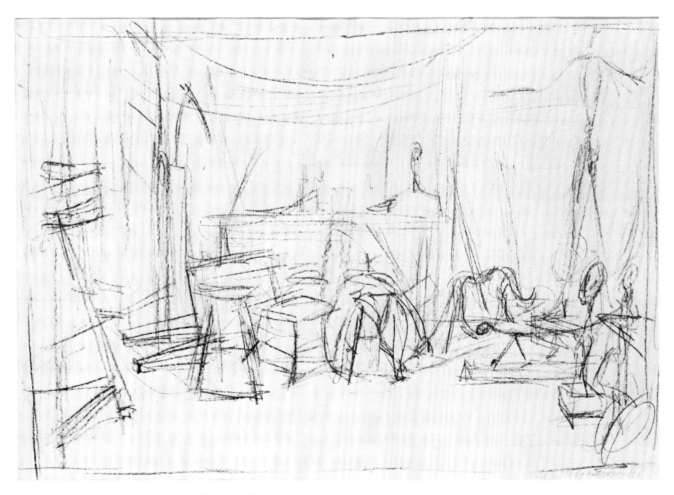

D6. STUDIO II. 1954. Crayon and lithograph.

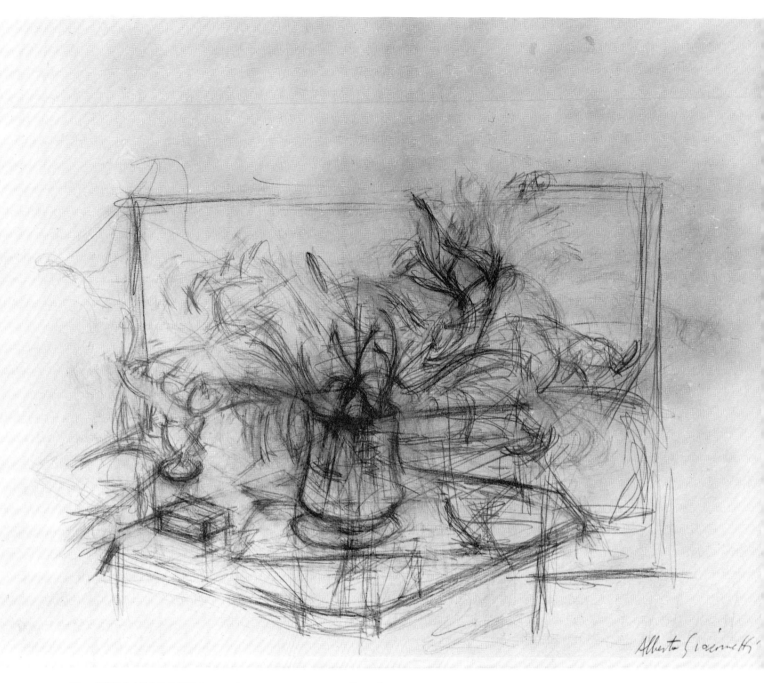

D7. THE LARGE BOUQUET OF FLOWERS. 1954. Pencil.

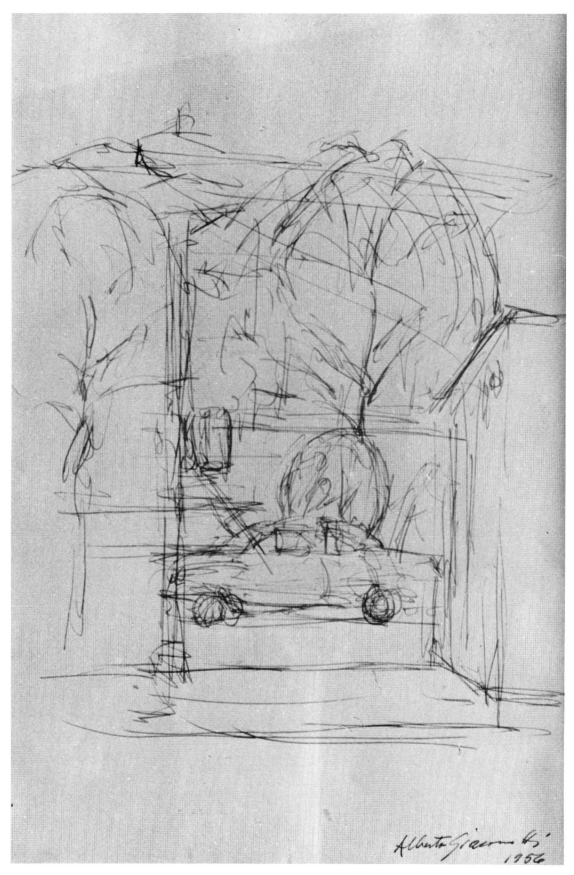

D8. THE AUTOMOBILE. 1956. India Ink.

DRAWINGS

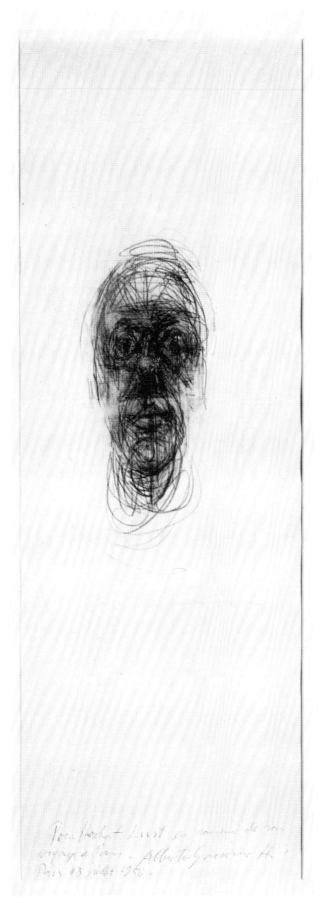

D9. HEAD OF DIEGO. 1956. Pencil.

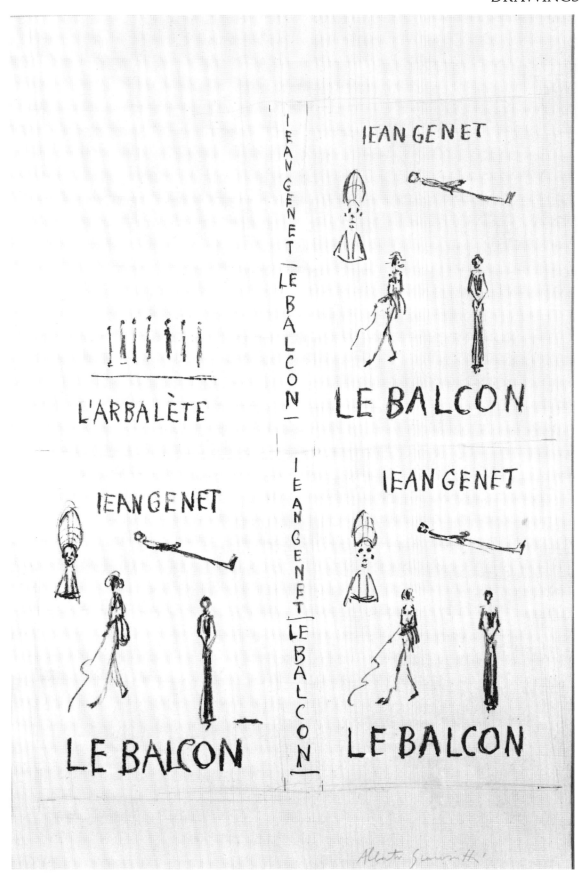

D10. "LE BALCON." 1956. Lithograph and pencil.

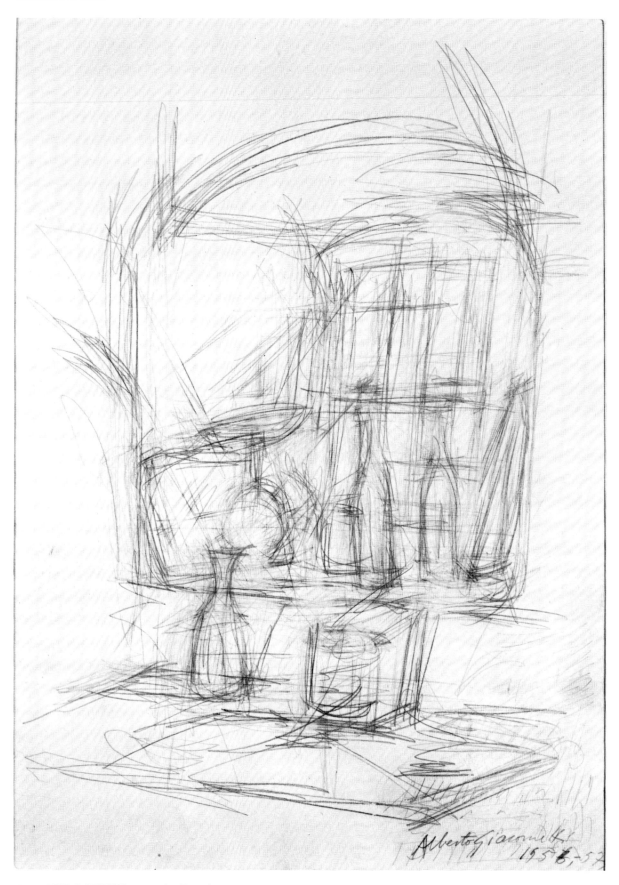

D11. THE BOTTLES. 1956/7. Pencil.

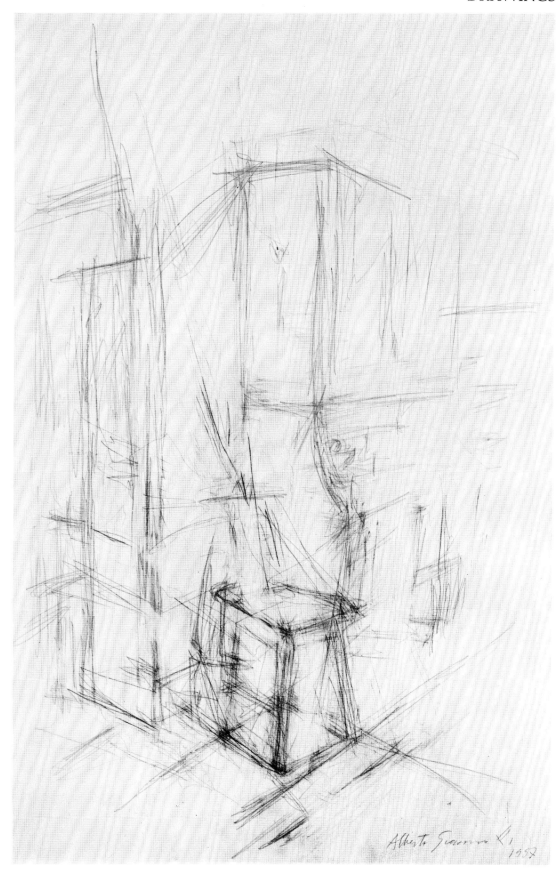

D12. THE STOOL. 1957. Pencil.

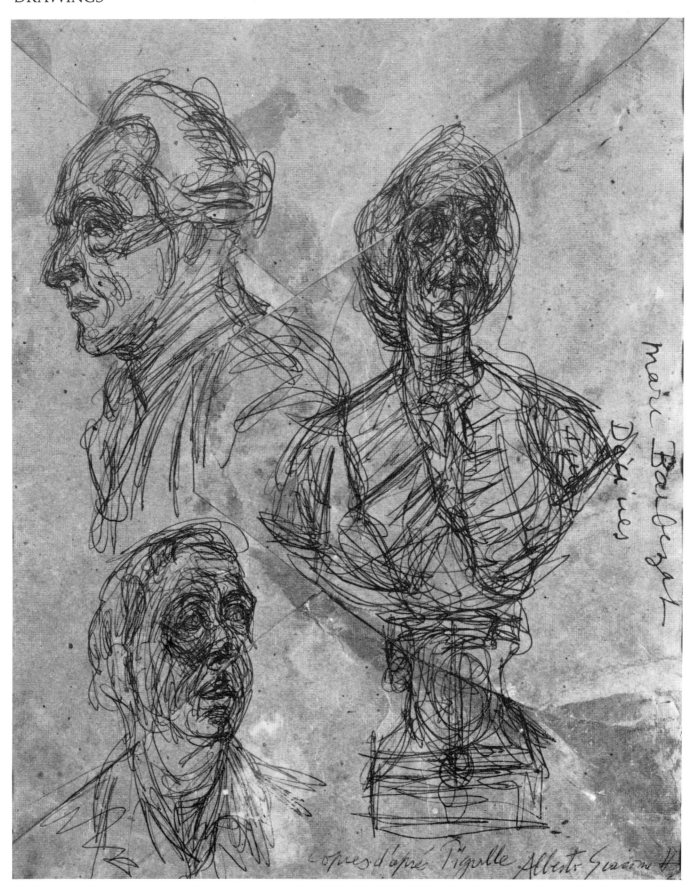

D13. HEADS AFTER PIGALLE. 1960. Ballpoint pen.

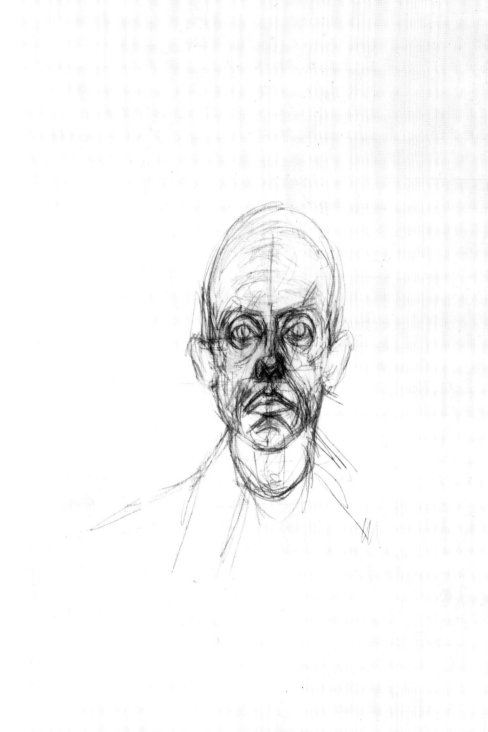

D14. PORTRAIT OF HERBERT LUST. 1961. Pencil.

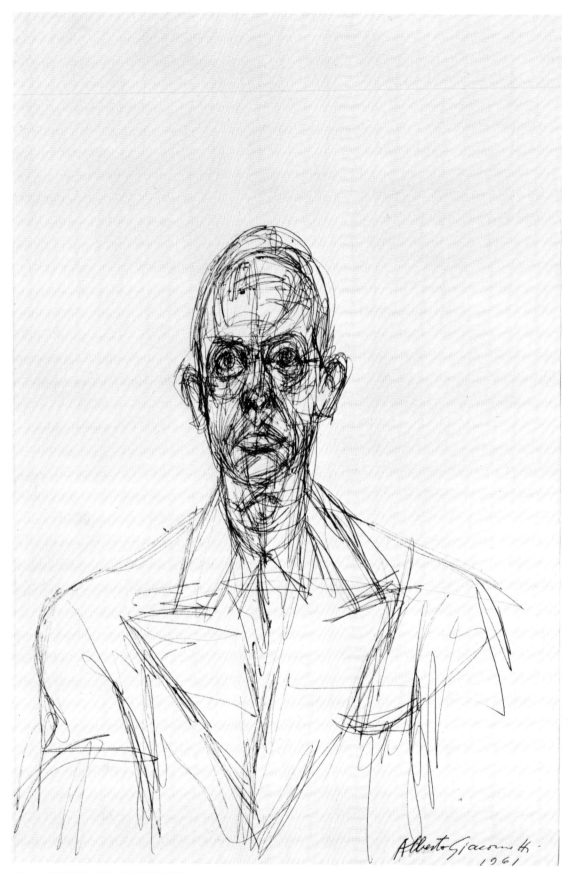

D15. PORTRAIT OF HERBERT LUST IN HIS FATHER'S TOPCOAT. 1961. Ballpoint pen.

2. The Early Phase
(1920-1938)

The drawings Giacometti did as a youth are about what one would expect from a talented youngster. The first known is a copy of the great Dürer engraving of *Knight, Death and the Devil*, indicating a bent for realistic copying, though it is hard to generalize from such instances.

In January, 1922, he entered Bourdelle's studio. The drawings done there have good form and are those of a sculptor. They are majestic and a bit heavy, like those done by the great French sculptors dominant at the turn of the century. The paintings are just as derivative, stemming from impressionism.

In 1925 Alberto and Diego took their own studio and Alberto began to feel the influence of Cézanne, cubism, abstraction and surrealism. This transitional period culminated in his surrealist sculptures, in particular the symbolic functional objects, the mobiles, and the other constructions created from 1929 to 1934. There is at least one great drawing from this period, the sketch of *The Palace at 4:00 A.M.*, now in the Matisse Collection.

In 1935 Giacometti turned away from surrealism and somewhere during this period was drummed out of the movement by André Breton, who despised Alberto's efforts to study the human face. "Any fool can draw a face after nature," Breton said, thereby betraying a certain inherent vulgarity that was to become more manifest in his later years. As for Giacometti, he was to become completely antisurrealist and antiabstract—indeed, almost as vehement as Picasso in his dislike of totally abstract art.

From 1935 to 1937 Giacometti produced some great drawings, such as the head in the Selle Collection. This work, though retaining the early heaviness, displays much power in the use of erasures to mould the human face.

In 1938 Giacometti did two great paintings: one of his mother, and another of a table with apples. These two pictures contained all the important aspects of his mature painting that were to surge forth some ten years later.

The stage, then, in 1938, was set for the worldwide disaster that was to put the artist into the crucible and fuse his genius into its mature style. Maurice Blanchot and many other French writers have testified how World War II changed them, as it did many others, from youths into men, profoundly transforming their artistic styles. The same was true for Giacometti.

The familiar Giacometti of the mature works is a phenomenon that appeared with World War II. There are of course fine drawings done by Giacometti before then, but to the best of my knowledge very few compare to those done in the forties. The huge bulk of them remain merely outstanding studies for a sculpture.

I've done everything possible to become as impassioned about Alberto's surrealist work as I am about his later work, but I must agree with his written criticism of it as too *précieuse,* that is, too cerebral, too thought out, not involved enough with the elemental fire. It goes without saying that it is fine work and contains at least one masterpiece, *The Palace at 4:00 A.M.* However, on balance the early drawings are just sensitive blueprints—their magic comes from the fact that they are now seen in the light of Giacometti's whole oeuvre, as part of the great chorale for which they were the first chant. Some fine critics would disagree with this assessment, but Giacometti himself would not.

3. The Mature Phase (1939-1966)

Rather than go into an elaborate analysis, which would tire both the reader and writer, let me just list the ten principal characteristics of most Giacometti drawings done after 1940. Sometimes all ten exist in one drawing, sometimes just a few. In no way, however, is this list intended to be definitive or all-embracing; it simply attempts to give a general idea of the various characteristics that make the drawings innovative:

1. *Independent works.* Most Giacometti drawings are actual art works in their own right and very different from either his bronzes or paintings. Although many of these works do retain a sculptural effect, they are indeed misunderstood if judged solely in the light of the sculpture. These drawings alone would have earned the artist a secure niche in art history, for nothing like them has ever been seen. In them, the deepest implications of the finest pencil drawings by Villon, Derain and Matisse are explored to their utmost limits. Giacometti, in fact, both recreated older techniques and brought new styles into pencil drawing.

2. *Structural erasing.* Giacometti's greatest innovation is his erasures that rinse out new lightings and shapes. There are some fine erasure drawings before 1939, but he did not use this technique systematically until the late forties.

3. *Self-sealing.* Many of the most exciting drawings are those which have a box drawn around them as if to seal them off from space. This is all part of the artist's effort to limit space, or keep objects in place. Excellent examples of self-sealing abound, but nowhere better than in the 1954 Studio lithographs (8-24). These "boxed" or "auto-framed" lithographs, like the drawings, give a visual effect similar to the transparent constructions Giacometti had done in the early thirties.

4. *Verticals.* A frequent device is a vertical or squadron of verticals that seems to fly off the page.

5. *Dynamic cross-hatching.* Various ways of cross-hatching so that space is seen as if through a coat of mail. At times Giacometti makes space swarm, or expand.

6. *Tilting.* Some drawings seem tilted or askew. In some "boxed" drawings such an effect is achieved by small diagonal slashes at one corner.

7. *Floating.* Often after 1960 large blank spaces are used so that the subject seems to float on a pearl sea.

8. *Realistic copies.* Once his flirtation with surrealism was over, Giacometti thought of his drawings as copies of real life. Many interior studies of the Stampa home, as a matter of fact are, according to Diego, almost exact replicas of their subjects.

9. *Transparent motion.* The fusion of cross-hatching, flying verticals, and erasures imparts a fluid transparency to the drawings. Sometimes this transparent motion is created in a much simpler manner, as, for example, by means of the huge white areas in the 1957 lithograph, *Man Walking* (202).

10. *The whirlpool and the majesty.* In a very general way one can say that before 1960 the drawings often seem like photographs of some stage of a whirlpool. After 1960 this "swirling" or "whirlpool" effect is increasingly abandoned for an eddy or calm, majestic effect, a marshalling of huge white areas to mould or freeze the shapes.

In a word, at its very best a Giacometti drawing is a transparent construction on paper.

One might well glean this conclusion from Alberto's 1947 letter to Pierre Matisse in which he stated that his unique world view must be a collision between "reality, transparent construction, and movement." The first great instances of this would be the mobiles done between 1929 and 1934 and *The Palace at 4:00 A.M.* of 1932-1933. We should emphasize here what is often forgotten — the fantastic continuity in Giacometti's work. The very same theories of the early thirties produced the emaciated bronzes of the fifties.

No one has stated the goals and theories of Giacometti as succinctly as Sartre: "He wanted to take the fat off space." But this, though excellent, does not go quite far enough. In addition to whittling down space, Giacometti also wanted to change it into an actor, that is, to impart to it transparency and motion. One must remember that, before him, space had been a three-dimensional receptacle in which the sculptor put his objects. In *The Palace at 4:00 A.M.* Giacometti created an architectural orchestration out of a warren of spaces. Here the empty spaces are the essential matter.

In *The Palace at 4:00 A.M.* the traditional lines between the sculptor's material and space are obliterated. Perhaps one might describe this adventure as translucent building in process.

This same radical use of space (or of its absence) is noted next in 1934 in the statue enigmatically called *Void Holding the Void* or *Invisible Object.* (Alberto once referred to this statue as *Hands Holding the Void.*) The same principles are also brilliantly embodied in the series of noses hung up in cages done from 1947 to 1951, *Figurine in a Box Between Two Houses* and *The Cage.*

In a similar way, in his drawings of the forties and fifties Giacometti never tired of putting his subjects inside a box, frame, or cage. Thus these drawings are "translucent constructions" on paper. Just as he tried to bring transparent movement to his sculpture by paring away the bronze, so he brought the same vision to his drawings. But this doesn't mean that the drawings are sculptural; quite the contrary. It does mean that the sculptures, paintings, drawings and graphic work derive from the same artistic goal—to make realistic transparent constructions with motion. Giacometti remains above all a metaphysician of space and light.

4. Transparent Motion Examined in a Few Drawings

In the forties Giacometti often attained a certain transparency in his drawing. In the *Tree Seen from Above* (D1), 1949, despite the heavy slashes of crayon one seems to be looking into and through a bubbling fountain. In the *Head in the Studio* (D2) of 1950 the statues are volatilized into light prisms and become an eddy between streaking verticals. Here a thicket of short, medium, and long verticals form a screen upon which the huge head is the actor. These are trussed together by nervous horizontals which form a number of prisms in turn boxed in by still other sweeping verticals.

As good as the early drawings are, their various techniques were not brought to perfection until the years from 1953 to 1955. The 1954 Maeght show, which exhibited his drawings done for the most part in 1954, was beyond doubt one of the greatest exhibitions of drawings by a living artist since World War II. Had Giacometti done nothing but these he would still be among the greatest drawing innovators of this century; for although erasing or smudging with a lead pencil had been used by artists before (for example, by Villon and Matisse) the technique had never become the dramatic floodlighting for the drawing's in-

ternal architecture as it had now. One might risk this astounding thesis: the translucency obtained by erasing in certain of these drawings breaks down the barriers between painting and drawing.

The year 1954 also saw Alberto perfect his use of the frame within the frame. Most drawings in this year are self-sealed, stitched within a box. This device is also explored in the great 1954 Studio lithograph cycle. All seventeen lithographs are enclosed by a cage of heavy dramatic black slashes inside of which the inky forms surge.

This unusual auto-cloistering takes two forms. One is very crude—for example, in the great Apple drawings of 1954, or the Studio lithographs, the frames are so apparent they seem to have been imposed with a ruler. On the other hand, the device is often quite subtle—a bowl of fruit stands on a table, which also frames it; or a torso is seated on a chair, which serves as its frame.

There are so many successful drawings in this year that it is almost by accident that one singles out the various studies for the flowers on a table. In an initial study, *Interior with Vase of Flowers*, the bouquet is framed three times—first by the table, then by the fireplace behind the table, and thirdly, in the primitive

manner, by a frame around the whole subject. It is as brilliant a layout of space as one could expect, stressing space's majesty, rather than its crowded, teeming intensity. Large pearl clouds swirl through and around the quick verticals and horizontals from the fireplace and table.

Another version of this subject, *The Large Bouquet of Flowers* (D7), is perhaps Giacometti's greatest drawing. It was the feature illustration in the book written for the 1954 show by Jean-Paul Sartre. It is in one drawing a perfect example of translucency and self-sealing. Its handling of space here teems, swarms with activity, and is volatilized into a translucent relief. In this drawing space becomes a veritable cinema.

The bouquet is framed twice—once by the window, and once again by the table over which it hovers. Through the window floods sunlight smashing the flowers, transforming them into dark clouds. It is a celebration of the fusion between the artifact of nature (the flowers) and nature itself (the sunlight). The drawing is erased as few Giacomettis are—smudged, muddied, swirled, so as to throw different vistas into space and illumination. One feels the strong sun beating through the window, into the table, through the flowers. It is realism, pure and simple, but realism transfigured, the sun so powerful it almost lifts the vase off the table—hence the vase, like the small box near it, seems vaporized, as if it were floating an inch over the table. Giacometti's drawings lead realism toward new planets.

In *The Large Bouquet of Flowers* the daring, sophisticated self-framing is as interesting as the plays on illumination. The drawing is divided into its objective two parts (a typical device of the artist): the vase and the flowers. The table frames the vase, or lower half of the drawing, while the window frames the flowers, or upper half. The lower part seems to revolve upward

to meet the descending upper part, both parts joining in magical balance toward the center of the vase, which is smudged with such skill it might be transparent marble. From this glistening center the flowers radiate sunny, swirling arms that challenge, without breaking, the double frame. In this still life, as in many others done during 1954, Giacometti met the acid test of great art: the ability to make a still life transmigrate.

In 1954 Giacometti did a series of chairs, a subject which obsessed him. He often said that he tried to draw these chairs so that they hovered an inch above the floor. This, of course, can be said for most of the inanimate objects he drew. In this Chair series the spacing of the verticals and diagonals is amazing, as are the very delicate erasings. Some ten years later Giacometti tackled the same subject again, but never came close to equaling these first architectonic shapes. Indeed, too often in the late drawings Alberto just repeated his past efforts. Even so, they are wonderful, though lacking the sheer fire of the early periods.

Among the more exciting moments in this exciting year are no doubt two versions of the Chandelier and Mother. One version, reproduced in many books, is quite realistic and shows the chandelier in great detail. The other one (D5), in my collection, is far more abstract. Here Giacometti again went to great lengths to make space the hero: the center of the drawing storms with slashing diagonals, cross-hatchings and smudges, all zeroing in on the mother, pinning her to the white sheet.

After 1954 there are, of course, many magnificent moments in the drawings, but as the years limp on, more and more of the magic dries up. This weakening can be seen by comparing two portraits Alberto did of me in 1961 (D14, D15) with a dramatic portrait of Diego (D9) done in 1956, which I will mention again in the next section.

5. Conclusion and Acknowledgment

Alberto was one of the few human beings who was very kind to me, and if, at times, I thought him mean or abrupt, it was because I was too fragile, too stupid to understand the heights from which he judged me. For example, in 1961, when I was agonizing about getting a divorce, he became irritated and thundered, "When something's finished, it's finished! Any fool knows that! Divorce her." On the other hand, he was that very rare person who could accept criticism from a friend and let it become a dialogue rather than a breach.

It is with an example of his kindness that I want to end this memoir.

In 1956 I managed to get back to Europe, where I hoped to buy art works. Alberto was at the Biennale in Venice when I arrived in Paris, but he returned a short while later. That day a number of his friends gathered with him at a café on the rue d'Alésia. When I saw him, his haggard countenance shocked me. Out of concern, I told him that he looked terrible and even used the words, "like a death's head." Alberto was visibly upset, and the others were shocked by my statement; they began trying to soothe Alberto by telling him that maybe he was a bit tired from the trip, but that he never looked better. As we left the café, though, I took him by the arm and said, "Alberto, I don't care what the others say, you look pretty bad and I think you may be ill. Why can't you take a vacation? Or at least see a doctor?"

"Look," he snarled, "if you don't like the way I look just don't come around and see me anymore. I feel great. You hear me! Don't see me anymore on this trip!"

His face was like granite as we separated. After mulling it all over for a few days I risked a return to his studio. He invited me to some coffee as if nothing had happened. We had our usual pleasant talk about art, politics and literature and even went for a stroll. Then at a most unexpected moment, he smiled in that wonderful sly way he had at times, and said, "Say, you were right the other day. I feel lousy. Maybe I'll get a checkup."

Perhaps at that time Alberto was already starting to suffer from the stomach trouble and general deterioration that was finally to kill him. It would seem to be so, for in every way possible there is less inventiveness and energy in his work from 1956 on, though the real weakening becomes apparent around 1962.

We started walking back to the studio and as we were about to separate Alberto smiled and said, "Come on in, I've been saving something for you." He held out a piece of paper to me and said, "Here, this is the best drawing I've ever done of a face." Then he sat down and inscribed the drawing to me: *Pour Herbert Lust en souvenir de son voyage à Paris. Paris 13 juillet 1956* (D9). I tried to thank him for it, but he said, "That's foolish. I might as well thank you for telling me how bad I looked. Come and see me soon."

Out in the Parisian street I walked and walked and gazed at the piece of paper. In the July sunlight the paper came alive, floated over my hand, celebrated. The head of Diego, as if emerging from a turgid pool, stared at me. The artist had erased it so much the surface was rubbed off in spots, space had been deckled, making the drawing an X ray of a human face. And around this dramatic vision the artist had drawn a box, seeming to say to the face, "Now look here, stay there in your spot in space. Don't try to jump out of it. Space must be limited."

It then dawned on me that drawing for Alberto was his attempt to realize his dream that couldn't be put into words, which is why this brief essay can only hint at it. No writing about Giacometti can do more than lead someone, who is already prepared, into those diverse, shifting levels inside his visions. His drawings are often failures, as he himself hastened to admit, yet he also knew that success does nothing for our understanding—it is only through failure that we learn. In this sense one must say that every Giacometti drawing, even the least one, is in some way a lesson, an effort to peer at reality in a new light.

At their very best Giacometti's drawings are boxes of trembling webs on translucent planes. They are like prisms turning against the light. In this sense they are the elaboration and true lineage of *The Palace at 4:00 A.M.*

PART III.

Some Conversations with Diego Giacometti

Some Conversations with Diego Giacometti

Nothing could be more symbolic of the Giacometti mentality than Diego's resistance to my efforts to get him to do a preface for this book. After all, my request seemed natural enough. Diego and Alberto had always been very close, and Diego's memories of his brother would have enormous value to art historians. Also, Diego is my close personal friend, in many ways closer than Alberto was. He would do anything to please me and to serve Alberto if he could, anything but compromise his idea of the truth about Alberto. He felt, however, that he himself was unable to put this truth into writing.

At first Diego refused my request for a preface point-blank. "There's nothing to say. We lived to the hilt, that's all." I argued with him. At one of our meetings I tried to enlist the aid of Elie Lotard, Alberto's last model, who was to die a few months later. Elie was no help. At a wonderful dinner the three of us had together at Alexander's he said, with that impish smile of his, "Diego's not a writer, so he doesn't want to write a preface."

Nevertheless, I persisted. But Diego is not one to be easily swayed. After many talks on the subject, however, at last Diego said, "You're a professional writer.

I'm not. So, let's do this. You ask me the necessary questions about Alberto and then write an article for me." I did this and sent the text to Diego for his approval, but it did not satisfy him. "Hell, that's not me," he said. So the article was scrapped.

Then in a round of talks, we at last agreed upon doing an interview instead of a preface. But at the last moment Diego again could not bring himself to compromise: "An interview is too formal. Life isn't like that."

At this point all was up in the air. However, I also learned this from Alberto: *never quit.* So I kept at Diego, objecting to all his objections. I fought him with his very own weapon, the truth. My main point was that he owed it to posterity to make a public statement for those who loved Alberto's art. After all, if you love a man's work, you also love the man, and want to know something about him. And to my knowledge nothing had ever been published about Alberto's life as a child.

At last Diego said, "I'll tell you what, we've talked a lot about Alberto over the years. You put down what you think is worth remembering. After all, I can't stop you from doing that. But I don't see the point of any

interview. However, if you're going to write something on our chats about Alberto, my advice is to keep it short."

In a certain sense he was right. What is conversation between friends but a type of informal interview? Diego and I always talked about everything that interested us and during Alberto's lifetime we'd naturally talked a lot about him. When we met after Alberto's death we spontaneously talked about various things that had transpired during his later years. So, in an important sense, everything had been discussed.

Now, keeping it very short, I am going to quote Diego from various notes I have made over the years. The thing that interested me the most was Alberto's childhood. Once when I asked Diego about this he went into the following monologue:

"Alberto was always different from the other boys in our group. He didn't like to play games or sports the other boys did. He was always more meditative, and this trait deepened with the years.

"I myself enjoyed playing with my fellows at various sports or having fun in the snow. Alberto was a year older than I and in addition was well liked. He was always welcome to romp along with me and the other fellows. But he preferred to stay by himself and either draw or read. Inside our warm family circle Alberto was adored and always got special treatment from everyone. For example, Alberto and I had certain chores to do together, but I often ended up doing them. It seemed natural that I should aid him in any way possible.

"Although Alberto was very robust as a boy he was from the very first a scholarly type. He loved reading, which, after drawing, was his favorite pastime. He could read for hours on end, completely oblivious to everything around him. When he came home from school Alberto always did his homework right away. He always received excellent marks. But as soon as he finished his homework, rather than join me at play, he began drawing. He at first drew the objects in our home or the landscape. Later on he drew either me or Bruno or other people as well as the familiar household objects.

"It is difficult to know the relation between Alberto and our father. It is certain that Father encouraged Alberto in everything and there was much love between them. Father never disciplined Alberto or repressed him in anything. Still, Father always had his opinion. For example, he never understood surrealism.

"There was a constant artistic atmosphere in our family. Both my father and my uncle were fine artists. They based their paintings on the reality before them.

I do not remember that they ever encouraged Alberto to draw. When he started to draw my parents were pleased, but they would also have been pleased if he had taken another hobby."

In other words Alberto had about the same kind of upbringing as Freud—he was the adored eldest son. Ernest Jones claims that when a son has this kind of upbringing he inherits an "Alexander the Great" complex—that is to say, he is not afraid to dare anything. Such a description fits Alberto the artist. As a man, he was afraid, of course, but he somehow found the ways to take the proper perspectives toward his fears, as Freud also did.

When I once asked Diego if he could describe Alberto's first artistic efforts he replied, "Of course. Very well. His first sketches were just tossed off. The first time he ever really worked at a drawing, it was, interestingly enough, not about a real subject. It was the first of what has come to be known as his "interpretive" drawings. It was a copy of the great Dürer etching *Knight, Death and the Devil*. He was around twelve years old at the time. There was a fine reproduction of this etching in a book we just got and Alberto was hypnotized by it. He decided that he had to have his own exact reproduction of it. He worked hard during all his free moments. After two or three days he finished it.

"In fact Alberto thought that nothing was so difficult as rendering an object just as it was. He never tired of drawing the chair or the buffet in our Stampa home, even though he knew them by heart. The many drawings he did of our familiar household objects were almost exact copies of them as they had always existed since our earliest years. All during his life he tended to draw whatever objects were before him. He thought that all objects had an equal beauty. It was up to the artist to discover it. A good example of this was the chandelier in our home. He first tackled this subject when he was ten years old. He wanted to put it *in* the air, so that it would not be glued to the page."

Such remarks about Alberto were the ones which most fascinated me. Diego once told me an interesting story about the war.

"In 1940 we started fleeing toward Switzerland on bicycle—impossible to find any other transportation. It was terrible. When we were several hundred miles away from Paris we thought it over and returned to our studio. As worried as we were about ourselves, we were more worried about the studio. Alberto then stayed on until 1941, but it was very hard for him. For one thing he loved to smoke and also to prowl around the city at night. Cigarettes were either difficult

to find or too expensive, and then came the curfew. Alberto was deprived of two of his real avenues of relaxation. We decided to take vacations; he would go first, and when he came back I would go. As luck would have it, just after Alberto left, the Germans cancelled all future visas, and I was stranded. So I took care of the studio until 1945."

And again:

"One of Alberto's most typical traits was his unwillingness to leave familiar surroundings. Although he sometimes traveled, it was usually because an exterior force connected with his artistic career necessitated the journey. When in Paris he was extremely reluctant to leave. He traveled most often to Stampa, feeling the duty to visit our mother. If he had traveled on his own volition it would have been to Greece or Egypt, as he so much admired their ancient art and wanted to see more of it. He sometimes talked about going to these places, but never did."

I once asked Diego if Alberto was ever foolhardy.

"Oh, he was impetuous once in a while, and almost always regretted it. For example, his departure from the Galerie Maeght. He thought that his very close friend Clayeux was not getting a good deal there, which was in fact not true at all. I was out of town and Alberto phoned me that he was sending in his written resignation to Maeght. I told him that this was a most foolish move and not to send the letter until the next day, when I would be back and we could talk it over. When I arrived Alberto had a sheepish expression on his face. He had sent the letter. 'Oh, what the hell,' he said. 'You have to be loyal to your friends.' I know that Alberto regretted this decision, but he never considered having another gallery in France."

Someday I will set down many more of these recollections, but for the time being I will follow Diego's sage advice and be brief. No doubt we leave the reader with a sense of incompleteness, but that would have suited Alberto. He always felt that everything he ever did was incomplete and imperfect. In fact he knew his imperfections so well that he became the most perfect artist of his time.

Scilly Island
December 12, 1969

215

PART IV.

A *Catalogue Raisonné* of Giacometti Graphics

A *CATALOGUE RAISONNÉ* OF GIACOMETTI GRAPHICS

By HERBERT LUST

The few numbers preceded by asterisks were not shown in the exhibition "Giacometti: The Complete Graphics" that originated with the Milwaukee Art Center.

* * * * *

All other numbers are in the collection of Mr. and Mrs. Herbert Lust, with the exception of those whose collection is acknowledged.

* * * * *

For lithographs and etchings other than those done for books we have followed the method employed by the Engelberts Giacometti catalogue of 1967 in assigning two numbers to each print. One number is that of our catalogue. A second number is composed of:

1. The year.

2. A letter: L (lithograph), or E (etching).

3. A number assigned the print in the year's work.

For example, the lithograph *Tête de chat* (9) was done in 1954 and was the second one on our list for that year. Thus its permanent number is: 1954/L2. Since there is a total of seventeen lithographs done in 1954 a newly discovered one would receive the number 1954/L18.

Dual numbers have not been used for illustrated books, however, because they would eventually require a complicated system of sub-numbering should two or more books from the same year come to light.

The advantage of the present system is that, regardless of future catalogues, this numbering by year will remain permanent, thus eliminating such confusion as now exists, for instance, among Picasso graphics, where one is often obliged to refer to three separate numbers from different sources. * * * * *

French titles are also given in cases in which a work has been known or previously catalogued under such titles.

* * * * *

All editions are signed by the artist unless designated as unsigned.

Lithographs

1. 1931/L1

MOVING, MUTE OBJECTS (*Objets mobiles et muets*). Edition: 30. Arches. 18½ X 12⅝ in. Publisher: Revue de surréalisme.

2. 1949/L1

TRISTAN TZARA. Edition: 16. Arches. 7¼ X 4¾ in. Collection: The Museum of Modern Art, New York. Gift of Tristan Tzara.

3. 1951/L1

THE COUPLE (*Le Couple*). Edition: 50. Vélin. 12 X 9⅞ in. Publisher: Edouard Loeb.

4. 1951/L2

THE COUPLE (*Le Couple*). A unique state of the above, on Japan, dedicated: *A Marcel Zerbib.* 13 X 9⅞ in.

5. 1951/L3

THE CAGE (*La Cage*). A few impressions exist. 19¼ X 13⅜ in.

6. 1951/L4

FIGURES IN THE STREET (*Personnages dans la rue*). A few impressions exist. Vélin. 16⅛ X 13 in.

7. 1951/L5

STANDING FIGURES. A few impressions exist. Vélin. 16⅛ X 13 in.

8. 1954/L1

FIGURE IN THE STUDIO (*Personnage dans l'atelier*). Edition: 30. Arches. 25⅝ X 19⅝ in. Publisher: Maeght (204).

9. 1954/L2

HEAD OF A CAT (*Tête de chat*). Edition: 30. Arches. 21¼ X 17⅛ in. Publisher: Maeght (211). Collection: Galerie le chat Bernard, Chicago.

10. 1954/L3

ANNETTE IN THE STUDIO (*Annette dans l'atelier*). Edition: 30. Arches. 21¼ X 17⅜ in. Publisher: Maeght (201).

11. 1954/L4

DOG AND CAT (*Chien et chat*). Edition: 30. Arches. 25⅝ X 19⅝ in. Publisher: Maeght (202).

12. 1954/L5

BUST IN THE STUDIO (*Buste dans l'atelier*). Edition: 30. Arches. 19⅝ X 25⅝ in. Publisher: Maeght (203).

13. 1954/L6

DOG, CAT, PICTURE (*Chien, chat, tableau*). Edition: 30. Arches. 19⅝ X 25⅝ in. Publisher: Maeght (205).

14. 1954/L7

SCULPTURES. Edition: 30. Arches. 25⅝ X 19⅝ in. Publisher: Maeght (206).

15. 1954/L8

STUDIO II (*Atelier II*). Edition: 30. Arches. 19⅝ X 25⅝ in. Publisher: Maeght (207). Collection: Galerie le chat Bernard, Chicago.

16. 1954/L9

RUE D'ALESIA. Edition: 30. Arches. 21¼ X 17⅜ in. Publisher: Maeght (208).

17. 1954/L10

HEAD OF A HORSE I (*Tête de cheval I*). Edition: 30. Arches. 21¼ X 17⅜ in. Publisher: Maeght (213).

18. 1954/L11

HEAD OF A HORSE II (*Tête de cheval II*). Edition: 30. Arches. 21⅛ X 17⅜ in. Publisher: Maeght (209).

19. 1954/L12

BUST (*Buste*). Edition: 30. Arches. 19⅝ X 25⅝ in. Publisher: Maeght (210).

20. 1954/L13

IN THE CAFE (*Au café*). Edition: 30. Arches. 19⅝ X 25⅝ in. Publisher: Maeght (212).

21. 1954/L14

THE DOG (*Le Chien*). Edition: 30. Arches. 21¼ X 17⅜ in. Publisher: Maeght (214).

22. 1954/L15

HEADS AND STOOL (*Têtes et tabouret*). Edition: 30. Arches. 25⅝ X 19⅝ in. Publisher: Maeght (216).

23. 1954/L16

STUDIO I (*Atelier I*). Edition: 30. Arches. 21¼ X 17⅜ in. Publisher: Maeght (217).

24. 1954/L17

FIGURINES AND STOVE (*Figurines et poêle*). Edition: 30. Arches. 21⅛ X 17⅜ in. Publisher: Maeght (218).

25. 1956/L1

THE STUDIO 1955 (*L'Atelier 1955*). Edition: 125. Arches. 25⅝ X 19⅝ in. Publisher: Schweizerische Graphische Gesellschaft.

26. 1956/L2

THE STUDIO 1955 (*L'Atelier 1955*). A unique state of the above. 25⅝ X 19⅝ in.

27. 1957/L1

GIACOMETTI'S HOUSE IN MALOJA (*Maison de Giacometti à Maloja*). Edition: 65. Arches. 19⅝ X 25⅝ in. Publisher: Kornfeld & Klipstein.

28. 1957/L2

MOUNTAIN IN MALOJA (*Montagne à Maloja*). Edition: 65. Arches. 19⅝ X 25⅝ in. Publisher: Kornfeld & Klipstein.

29. 1959/L1

CHANDELIER (*La Suspension*). Edition: 75. Arches. 26 X 19⅞ in. Publisher: Maeght (230).

30. 1960/L1

BUST I (*Buste I*). Edition: 90. Rives. 25⅝ X 19⅝ in. Publisher: Maeght (231).

31. 1960/L2

BUST II (*Buste II*). Edition: 150. Rives. 25⅝ X 19⅝ in. Publisher: Maeght (232).

32. 1960/L3

NUDE WITH FLOWERS (*Nu aux fleurs*). Edition: 90. Rives. 25⅝ X 19⅝ in. Publisher: Maeght (233).

33. 1960/L4

CHAIR AND GUERIDON (*Chaise et guéridon*). Edition: 90. Rives. 25⅝ X 19⅝ in. Publisher: Maeght (235).

34. 1960/L5

RECLINING WOMAN (*Femme couchée*). Edition: 90. Rives. 25⅝ X 19⅝ in. Publisher: Maeght (234).

35. 1961/L1

STANDING NUDE I (*Nu debout I*). Edition: 75. Rives. 29⅞ X 22 in. Publisher: Maeght (236).

36. 1961/L2

STANDING NUDE II (*Nu debout II*). Edition: 75. Rives. 29⅞ X 22 in. Publisher: Maeght (237).

37. 1961/L3

SEATED NUDE (*Nu assis*). Edition: 75. Rives. 22 X 29⅞ in. Publisher: Maeght (238).

38. 1963/L1

MAN STANDING AND SUN (*Homme debout et soleil*). Edition: 150. Rives. 25⅝ X 19⅝ in. Publisher: Université de Saint-Gall.

39. 1963/L2

DIEGO. Edition: 100. Arches. 24¾ X 18½ in. Publisher: Giulio Einaudi, Torino.

40. 1963/L3

PORTRAIT OF LAMBERTO VITALI. Edition: 10, with 5 artist's proofs. Fabriano. Inscribed: *Epreure d'essai pour Mario Miglinccio.* 22½ X 16¼ in. Publisher: Graphica Una, Milano. Collection: Miss Shelly Wexler, New York.

41. 1964/L1

LANDSCAPE WITH TREES (*Paysage aux arbres*). Edition: 75. Rives. 25⅝ X 18⅞ in. Publisher: Maeght.

42. 1964/L2

BUST OF MAN (*Buste d'homme*). Edition: 75. Vélin. 26¾ X 19⅝ in. Publisher: Maeght.

43. 1964/L3

IN THE MIRROR (*Dans le miroir*). A self-portrait. Edition: 75. Rives. 26¾ X 19⅝ in. Publisher: Maeght.

44. 1964/L4

THE ARTIST'S MOTHER READING III (*Mère de l'artiste lisant III*). Edition: 75. Rives. 26 X 19⅝ in. Publisher: Maeght.

45. 1964/L5

DISTURBING OBJECT II (*Objet inquiétant II*). Edition: 75. Rives. 26 X 19⅝ in. Publisher: Maeght.

46. 1964/L6

STAMPA. Edition: 75. Rives. 25⅝ X 18⅞ in. Publisher: Maeght.

47. 1964/L7

HEAD OF MAN (*Tête d'homme*). Edition: 75. Rives. 25⅝ X 18⅞ in. Publisher: Maeght. Collection: Galerie le chat Bernard, Chicago.

48. 1964/L8

HEAD OF YOUNG MAN (*Tête de jeune homme*). Edition: 75. Rives. 26¾ X 18⅞ in. Publisher: Maeght.

49. 1964/L9

THE ARTIST'S MOTHER AT THE WINDOW (*Mère de l'artiste à la fenêtre*). Edition: 75. Vélin. 26¾ X 19⅝ in. Publisher: Maeght.

50. 1965/L1

THE ARTIST'S MOTHER SEATED I (*Mère de l'artiste assise I*). Edition: 75. Rives. 25¼ X 19⅝ in. Publisher: Maeght.

51. 1965/L2

THE ARTIST'S MOTHER SEATED II (*Mère de l'artiste assise II*). Edition: 75. Rives. 25¼ X 18⅞ in. Publisher: Maeght.

52. 1965/L3

INTERIOR (*Intérieur*). Edition: 75. Rives. 26⅜ X 19⅝ in. Publisher: Maeght.

53. 1965/L4

SEATED NUDE (*Nu assis*). Edition: 100. 30¼ X 20⅞ in. Publisher: Gemini Ltd. Collection: Gemini Ltd., Los Angeles.

54. 1965/L5

DISTURBING OBJECT I (*Objet inquiétant I*). Edition: 75. Rives. 26 X 19⅝ in. Publisher: Maeght.

55. 1965/L6

THE ARTIST'S MOTHER READING II (*Mère de l'artiste lisant II*). Edition: 75. Rives. 26 X 19⅝ in. Publisher: Maeght.

Etchings

56. 1933/E1

CUBIST HEAD. A unique impression done at the studio of Stanley W. Hayter. 12¼ X 10¼ in. Collection: The Museum of Modern Art, New York. Gift of Stanley W. Hayter.

57. 1934/E1

HANDS HOLDING A VOID. Edition: 2 or 3. 13 X 10⅝ in. Publisher: executed at Hayter's studio. Collection: The Museum of Modern Art, New York. Gift of Victor S. Riesenfeld.

58. 1954/E1

THE TWO STOOLS (*Les Deux Tabourets*). Edition: 30. Arches. 10½ X 7⅝ in. Publisher: Maeght (221). Collection: Galerie le chat Bernard, Chicago.

59. 1955/E1

BOUQUET I. Edition: 50. Arches. 10½ X 7⅝ in. Publisher: Maeght (223).

60. 1955/E2

BOUQUET II. Edition: 30. Arches. 10½ X 7⅝ in. Publisher: Maeght (221).

61. 1955/E3

BOUQUET WITH TWO PORTRAITS (*Bouquet aux deux portraits*). Edition: 50. Arches. 10½ X 8¼ in. Publisher: Maeght (222).

62. 1955/E4

ANNETTE FACING FRONT (*Annette de face*). Edition: 50. Auvergne à la main. 3½ X 1⅛ in. Publisher: Maeght (220). Collection: Galerie le chat Bernard, Chicago.

63. 1955/E5

BOUQUET. A unique state, possibly for *Bouquet I*. Dedicated by the artist: *Epreuve d'essai, à Philip Bruno. Paris 18.III.1955.* 10½ X 7⅝ in. Collection: Philip A. Bruno, New York.

64. 1955/E6

NUDE IN PROFILE (*Nu de profil*). Edition: 50. Auvergne à la main. 3½ X 2½ in. Publisher: Maeght (224).

65. 1955/E7

NUDE FACING FRONT (*Nu de face*). Edition: 30. Auvergne à la main. 3½ X 2½ in. Publisher: Maeght (226).

66. 1955/E8

STUDIO WITH TWO PAILS (*Atelier aux deux seaux*). Edition: 50. Arches. 10⅜ X 8⅜ in. Publisher: Maeght (225).

67. 1955/E9

SMALL NUDE STANDING (*Petit Nu debout*). A unique impression with pencil drawing. 6¼ X 2½ in.

68. 1956/E1

HEAD OF WOMAN (*Tête de femme*). A unique impression. Arches. Unsigned. 4¼ X 2¾ in.

69. 1956/E2

STANDING FIGURE IN THE STUDIO (*Figure debout dans l'atelier*). A unique impression. Arches. Unsigned. 5¾ X 3¼ in.

70. 1956/E3

INTERIOR WITH THE STOVE (*Intérieur au poêle*). Edition: 150. Arches. 8⅛ X 5½ in.

71. 1964/E1

STUDIO WITH THE TURNTABLE (*Atelier à la sellette*). Edition: 450. 380 for a Christmas card, 55 for commercial distribution, 15 signed. 13⅞ X 9⅞ in. Publisher: Galerie Beyeler.

72. 1965/E1

STUDIO WITH THE EASEL (*Atelier au chevalet*). Edition: 125. Rives. The artist authorized the printing, but did not live to sign the plates. 16¼ X 12⅜ in. Publisher: Schweizerische Graphische Gesellschaft.

73. 1965/E2

THE ALARM CLOCK (*La Réveille-matin*). Edition: 70. Rives. The artist authorized the printing, but did not live to sign the plates, which were signed by his brother Diego: *Pour Alberto—Diego Giacometti.* 16¼ X 12⅜ in. Publisher: Kornfeld & Klipstein.

74. 1965/E3

VIEW FROM THE BED, WITH LAMPSHADE (*Vision du lit et abat-jour*). Edition: 70. Rives. The artist authorized the printing, but did not live to sign the plates, which were signed by his brother Diego: *Pour Alberto—Diego Giacometti.* 16¼ X 12⅜ in. Publisher: Kornfeld & Klipstein.

75. 1965/E4

SCULPTURES (*Les Sculptures*). Edition: 70. Rives. The artist authorized the printing, but did not live to sign the plates, which were signed by his brother Diego: *Pour Alberto—Diego Giacometti.* 22¼ X 17¾ in. Publisher: Kornfeld & Klipstein.

Illustrated Books and Miscellaneous Graphics

(In the following inventory we have not listed the states of prints unless we could also reproduce them. All final versions in the books are reproduced.)

***76-79.**

Breton, André. *L'Air de l'eau.* Paris, Cahiers d'Art, 1934. One volume, 12 X 7½ in. Contains 4 etchings. 6½ X 5¼ in. 5 copies on Japan and 40 on Montval. The books were signed by both Giacometti and Breton.

80.

Jakovski, Anatole. *23 Gravures.* An album containing etchings by Arp, Calder, and Giacometti. Plate 7 is by Giacometti. Paris, H. Orobitz, 1935. 11¾ X 9⅞ in. 50 signed copies were published. Collection: The Museum of Modern Art, New York.

81-83.

Bataille, Georges. *Histoire de rats.* Paris, Editions de Minuit, 1947. 3 etchings. 5⅜ X 3½ in. 40 copies on Arches with a series of 3 refused etchings, and 160 copies on Rives, were printed.

84.

Iliazd. *Poésie de mots inconnus.* Paris, 1949. An anthology of poets for which Giacometti illustrated a poem by Alexey Yeliseyevich Krutchonykh with his etching *Couple Facing Each Other.* 6¼ X 4⅝ in. 115 copies, plus 41 on Ile-de-France, were printed.

85-91.

Loeb, Pierre. *Regards sur la peinture.* Paris, Galerie La Hune, 1950. Contains 3 etchings limited to 15 impressions each:

85. BOTTLES IN THE STUDIO (*Bouteilles dans l'atelier*). 7⅝ X 5½ in. (Kovler Gallery, Chicago)

86. THE HAND (*La Main*). 7⅝ X 5½ in. (Kovler)

87. CHARACTERS IN THE STUDIO I (*Personnages dans l'atelier I*). 7⅝ X 5½ in. (Kovler)

88. CHARACTERS IN THE STUDIO II (*Personnages dans l'atelier II*). A more advanced version of 87. 30 impressions were made of this one. 5¼ X 3⅞ in.

***89-91.**

In addition there are 3 refused plates in the Bernard Gheerbrant Collection on Arches, measuring 7⅝ X 5⅜ in.

92-94.

Derrière le miroir, nos. 39-40, text by Michel Leiris. Paris, Maeght, June 1951. The catalogue for the 1951 show at Maeght. Contains 3 lithographs (collection: Galerie le chat Bernard, Chicago):

92. ANNETTE, HORSE, STOOL. 15⅜ X 11¾ in.

93. STANDING STATUES IN STUDIO. 15⅜ X 11¾ in.

94. MAN WALKING IN THE STUDIO. 15⅜ X 23⅝ in.

(NOTE: the 3 color lithographs in the 1954 *Derrière le miroir*, text by Jean-Paul Sartre, are not by Giacometti, but done "in the manner of" as illustrations for this text of his 1954 Maeght show.)

***95.**

Char, René. *Poèmes des deux années, 1953-1954*. Paris, GLM, 1955. One etching limited to 50 impressions. 5⅞ X 3¼ in.

96.

Femme qui marche. Etching. A Christmas card for the Galerie Maeght. 1955. Arches. Edition: 550. 12⅝ X 9⅞ in. None were signed or offered for commercial distribution.

***97.**

Du Bouchet, André. *Le Moteur blanc*. Paris, GLM, 1956. 50 copies. Etching. 6½ X 4⅝ in.

***98.**

Eluard, Paul. *Un Poème dans chaque livre*. Paris, Louis Broder, 1956. An etching of the artist illustrates poem XII. 5⅛ X 5⅜ in. Edition: 160, with 120 unsigned copies on Arches, and 40 signed copies on various papers.

***99.**

Genet, Jean. *Le Balcon*. Décines, L'Arbalète, Marc Barbezat, 1956. Lithograph on the cover. 7⅝ X 5¾ in. Edition: 3000 copies.

100-102.

Genet, Jean. *L'Atelier d'Alberto Giacometti*. Paris, Maeght, 1957. This catalogue for the 1957 Maeght show contained the following 3 lithographs, all in signed editions of 100:

 100. THE STUDIO WITH BOTTLES (*L'Atelier aux bouteilles*). Rives. 16⅛ X 21⅞ in.

 101. MAN STANDING (*Homme debout*). Arches. 11¼ X 16⅛ in.

 102. HEAD OF MAN (*Tête d'homme*). Arches. 16⅛ X 11¼ in.

The margins of this edition, done before the book, are larger than those found in the book itself.

***103.**

Lély, Gilbert. *La Folie Tristan*. Paris, Jean Hugues, 1959. 50 copies with a signed etching. 5⅞ X 8¼ in.

104-105.

Catalogue Kornfeld & Klipstein. Bern, 1959. Contains 2 etchings:

 104. SMALL STANDING NUDE (*Petit Nu debout*). Edition: 50. 6⅛ X 3⅛ in.

 ***105.** THREE FIGURINES (*Trois Figurines*). Edition: 100. 6¼ X 4⅜ in.

***106.**

Dupin, Jacques. *L'Epervier*. Paris, GLM, 1960. One etching. Arches. Edition: 65. 5⅞ X 4 in.

107.

Du Bouchet, André. *Dans la chaleur vacante*. Paris, 1961. Edition: 70. Etching. Frontispiece. Vergé d'Auvergne. 6½ X 4⅝ in.

108-126.

Leiris, Michel. *Vivantes Cendres, innomées*. Paris, Jean Hugues, 1961. Edition: 100 copies with 13 unsigned etchings; also 25 deluxe copies with these 13 etchings plus a suite of 6 refused, signed etchings limited to 25. All the plates measure 7¾ X 5½ in.

 108. HEAD OF A MAN.
 109. MAN IN BED I.
 110. MAN IN BED II.
 111. MAN IN BED III.
 112. HEAD OF A MAN.
 113. HEAD OF A MAN.
 114. HEAD OF A MAN.
 115. OPEN WINDOW.
 116. BAROQUE DETAIL.
 117. CANDLESTICK AND MIRROR.
 118. JACKAL-HEADED ANUBIS.
 119. LAMP AND TABLE.
 120. RECLINING HEAD OF A MAN.

Six refused states:

 121. ROOM INTERIOR.
 122. DETAIL.
 123. ROOM INTERIOR WITH TABLE.
 124. ROOM INTERIOR WITH CHAIR.
 125. HEAD OF A MAN.
 126. PROFILE OF A MAN.

Collection: Galerie le chat Bernard, Chicago.

127.

Iliazd. *Sentence sans paroles*. Paris, 1961. Etching frontispiece signed by the artist. (The cover has a Braque drawing reproduced on it and Braque's signature on the title page.) Edition: 62 copies, 30 on Japan and 32 on China paper. 5⅜ X 4⅛ in.

128-147.

Leclercq, Léna. *Pomme endormie*. Décines, L'Arbalète, Marc Barbezat, 1961. Edition: 100 copies, with 8 unsigned lithographs; also a deluxe edition with a suite on Japan of these 8 signed and a suite on Japan of 8 refused states, this being limited to 23 copies. In addition, Edwin Engelberts has 4 exceptional states, thus making a total of 20 lithographs done for this book. All measure 12⅜ X 9⅞ in.

 128. WHALE, SUN, SHIP, AND STANDING MAN (*Baleine, soleil, bateau, homme debout*).
 129. GALLOPING HORSE (*Cheval galoppant*).
 130. THE CANDLE (*La Bougie*).
 131. SLEEPING APPLE (*Pomme endormie*).
 132. THREE APPLES (*Trois Pommes*).
 133. LEANING WOMAN (*Femme s'appuyante*).
 134. BOUQUET AND APPLE (*Bouquet et pomme*).
 135. BOUQUET AND BOWL OF FRUIT (*Bouquet et bol de fruits*).
 ***136.** Variation of 128.

*137. Variation of 132.

*138. EYE AND TREE (*Oeil et arbre*).

*139. LANDSCAPE WITH FIGURES (*Paysage avec figures*).

*140. Variation of 139.

*141. Variation of 130.

*142. COUPLE SEARCHING FOR EACH OTHER (*Couple se cherchant*).

*143. Variation of 135.

Four rare trial proofs in Edwin Engelberts' collection:

*144. First trial proof of 128.

*145. Second trial proof of 128.

*146. Trial proof of 138.

*147. BUSTS, SCULPTURES STANDING IN THE STUDIO (*Bustes, sculptures debout dans l'atelier*).

148-161.

Derrière le miroir, no. 127, text by Isaku Yanaihara and others. Paris, Maeght, 1961. The catalogue of the 1961 show at Maeght. There is a deluxe edition of these 14 lithographs limited to 125 copies signed by the artist. 15⅜ X 11⅞ in.

*148. NUDE. [Front cover]

149. NUDE IN PROFILE.

150. SEATED MAN AND SCULPTURE.

151. SEATED NUDE.

152. BUST OF SEATED MAN.

153. SEATED NUDE.

154. NUDE.

155. HEAD OF A MAN.

156. BUST OF A NUDE.

157. HEAD OF A MAN.

158. SEATED FIGURE.

159. STUDIO WITH SCULPTURES.

160. NUDE IN PROFILE.

*161. NUDE. [Back cover]

162-173.

Iliazd. *Les Douze Portraits du célèbre Orbandale*. Paris, 1962. Edition: 40. Rustic China. 12 etchings. Only the book was signed. 9⅜ X 4⅛ in.

*174.

Cervantes, Miguel de. *La Danse du Château*. Paris, 1962. Frontispiece etching, a portrait of Louis Chavignier. Vélin. Edition: 120 copies. 11¼ X 7⅝ in.

175.

Rimbaud vu par les peintres. Paris, Matarasso, 1962. Edition: 97. Etching. Rives. 11⅝ X 9½ in.

176.

Benoit, Pierre-André. *Bibliographie des oeuvres de René Char de 1928 à 1963*. Ribaute-les-Tavernes, 1964. Edition: 100. Etching. 5⅞ X 3⅞ in.

177-183.

Lebel, Robert. *La Double Vue*. Paris, Le Soleil Noir, 1964.

7 etchings. One diptych, 20⅛ X 15⅜ in., and 6 smaller etchings, 10 X 7⅝ in. for the deluxe editions. Edition: 111 copies. Rives. 1 copy contains the diptych and the suite of the 6 smaller etchings, all signed. 10 copies (2-11) contain the diptych and 3 smaller etchings, all signed. 100 copies, the regular edition, contain only the diptych and are numbered 12-111 and are signed on the title page. In addition, there are 15 copies designated HC/A to HC/O, with the suite of 6 smaller etchings, all signed. The book also contains the last signed work of Marcel Duchamp, a tiny construction, *La Pendule du Profil*.

177. STUDIO AND ANNETTE (DIPTYCH).

178. ANNETTE WITH CROSSED ARMS.

*179. ANNETE I.

*180. ANNETTE II.

*181. ANNETTE III.

182. WOMAN WITH CROSSED LEGS.

*183. STOOL AND PICTURE.

184.

La Double Vue. A printer's proof of the diptych with the images in reverse. Dedicated by the publisher of Le Soleil Noir, François di Dio, to Herbert Lust. 15⅜ X 20⅛ in.

185.

Catalogue Galerie Beyeler. Basel. 1964. Edition: 150. 11⅝ X 9¼ in. Etching: *Sculptures dans l'atelier*.

186.

Crevel, René. *Feuilles éparses*. Paris, 1965. Etchings by many artists, including Giacometti. Giacometti's is sometimes known as "*L'Arbre.*" Edition: 50. Vélin. 10⅜ X 8⅜ in.

187.

Lazar-Vernet. *Paroles peintes*. Text by various authors. Paris, 1965. Etching (called "*Dans l'Atelier*" by Engelberts). Edition: 50 signed impressions, 35 on Richard de Bas and 15 on Japan. 150 impressions unsigned. 10 X 7⅝ in.

188-191.

Char, René. *Retour Amont*. Paris, GLM, 1965. 4 etchings. Edition: 188. Rives. 8⅝ X 6½ in.

192-193.

La Magie quotidienne. Paris, 1966. A suite of etchings by various artists. Edition: 74. 70 on Arches and 4 on Japan. Two by Giacometti. 16¼ X 11¾ in.

192. YOUNG WOMAN.

193. FIGURINES IN THE STUDIO (*Figurines dans l'atelier*).

194-199.

Du Bouchet, André. *L'Inhabité*. Paris, Jean Hugues, 1967. 6 etchings. Edition: 125. Auvergne des Moulins Richard de Bas. 6¼ X 4¾ in.

194. HEAD OF A MAN.

195. ROADWAY.

196. TREE.

197. TREE AND BUILDINGS.

*198. PILED-UP PICTURES. [Verso of 197]

199. ROADWAY.

200.

SCULPTURES IN THE STUDIO. Exposition Giacometti 1951. Lithograph. There was supposed to have been an *avant-la-lettre* edition limited to 100, but I have never seen it. The publisher does not seem to know about it. 24¾ X 20½ in. Publisher: Maeght (15).

201.

RUE D'ALESIA. Exposition Giacometti 1954. Color lithograph. Very little of the stone was done by the artist. However, he authorized and signed an edition of 200 *avant-la-lettre*. 25⅝ X 21¼ in. Publisher: Maeght (16).

202.

MAN WALKING (*L'Homme qui marche*). Exposition Gia-cometti 1957. Lithograph. Poster for 1957 show. *Avant-la-lettre* edition of 200. 29⅞ X 22⅞ in. Publisher: Maeght (57).

203.

WOMAN STANDING (*Femme debout*). Exposition Gia-cometti 1961. Lithograph. 25⅝ X 21¼ in. Publisher: Maeght (74).

204-353.

Paris sans fin

Giacometti, Alberto. *Paris sans fin*. Paris, 1969. Text and 150 lithographs by the artist. Edition: 250 copies on Vélin d'Arches, numbered 1-250 and 20 copies *hors commerce*, numbered I-XX. Publisher: Tériade. 16¾ X 12¾ in.

Only a selection of these lithographs were shown in the exhibition.

15 Drawings

D1. TREE SEEN FROM ABOVE. 1949. Crayon. 18½ X 12½ in.

D2. HEAD IN THE STUDIO. 1950. Pencil. 19¾ X 12¾ in.

D3. STATUES IN THE STUDIO. (Verso of D2.) Pencil. 19¾ X 12¾ in.

D4. CHAIR AND FLOOR. 1953 (signed 1954). Pencil. 19¾ X 12⅝ in.

D5. MOTHER AND CHANDELIER. 1954. Pencil. 19½ X 12⅝ in.

D6. STUDIO II. 1954. Crayon and lithograph. 14¾ X 21½ in. (A study for the lithograph *Studio II* [15], 1954.)

D7. THE LARGE BOUQUET OF FLOWERS. 1954. Pencil. 16 X 22 in.

D8. THE AUTOMOBILE. 1956. India ink. 14¼ X 9½ in.

D9. HEAD OF DIEGO. 1956. Pencil. 19½ X 6¾ in. (Inscribed by the artist: *Pour Herbert Lust en souvenir de son voyage à Paris. Paris 13 juillet 1956.*)

D10. "LE BALCON." 1956. Lithograph and pencil. 19⅜ X 12⅞ in. (A study for the cover lithograph [99] for the Genet play.)

D11. THE BOTTLES. 1956/7. Pencil. 16½ X 11⅜ in.

D12. THE STOOL. 1957. Pencil. 19½ X 12½ in.

D13. HEADS AFTER PIGALLE. 1960. Ballpoint pen. 19½ X 12 in.

D14. PORTRAIT OF HERBERT LUST. 1961. Pencil. 19¾ X 12¾ in.

D15. PORTRAIT OF HERBERT LUST IN HIS FATHER'S TOPCOAT. 1961. Ballpoint pen. 19¾ X 12¾ in.